ocean liner POSTERS

HOLLAND-AMERICA LINE

S.S. STATENDAM

Gabriele Cadringher

Text by Anne Massey

ocean liner POSTERS

Antique Collectors' Club

Contents

Hamburg, Hamburg-Amerika
Linie, c.1934
Ship: *Albert Ballin*, one of the
finest vessels
84.2 x 60.7cm

PAGE 2 :
Holland-America Line
C. Jocker, 1928
Ship: *Statendam*
93.6 x 69.2cm
Maritime Museum, Rotterdam

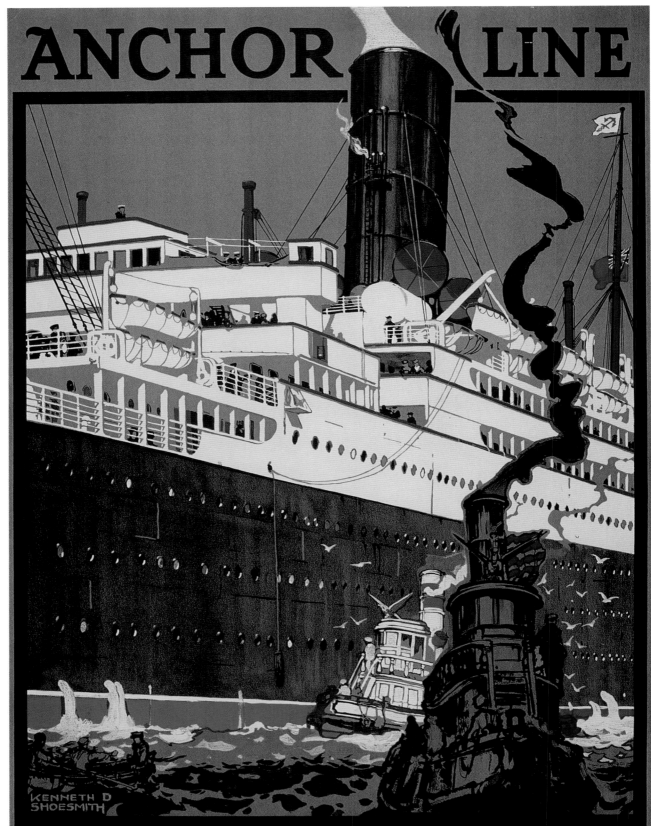

Preface

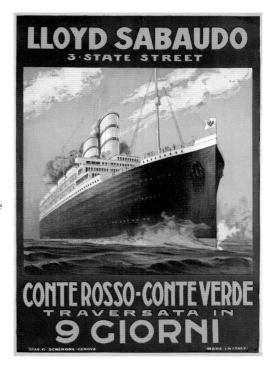

'Nine-day crossing', Lloyd Sabaudo, c.1925, Stab. G. Schenone, Genoa
Ships: *Conte Rosso, Conte Verde*
99.5 x 69cm
Alessandro Bellenda, Galerie L'IMAGE, Alassio, Italy

T he *France*, once the pride of the French merchant navy, is now disintegrating on a far off Indian beach. The *United States*, the last ocean liner to have won the Blue Riband, is rusting in the corner of the port of Philadelphia. The *Queen Mary*, the most famous of the long dynasty of English ocean liners has become a hotel for Americans yearning for memories in the port of Long Beach.

During the last century, however, there were hundreds of ocean liners sailing the seas – what has become of them all? The *Lusitania* and the *Mauritania*, Cunard's distinguished sister ships; the *Kaiser Wilhelm II*, the *Imperator* and the other German giants; the *Olympic* and the *Titanic*, whose tragedy is carved in history; the *Paris* and the *Île-de-France*, veritable floating palaces and living exhibitions of French style and art; the *Bremen* and the *Europa*, symbols of the German Renaissance of the inter-war years; the *Rex* and the *Conte di Savoia*, flagships of the Italian Navy; the *Nieuw Amsterdam*, the largest of the Dutch ocean liners; the *Normandie*, the very largest of all the greyhounds of the seas and a marvel of technology and beauty…

These ships have either been lost at sea or scrapped. All that remains are memories, keepsakes and photos, which bring joy to collectors. Hundreds of books, mostly of photographs, have been published about shipping companies and their fleets. This book aims to look at their marvellous history in a different way, illustrated with the posters that the companies published in order to advertise their vessels and their lines.

The shipping companies were founded around the middle of the nineteenth century, at about the same time as technical advances were made in lithography. For the next hundred years – until the 1960s, when aeroplanes finally replaced ships as the preferred mode of transport between continents and television began to dominate the printed image – posters were the shipping companies' main method of communication; as a result, their histories are inextricably linked.

Shipping Company Posters

Shipping posters recount artistic, cultural, social and industrial history. The artistic history can be seen through the clear development in the design itself. The image of the ship, which appeared in posters in the nineteenth century along with information about the routes on offer, would become far more important from a graphical and visual point of view in the Art Nouveau era. Next came the Art Deco era, when greats such as Cassandre signed their work, in particular for the *Normandie* and the *Atlantique*, and this remained inscribed on the mind. Finally, after the Second World War and until the end of the transatlantic routes, the poster was changed again in line with the current trend for modern art.

Posters depict cultural and human history of more than a century, as ocean liners remained 'the only way to cross!' from one continent to another, as the historian John Graham Maxwell wrote. Millions of passengers made the transatlantic crossings, from the millionaires who occupied the lavishly decorated suites, to the immigrants in search of a better future huddled together in Third Class, not forgetting civil servants from the colonies, soldiers, businessmen and tourists. Countless people travelled on these ships, which were the greatest machines of transportation that man had ever built.

Finally, posters portray industrial history, as ocean liners were an important way for their countries to display their technological expertise. As for the designs, they showed both the latest technical and artistic advances. A fine example is the *Normandie* and its fittings, designed by the best artists of the time.

GABRIELE CADRINGHER, Monaco, June 2008

Glasgow & New York, Anchor Line,
Kenneth D. Shoesmith, 1923
Thomas Forman & Sons, Nottingham
Ships: *Cameronia, Tyrrenia, Tuscania, California*
99 x 60cm
Museum für Gestaltung Zürich, Poster Collection

Introduction

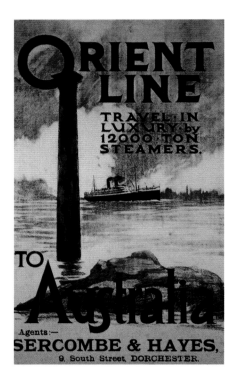

'To Australia', Orient Line, c.1909
Ships: *Orsova, Otway, Osterley, Otranto, Orvieto, Orama*
98.8 x 60.5cm
P & O Heritage Collection

The Birth of Posters

Despite the fact that lithography had been possible since 1798, it was originally too expensive and too time-consuming to be suitable for the production of posters. Most posters were therefore printed using carved wood or metal and contained little colouring.

Everything changed with Jules Chéret's 'lithography stones'. This invention made it possible to reproduce every colour of the rainbow using just three base colours: red, yellow and blue. The process was quite complex, but it gave a remarkable intensity of colour and texture, with beautiful clarity and subtle shades that were impossible to achieve with other techniques. This ability to link word and image in a format that was as economical as it was attractive, made the lithographic poster a tremendous invention. It became the main tool of mass communication in Europe and America from the 1870s, where the towns and cities were expanding extremely quickly. The main roads of Paris, Milan and Berlin quickly became 'street art galleries', and so began the era of advertising.

The Belle Époque

In the 1890s, known in France as the 'Belle Époque', posters were to be seen everywhere. In 1891, the first poster by Toulouse-Lautrec was created for the Moulin Rouge, raising the genre to the rank of Fine Art. From that point onward, there would be many exhibitions of posters and magazines. At the start of the decade, the Parisian merchant Sagot had 2,200 different examples in his sales catalogue!

In 1894, Alphonse Mucha, a Czech artist working in Paris, created the first Art Nouveau poster masterpiece. The Art Nouveau style, with its flowing lines, was born about the same time as Mucha produced a poster for Sarah Bernhardt, who was captivating Paris at the time. Combining many sources of inspiration, such as the Pre-Raphaelites, the Arts and Crafts movement and Byzantine art, among others, Art Nouveau would dominate the Parisian stage for the next decade. It remained the main expression of decorative art in the world until the First World War.

Posters were slowly introduced to other countries during the 1880s, but they really became popular everywhere during the Belle Époque. In each country, the poster was the preferred medium for promoting the specific cultural trends: in France,

it was the cafés (and absinthe); in Italy, opera and fashion; in Spain, it was bullfighting and fiestas; in the Netherlands, literature and household products; and in Germany, it was trade fairs and magazines; whereas in Great Britain and America, literary reviews and circuses were the main focus.

The first poster exhibitions were held in Great Britain and Italy in 1894, in Germany in 1896 and in Russia in 1897. The largest was held in 1896 in Reims with 1,690 examples on display. Along with the different influences and national characteristics, the Belle Époque witnessed the development of the genre. The Dutch posters were characterised by their restraint and their rigour. The Italians stood out with their large format theatre posters and the Germans by their medieval inspiration. France's omnipotence in this area had met its match.

The New Century

Although Art Nouveau did not end at the turn of the century, imitation and repetition had caused it to lose much of its dynamism. The death of Toulouse-Lautrec in 1901 and then the fact that Mucha and Chéret both stopped producing posters to devote more time to painting, left a great void in France. However, at the start of the new century, this void was filled by a young Italian caricaturist called Leonetto Cappiello who arrived in Paris in 1898.

Greatly influenced by Chéret and Toulouse-Lautrec, Cappiello broke away from Art Nouveau. He concentrated on the creation of a simple image that was often humorous or bizarre. It could immediately capture the attention and imagination of the viewer on the busy boulevards. In 1906, he designed a poster of a green devil on a black background with simple lettering for Quina Morin absinthe. It reflects the development of a style that would dominate poster art in Paris until the first Art Deco poster, signed by Cassandre, appeared in 1923. His ability to create a brand identity established Cappiello as the 'father of modern advertising'.

During this time, artists working in the Glasgow School, at the Vienna Secession and the Deutscher Werkbund were also transforming Art Nouveau. These schools rejected curvilinear ornamentation in favour of a geometric structure based on functionalism.

One of the main examples of these trends is the German Plakatstil, or Poster

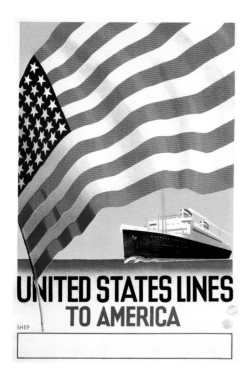

'To America', United States Lines,
Shep, c.1934
Ships: *Washington, Manhattan*
100.4 x 62.4cm

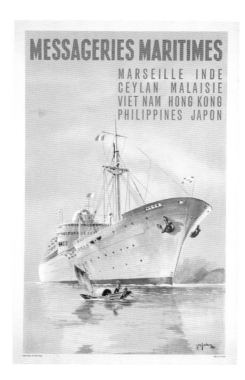

Marseille-India-Ceylon-Malaysia-
Vietnam-Hong Kong-Philippines-
Japan, Messageries Maritimes,
J. des Gachons, 1958, Edita, Paris
Ships: *Laos, Vietnam, Cambodge*
99.2 x 63cm

Style, which was started in 1905 by Lucien Bernhard in Berlin and Ludwig Hohlwein in Munich. Bernhard introduced a new approach for a poster competition sponsored by Preister. He drew two big matches and printed the brand name above in bold type. The simplicity of his design won him victory. Bernhard moved away from naturalism by placing the accent on colour and shape. His work was a step towards the birth of a modern visual language.

The First World War and the Bolshevik Revolution

The First World War provided posters with a new role: propaganda. In fact, the War was the time of the greatest communication campaign to date, serving the needs of each country involved. It helped to gather funds, to recruit soldiers and to strengthen volunteer action. It stimulated production and engendered indignation towards the atrocities perpetrated by the enemy. In little more than two years, the USA alone produced some 2,500 designs and 20 million posters, which equated to one for every four citizens.

The Bolsheviks learnt from this and used posters in their fight against the White Russians. Lenin and his successors proved to be pioneers of modern propaganda, with the poster being one of its weapons used across the world throughout the century.

Between two Wars: Modernism and Art Deco

After the First World War, Art Nouveau lost its inspiration in a society that was becoming more and more industrialised. Its new realities were better expressed by modern art movements such as Cubism, Futurism, Dadaism and Expressionism, which all had a profound influence on graphic design.

In the Soviet Union, the Constructivism Movement came about during the 1920s. Its aim was to create a new technological society. Based on Kazimir Malevitch's Suprematist Movement, the Russian extension of Cubo-Futurism, the Constructivists developed a style of composition that was marked by strong diagonals, photomontage and colour. Led by El Lissitsky, Alexander Rodtchenko, Gustav Klutsis and the Stenberg brothers, Constructivist work would have a major impact on Western design, especially in the Bauhaus and the De Stijl movement.

This 'scientific' language of design was made popular in a new international context named Art Deco. During this time the machine, power and speed had become the main themes. Shapes were simplified and rationalised. Curved letters were replaced by an elegant repertoire of angular lines. Art Deco reflected a great variety of graphical influences including modern art movements such as Cubism, Futurism, Vorticism and Dadaism. It also displayed audacious designs from the Vienna Secession, Plakatstil, Russian Constructivists and even Persian, Egyptian and African art.

The term 'Art Deco' was coined in reference to the Exposition des Arts Décoratifs of 1925 in Paris, which proved to be a great showcase for the style. In Paris, Cappiello's caricatured style gave way to Cassandre's geometric, structured images. His huge posters for the *Normandie*, the *Statendam* or the *Atlantique* became icons of the industrial era.

Art Deco spread rapidly throughout Europe. It was created, among others, by Federico Seneca and Giuseppe Riccobaldi in Italy, Ludwig Hohlwein and Julius Engelhard in Germany, Pieter Hofman in Holland, Otto Morach and Herbert Matter in Switzerland, Edward McKnight Kauffer and Tom Purvis in England and Francisco de Gali in Spain.

The Second World War and the End of Lithography

The poster would again play a great role in communication during the Second World War. However, this time, it was used alongside other media, in particular, radio and the press. At this time, most posters were printed offset. The use of photography in the composition, which appeared in the Soviet Union in the 1920s, had become just as common as illustration. Post-war, the role of the poster continued to decline in many countries as television became an additional rival.

The role and the design of the poster continued to change throughout the last century, adapting to changes in society. Although its role today is less significant than it was a hundred years ago, the poster can still evolve and become as revolutionary as the twenty-first century means of communication such as computers and the internet.

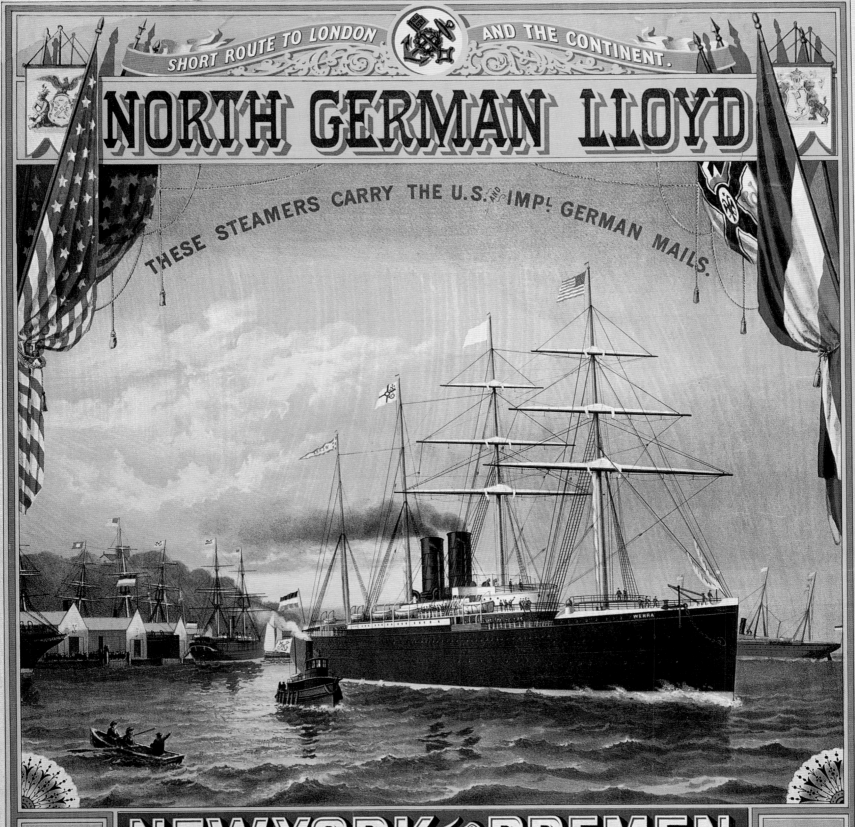

1873-1900

The Second Half of the Nineteenth Century: The Birth of Maritime Companies

Liverpool & Australian Navigation Co.,
Great Britain, 1873
Ship: *Great Britain*
37 x 22cm
By courtesy of the SS Great Britain Trust

New York-Bremen, North German Lloyd,
c.1884, The Major & Knapp Eng. Mfg. &
Lith. Co., New York
Ship: *Werra*
78 x 59cm
Museum für Gestaltung Zurich,
Poster Collection

Today we think of ocean liner travel as being luxurious, even glamorous. This may have been true for a certain class of passengers from the late nineteenth century onwards, but travellers before that were not so lucky. Travel by sea leading up to and during most of the nineteenth century was a very uncomfortable and even dangerous experience for the majority of passengers. The ships were dependant on sail power, unreliable currents and uncertain winds. Accommodation was basic and passengers were only allowed on board at the discretion of the ship's captain. However, only a very small percentage of the population travelled by sea at all; ships were largely for the transport of cargo or for naval battles. Therefore, there were no posters to advertise travel and the ships were far from accommodating. This was soon to change.

The Industrial Revolution of the late eighteenth and nineteenth centuries led to far reaching technological innovations in all areas of transport, beginning with train travel and then changing shipping. Massive social changes were also prompted by the Industrial Revolution, including a move from the countryside to the city, the mass production of goods, the growth of consumerism and the mass colonisation of the world beyond Europe. Initially, the stimulus to build ocean liners came more from the need to transport mail and cargo more speedily than from the necessity to move passengers. Therefore, safety and speed were of prime importance. This period witnessed the transformation of ship construction from timber to iron, as the impact of the industrial revolution was felt. Parallel to this was the transition from sail to steam power. It was also a period when the economic and political climate stimulated an increase in sea travel for the purposes of both trade and emigration, with the beginnings of the colonisation of many parts of the world by Britain, France, Holland, Portugal and Spain. Before the era of mass passenger sea travel, ships were designed to carry the optimum cargo and often incorporated means of defence, so attracting passengers and making them comfortable was not a priority. For example, the 102 passengers on the famous voyage of the *Mayflower* in 1620 from Plymouth to North America lived mainly on the gun deck in cramped conditions. Advertising by poster had not begun at this point for many reasons, most notably because many people were illiterate.

In the early nineteenth century work began on applying steam power to ships. This has first begun with the railways, and the aims were to make sailing times more reliable and to increase the size of ships to enable them to carry more cargo. The main challenge was to make the engines efficient so that the amount of coal that needed to be carried was not prohibitive. The first use of steam power was for small vessels undertaking short trips. For example, the *Comet* was a wooden paddle-steamer and, from 1812, the first to offer a regular service between Glasgow, Greenock and Helensburgh on the Clyde. Steamers were also launched on the Thames and were pioneered on routes between Britain and Ireland during the early nineteenth-century. In America small scale steamers were introduced in the late eighteenth-century, with

Hamburg-Amerika, Union, c.1888,
F.W. Kähler, Hamburg
Ship: one of the four vessels named
Australia, *California*, *Polaria* and *Polynesia*
69 x 34.7cm

12

the start of a steamboat service on the Delaware River by John Fitch. In 1807 Robert Fulton's *North River Steam Boat* (later renamed the *Clermont*) began operating on the Hudson River, from New York to Albany. The longer route from North America to Britain was first successfully completed with steam power by the American boat, *Savannah*, in 1819. However, the majority of the thirty day journey was made under sail and it carried no cargo or passengers. The ship had the appearance of a traditional square-rigger, complete with three masts and sails, but with the addition of a funnel, paddle wheels on either side and an engine below.

The emigrant trade from Ireland and Great Britain, Germany, Norway, Sweden, Italy, Austria-Hungary, Russia, Poland, Estonia and Lithuania, Greece, Albania, Serbia, Bulgaria, Syria and Armenia to North America was booming during the nineteenth century. From 1820 to 1920, thirty-five million passengers made the dangerous and uncomfortable journey across the Atlantic, most in desperate search of a better life. There was also mass emigration to Australia and South America. Although the new technology of steam was used to pack more passengers into larger, faster boats, the conditions for most emigrants were appalling. Crammed into tiny spaces, with little or no privacy, they were prey to diseases such as cholera and typhus. On the route from America to Europe, until as late as the 1890s, the space used for human traffic on the westward journey was used to transport cattle eastwards.

The situation began to change during the second half of the nineteenth century, as the number of passenger routes and liners grew. The volume of the emigrant trade made it highly profitable, and it was the core of many companies which sailed the Atlantic. Samuel Cunard commissioned the first purpose built ocean liner for transatlantic travel in 1840. Powered by steam and sail, it could only carry just over 100 First Class passengers. The Cunard company was slow to meet the needs of the emigrant trade and the company suffered, resulting in a financial crisis in 1878, which forced Cunard to look again at how it accommodated passengers.

It was Isambard Kingdom Brunel who pioneered the technology for global travel by steam and was the first to replace the paddles on either side of the vessel with a screw propeller at the stern of the ship. The *Great Britain* was the first ship to be made from iron, rather than wood, and driven by a screw propeller (p.11). It was launched with no interior fittings except for the carpets which had been laid in preparation for the royal visit. Launched by Prince Albert in July 1843, the ship was a massive 322ft long, 50ft 6in wide, and 1,016 tons. It could accommodate 252 passengers in berths and needed 120 crew to sail it. Steam was the primary source of power, with auxiliary sails to save coal if the winds were favourable. The interiors were fairly sparse by modern standards, with long tables and benches and simple beds in the cabins. There was some decorative plasterwork, supplied by Jackson and Sons, and some painted ornaments in the first class saloon. The *Great Britain*'s career as a cross Atlantic steamship was short-lived, however, and it was sold in 1850 to Gibbs, Bright and Company of Liverpool for the burgeoning Australia journey, precipitated by the gold

rush. The ship was changed from a steam ship with sails to a sailing ship with steam capacity and could now take 730 passengers; only 50 were First Class as a new deck was created for those in Second Class as part of the new deckhouse.

From 1852 until 1876, the *Great Britain* sailed between Australia and Britain, carrying emigrants to Australia and bringing wool and cotton back to Britain in a journey averaging two months. The poster illustrated here is simple, with red and black type, and the image of the ship being used to advertise the voyage to a better life in Australia. In 1876, use of the Great Britain for the Australia run ceased and was put up for sale. In 1882 it was bought by Antony Gibbs, Son and Co. to be converted to a sailing ship which would carry coal from Cardiff round the Horn to San Francisco, returning with wheat. She ran into trouble rounding Cape Horn, however, and ended up in the Falkland Islands where she was used for storage, firstly of wool and later of coal. In 1937 she was towed out of the harbour and beached at Sparrow Cove, then in 1970, she was towed back to Bristol for extensive restoration and conservation.

Whilst the history of the *Great Britain* reveals greater success on the Australia route, competition emerged from new lines for the trans-Atlantic route right across Western Europe. The Belgium based Red Star Line, was founded in 1872 with American support, to provide sailings from Antwerp to New York and Philadelphia. The *Westernland*, seen illustrated in these posters (pp.16 and 17), was built in 1883 and provided regular transport on the Antwerp to New York line, until it was scrapped in Italy in 1912. As shown by the posters, the two funnels sported the Red Star logo, whilst the sails showed that there was still a need to rely on wind power for parts of the journey. These posters are far more illustrative than that of the *Great Britain*, with a painting of the ship, rather than a simple black and white drawing.

Sailings from Germany to America were provided by Norddeutscher Lloyd (N.D.L.), founded in 1856, and the Hamburg-Amerikanische Packetfahrt Actien-Gesellschaft (H.A.P.A.G.), founded in 1847; this was also known as the Hamburg-Amerika Linie or Hamburg-American Line. The *Werra* (p.10) first sailed from Bremen to New York for N.D.L. in 1882 and provided a fast transatlantic service for 868 passengers in Steerage, 144 in Second Class and 190 in First Class. She was one of three express steamers built by the company, enabling them to cut the travel time from Germany to America to eight or nine days. The Carr-Union Line, also based in Germany, catered for the lower end of the market, and took 17–19 days to travel westwards to New York, although the prices were considerably cheaper. The *Australia*, *California*, *Polaria* and *Polynesia*, as well as a half-share in the Union Line, were bought by the Hamburg-American Line in 1888. Hamburg-American bought the remainder of the Carr-Union ships in 1890-91 (p.12).

The German shipping company of Deutsche Dampfschifffahrts-Gesellschaft Kosmos (D.D.G. Kosmos) specialised in shipping from Germany to the west coast of South America. Founded in 1872, the company was slow to offer passenger accommodation. The *Denderah* was modest in size, only 2,253 gross tons, having been

Kosmos, c.1888
Ship: *Denderah*
90 x 65cm
Museum für Gestaltung Zurich,
Poster Collection

bought from the Dutch Stoomboot Maatschapij Insulinde company in 1886 (p.13). Note that the poster does not depict sails, only the single steam funnel and rigging. This shows the gradual decline in the use of sail for passenger vessels.

German lines also sailed to Australia. The German-Australia line provided passage from Hamburg via Antwerp and the Cape to Adelaide, Melbourne and Sydney. Launched in 1889, the service provided by ships such as the *Elberfeld* was shortlived, and the line discontinued passenger services after a couple of years (p.19). The *Elberfeld* was sold to Hamburg-American Line in 1894. The German-America line used an image of the *Hammonia* to promote travel from Germany to New York, and from Antwerp to Canada (p.14). The ship had been sold to the French Line in 1889, but the company still chose to use this image for its posters.

Italian shipping companies also provided transport to South America. For example, La Veloce Linea di Navigazione Italiana a Vapore (La Veloce) was founded in 1884, though by 1900 it was owned by German banks. The *Nord America* was bought by the line as the *Stirling Castle* and renamed in 1888 (p.18). In 1909 became cargo only, and in 1911 the ship was scrapped after stranding damage at Morocco.

The main German rival to N.D.L. on the trans-Atlantic route was Hapag, or the Hamburg-American Line, as the company was based in Hamburg. By the late nineteenth century, the Hamburg-American line had acquired the Adler Line and the Carr-Union Line. To ensure a monopoly for sailings from the Mediterranean, the Hamburg-American Line and NDL worked together to provide a joint service from Naples, Algiers and Genoa to New York. The Hamburg-American Line also offered sailings to South America, Canada and Australia for the burgeoning immigrant trade. The *Fürst Bismarck* was German-built, and was an impressive 8,430 gross tons. She was 502ft in length with three funnels and a top speed of 19 knots. She could carry 420 passengers in First Class, 172 in Second Class and 700 in Third Class (p.20), and sailed primarily between Hamburg, Southampton and New York, beginning in 1891. She also sailed between Genoa, Naples and New York from 1894 until 1902. She was eventually sold to Russia in 1904.

The needs of the emigrant trade were also met in Britain by a whole host of shipping companies, including the Dominion Line, which specialised in voyages to Canada and Boston from Liverpool. The *New England* was built in 1898 at Harland & Wolff in Belfast (p.21). She was an impressive 11,394 gross tons with a length of 550ft, one funnel, two masts, twin screws and a top speed of 15 knots. The ship could carry 200 First Class, the same number of Second Class and a massive 800 passengers in Third. Her maiden voyage started on 30 June 1898 from Liverpool to Boston and this is possibly the crossing to which this poster refers. Note that the sails have all but disappeared from the image of the ship – a sign that the general public had become more accustomed to ships driven only by steam.

This same feature can be seen on the Messageries Maritimes poster from 1898, showing the *Annam* ploughing effortlessly through the waves, powered by steam (p.22). The company had been founded by the French government in 1835 to provide travel by steamship from Marseilles to the Levant. By the time of this poster in 1899, however, the company was providing sailings to North Africa, South America, India, the Middle East and Australia. By 1899 Cunard had revised its approach to advertising and to accommodating passengers on the trans-Atlantic route. More staid than rivals such as White Star and Hamburg-American, Cunard had a reputation for solid, efficient, reliable service which is reflected in the fairly stark representation of the *Campania* and *Lucania* (p.23). These were gigantic ships, capable of carrying 1,000 Third Class passengers, 400 Second Class and 600 First Class. The ships were also very fast, with the *Campania* travelling from Queenstown to Sandy Hook in less than five and a half days, breaking all previous records. The *Lucania* held the record for the fastest trans-Atlantic voyage for four years from 1897, when the *Kaiser Wilhelm der Grosse* succeeded in winning the Blue Ribband.

Therefore, competition between the different lines and different nations was growing towards the close of the nineteenth century, particularly between Britain and Germany. It was not only technical might and speed which were important weapons in this battle – advertising and accommodation also played a part in the struggle to attract customers. The Red Star Line continued to provide a service between Antwerp and New York throughout this period, and at the turn of the century it launched four new ships – the *Vaderland*, *Zeeland*, *Kroonland* and *Finland* (p.24). The company employed the Art Nouveau designer, Cassiers, to produce an arresting and novel image. The simplicity of the Art Nouveau style is in direct contrast to the more representational style of the previous posters. The ship is shown in profile, with a simplified group of people watching it who are shown in the blocked colours of traditional Belgian costume. The American Line employed the same artist, but in this poster, male onlookers are depicted viewing the departure of the *St Louis* or her sister ship, the *St Paul*, to New York (p.25). The Red Star Line poster from c.1900 (p.15) for travel on the *Vaderland*, *Zeeland*, *Kroonland* and *Finland* is again in Art Nouveau style, with a woman reclining on a liner deck chair and the silhouette of an ocean liner on the horizon. More traditional in presentation is the depiction of the *Cap Frio* for the Hamburg South-America Line which offered voyages between Hamburg, Lisbon, Bahia, Rio de Janeiro and the River Plate (p.28).

A more complex form of Art Nouveau was used by the German Norddeutscher Lloyd (N.D.L.) company to promote travel to the Near East and Far East. A Japanese aesthetic is used to advertise voyages to the land of the rising sun with black and gold to imitate lacquerwork (p.26). The highly stylised typography in flowing lines is intended to evoke the exotic destinations of places like Shanghai and Nagasaki on the poster for *König Albert* (p.27). Soft pastel colours and a gentle group of Japanese on-lookers complete the scene. Less gentle was the imagery used by the same company for the trans-Atlantic route, however. By this stage, competition on the trans-Atlantic route amongst competing lines was intense. In 1893, N.D.L. launched

Colón-Hamburg-Le Havre, H.A.P.G.,
c.1893, Mühlmeister & Johler, Hamburg
Ship: *Hammonia*
89.8 x 68.2cm

Antwerp-Canada, H.A.P.G., c.1893,
Mühlmeister & Johler, Hamburg
Ship: *Hammonia*
90.2 x 67.5cm

14

the *Kaiser Wilhelm der Grosse* and she is seen here from a low viewpoint which makes the ship almost tower over the viewer (p.29). At the time of her launch, she was the biggest ship afloat and also the first ocean liner to have four funnels; this feature is accentuated in the poster with dramatic backlighting and plumes of thick, black smoke. This build enabled the builders to place broad, high-ceilinged public rooms at the centre of the ship which were lit from above with huge skylights. The *Kaiser Wilhelm der Grosse* could carry 332 First Class, 343 Second Class and 1,074 Third Class passengers. The British designer of the *Aquitania*, Arthur Davis, wrote a seminal article on ship design for the British architectural periodical, *Architectural Review*, in 1914. In the article Davis was very critical, as were most British commentators, of German design: 'Another temptation to be avoided is to overcrowd a room with heavy ornament and meretricious decoration. This fault has been very apparent on some of the earlier German liners, where refinement of detail has been often sacrificed to tawdry magnificence and over-elaboration.' (Davis 1914: 89)

Of course, part of the reason for the British dislike of German ships may have been their dominance of the North Atlantic. The *Kaiser Wilhelm der Grosse*, built by the Bremen based N.D.L Line, wrested the Blue Riband from Britain's *Lucania* in 1898. The interiors were designed by Lloyd's chief architect, Johannes Poppe, master of the grandiose. The massive public rooms were decorated in heavy, Baroque Revival style: '…every available surface writhing with putti, garlands, shields, rocks and clouds, many of them gilded, but all defying both gravity and the suspension of disbelief.'

(Votolato 2007:109). There was a heavy, dark smoking room at the aft end of the promenade deck with a heavily carved ceiling, with dark brown, stamped leather panels, some of which were decorated with representations of naval history. The chairs were made from dark wood and the oblong tables were of the same material, both facing banquettes covered in dark brown patterned textile. This was in direct contrast to the ladies' drawing room decorated in light French Rococo revival style, with white and gold panelling and light blue upholstered settees and chairs. The ship was a great success, as the largest and fastest of its time, and set the scene for prolonged German domination of the Atlantic.

With the growth of the imperial powers of Britain, Germany, Holland, Italy and France came the need to support this with speedy and efficient naval transport for passengers, mail and cargo. Coupled with this was the burgeoning need to express competing national identities as part of the interior design of the ships. The need to attract passengers was also paramount, particularly on the trans-Atlantic route and the emigrant trade. The pioneering struggles of Brunel had been superseded by a more industrially organised and mechanically based shipbuilding industry, particularly in Germany and Great Britain. The development of ocean liner poster design through the second half of the nineteenth-century mirrored this development. From the simple diagram with text for the Great Britain to the flowing lines of Art Nouveau, the replacement of sail by steam and the inclusion of more pictoral references, especially those of people and places, characterise this era.

Antwerp-New York, Red Star Line, Victor
Creten, c.1900, Josse Goffin Fils
lithography, Brussels, and Stockmans & Co.,
Antwerp
Ship: one of the four vessels named *Finland,
Kroonland, Vaderland* and *Zeeland*
79.5 x 58.8cm

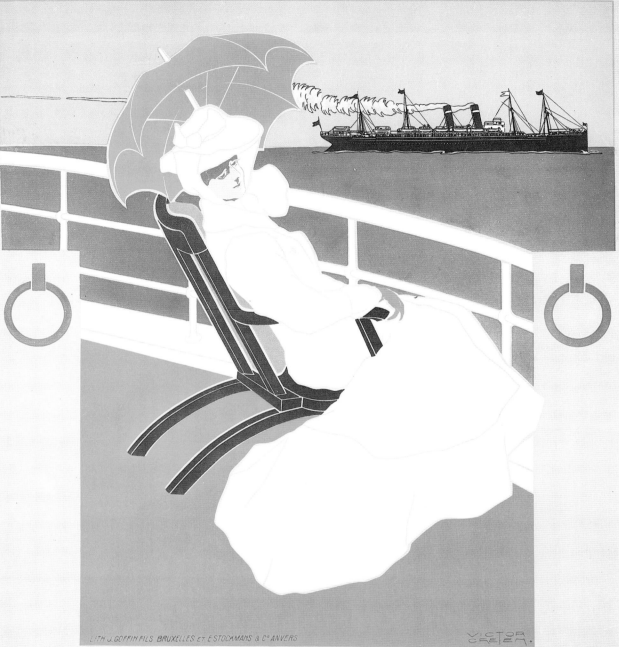

15

16

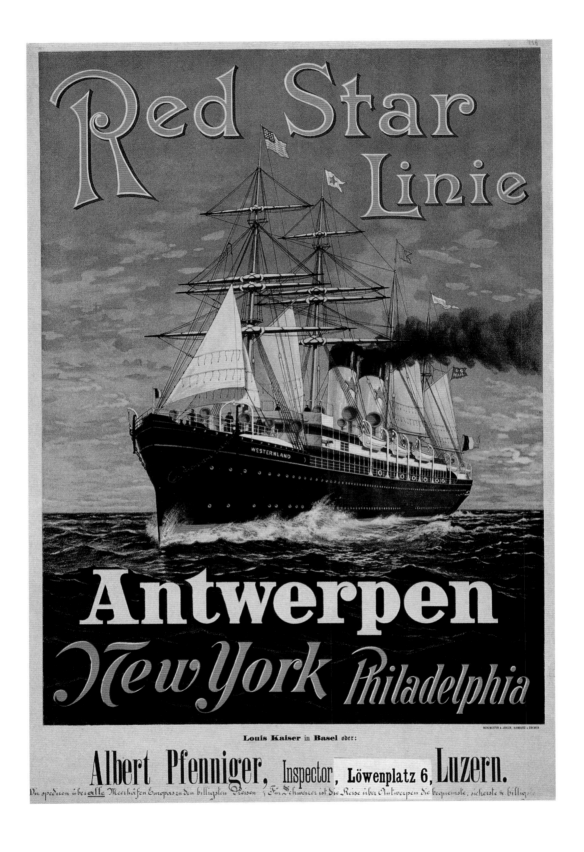

Antwerp-New York-Philadelphia,
Red Star, c.1883,
Mühlmeister & Johler, Hamburg
Ship: *Westernland*
68 x 45cm
Museum für Gestaltung Zurich,
Poster Collection

Antwerp-New York-Philadelphia,
Red Star, c.1883,
Mühlmeister & Johler, Hamburg
Ship: *Westernland*
68 x 45cm
Museum für Gestaltung Zurich,
Poster Collection

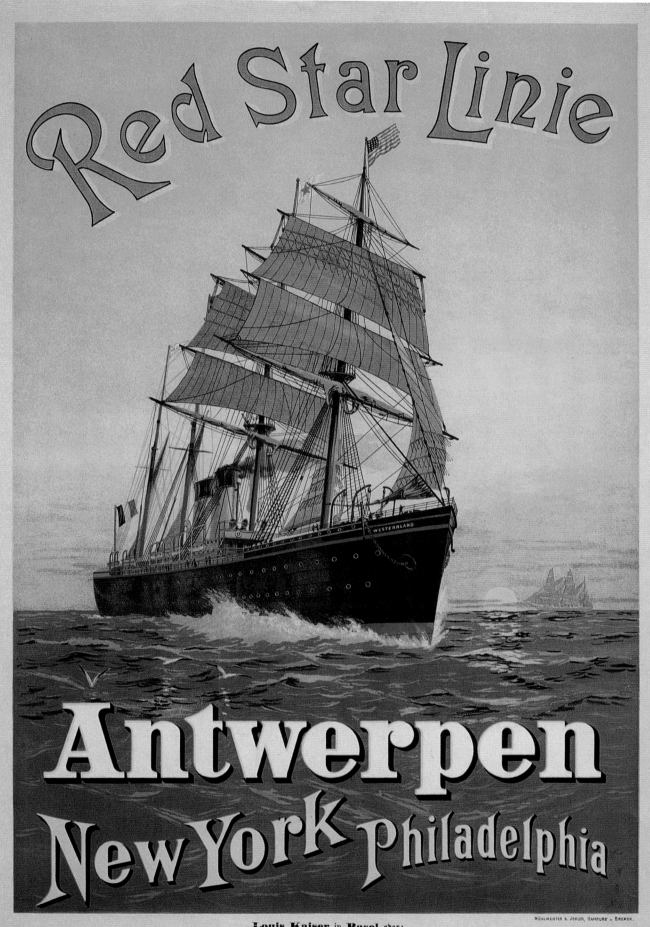

18

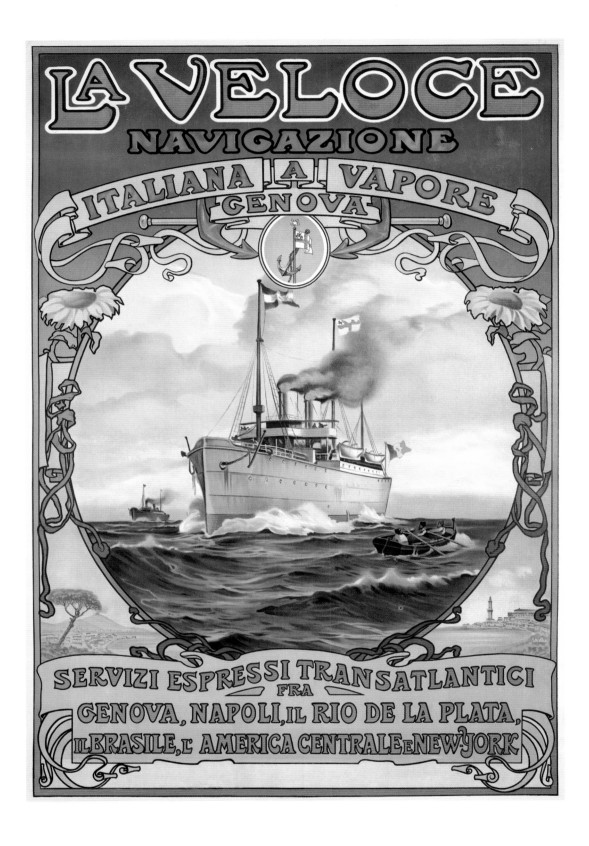

'Express Transatlantic Services',
La Veloce Linea di Navigazione Italiana
a Vapore, c.1889
Ship: *Nord America*
95.8 x 65.4cm

Hamburg-Australia, c.1889,
F.W. Kähler, Hamburg
Ship: *Elberfeld*
70 x 50cm
Museum für Gestaltung Zurich,
Poster Collection

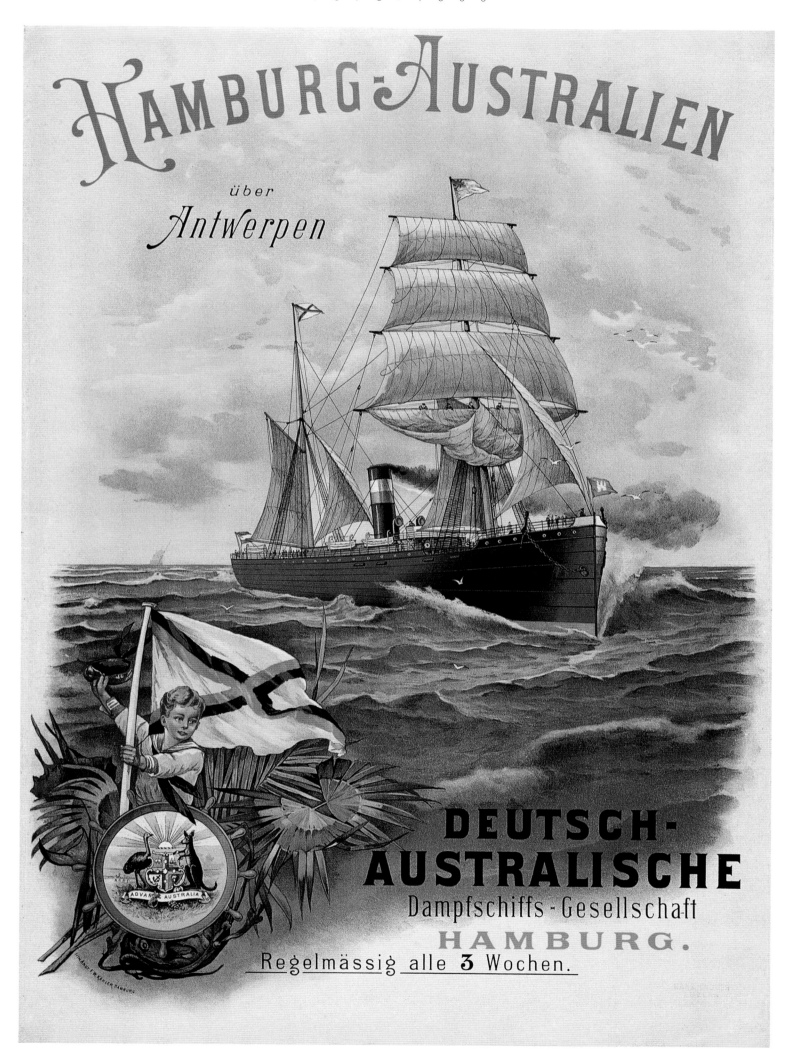

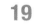

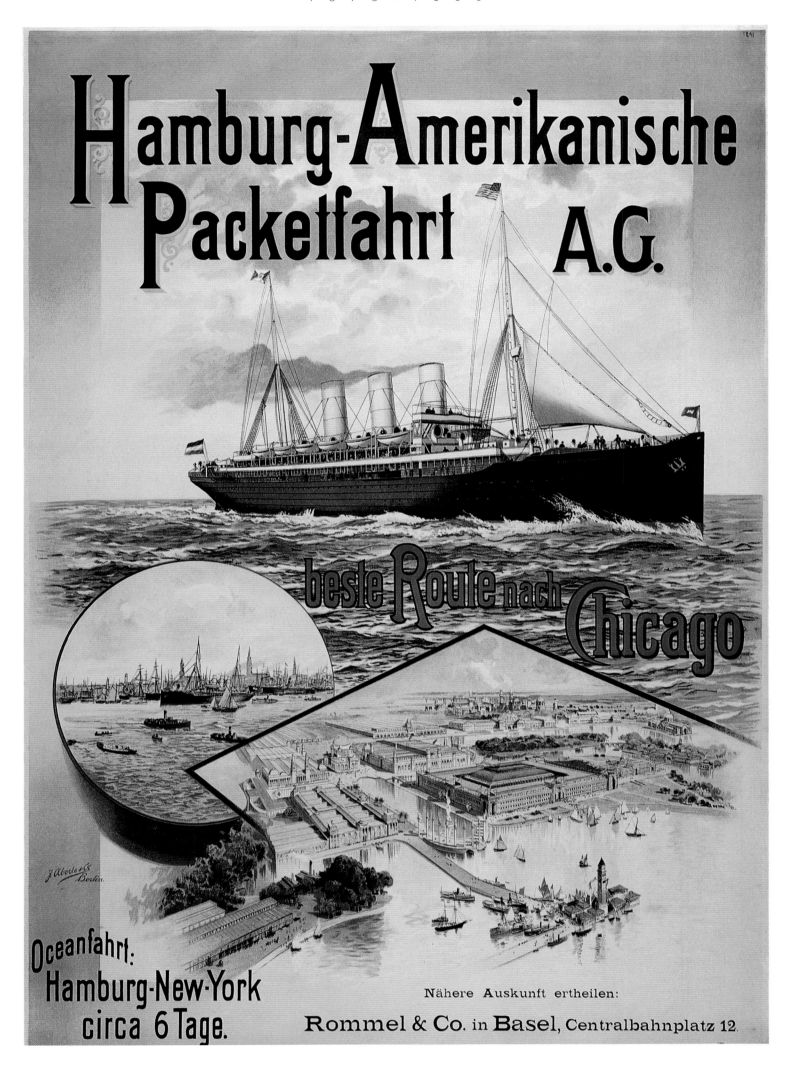

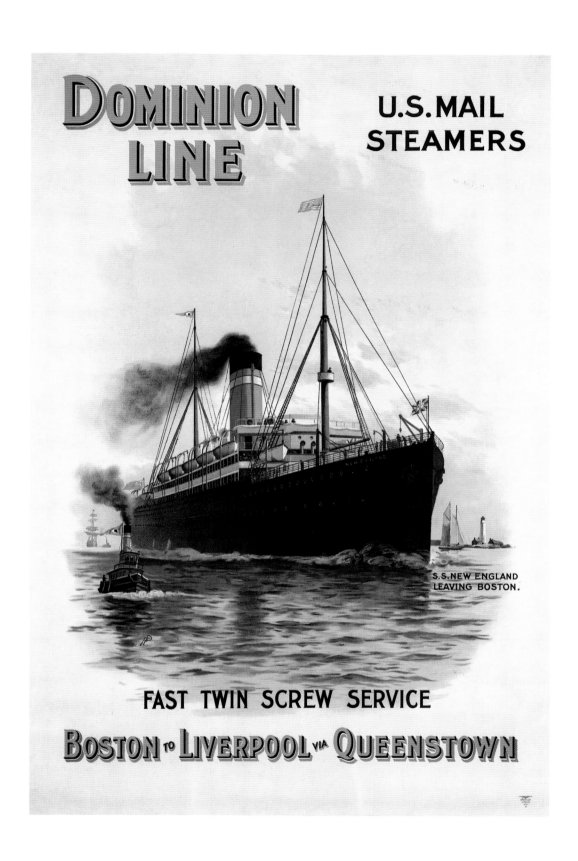

'Best route to Chicago', Hamburg-
Amerikanische Packetfahrt A.G.,
c.1893, J. Aberle & Co., Berlin
Ship: *Fürst Bismarck*
93 x 65cm
Museum für Gestaltung Zurich,
Poster Collection

Boston-Liverpool via Queenstown,
Dominion Line, FP, c.1898,
American Litho. Co., New York
Ship: *New England*
87 x 57.8cm

22

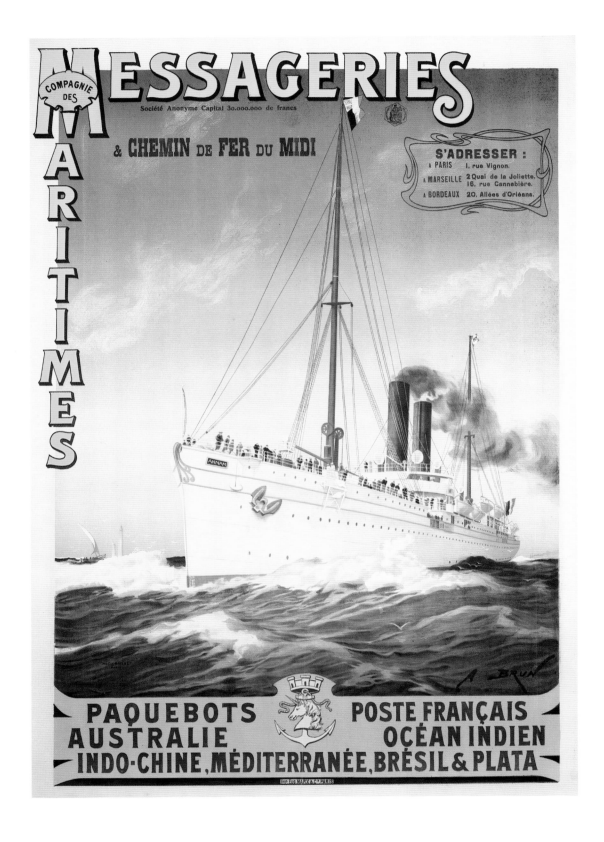

'*Paquebots-poste français*',
Compagnie des Messageries Maritimes,
A. Brun, c.1899,
Eugène Marx & C^ie Printing House, Paris
Ship: *Annam*
105.6 x 73.2cm

'*Campania & Lucania*', Cunard Line,
R.H. Neville-Cumming, c.1900,
Hazell, Watson & Viney LD Lith.,
London & Aylesbury
Ships: *Campania, Lucania*
100 x 70.5cm

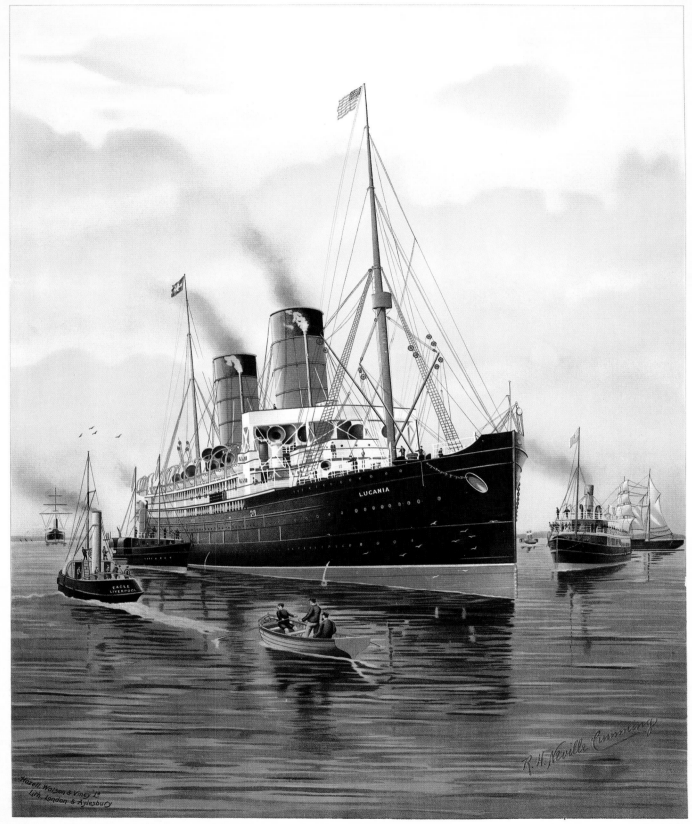

24

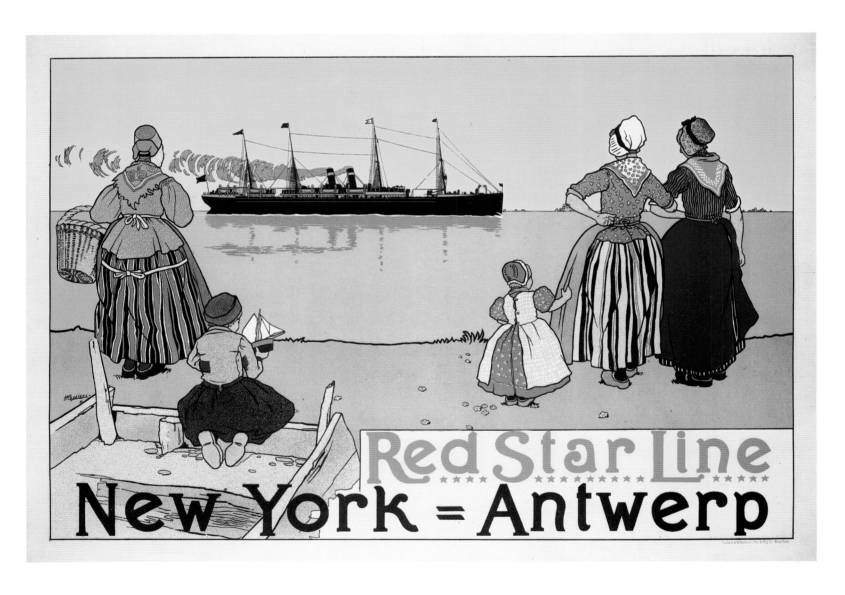

New York-Antwerp, Red Star Line,
Henri Cassiers, c.1900, Sackett &
Wilhelms Litho & Ptg Co., New York
Ship: one of the four vessels named
Finland, Kroonland, Vaderland and
Zeeland
54.5 x 79cm

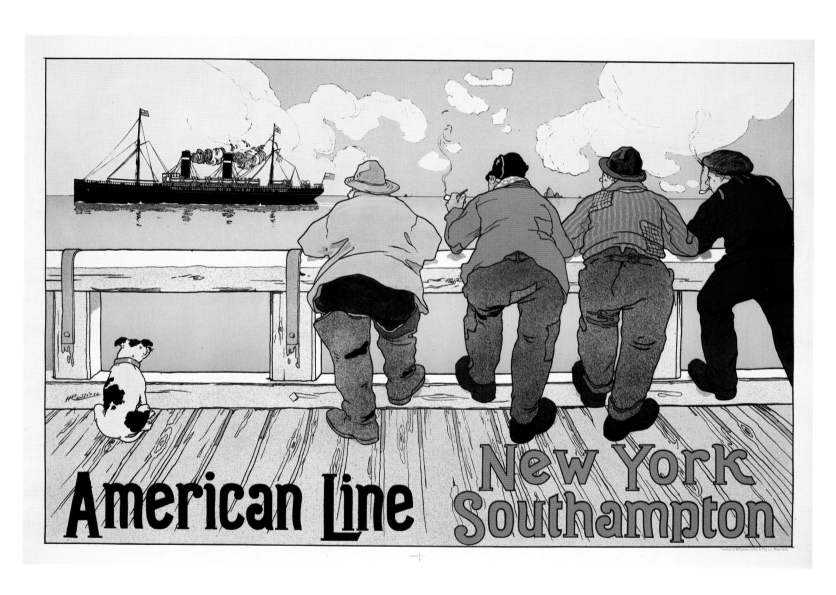

New York-Southampton, American Line,
Henri Cassiers, c.1900, Sackett &
Wilhelms Litho & Ptg Co., New York
Ship: one of the sister ships *Saint Louis*
and *Saint Paul*
54.5 x 79.2cm

26

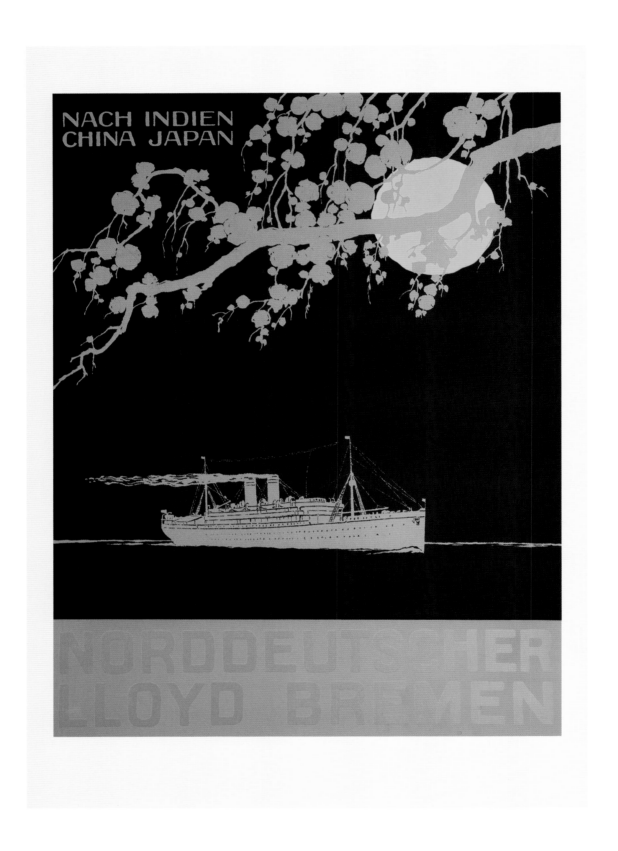

'To India-China-Japan',
Norddeutscher Lloyd Bremen, c.1900
Ship: *König Albert*
86.7 x 62.2cm

German Imperial Navy, Norddeutscher
Lloyd Bremen, East Asia Line, c.1900,
Leuter & Schneidewind, Dresden
Ship: *König Albert*
99.8 x 63.3cm

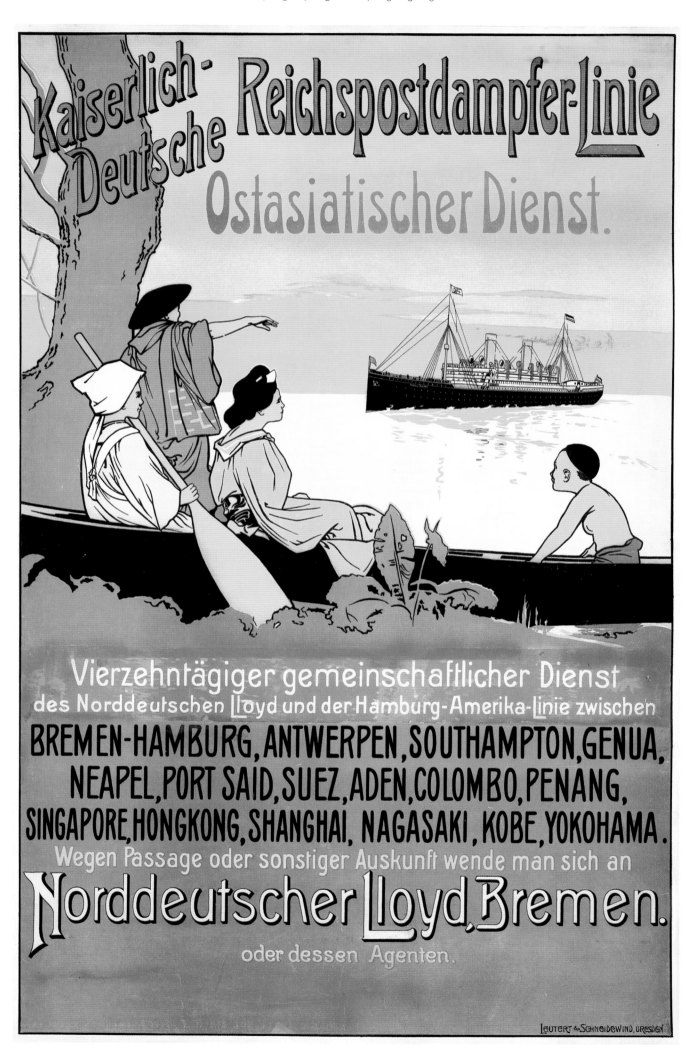

28

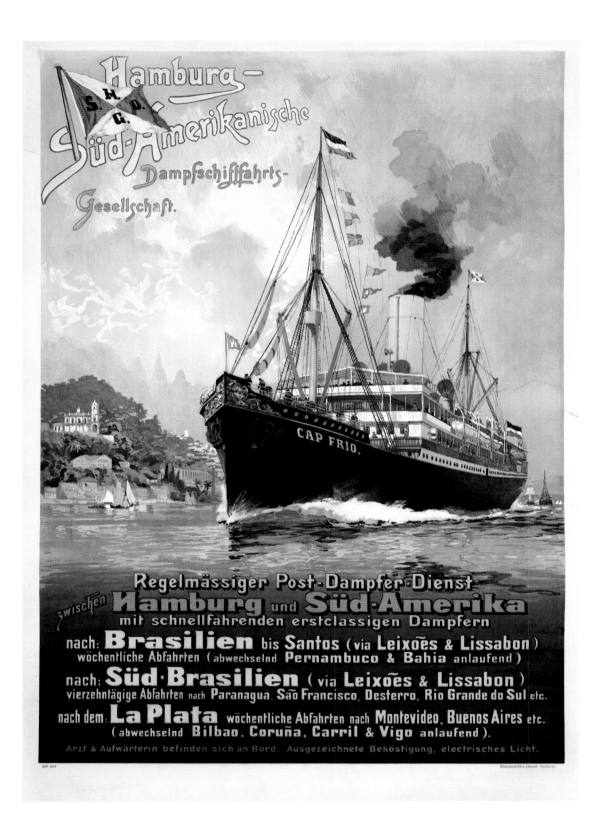

Hamburg-Süd Amerikanische
Dampfschifffahrts Gesellschaft, c.1900,
Mühlmeister & Johler, Hamburg
Ship: *Cap Frio*
100 x 70.3cm

'Ameria-The East-Asia-Australia',
Norddeutscher Lloyd Bremen,
Hans Bohrdt, c.1900, Mühlmeister &
Johler, Hamburg, Bremen
Ship: *Kaiser Wilhelm der Grosse*
89 x 62cm
Museum für Gestaltung Zurich,
Poster Collection

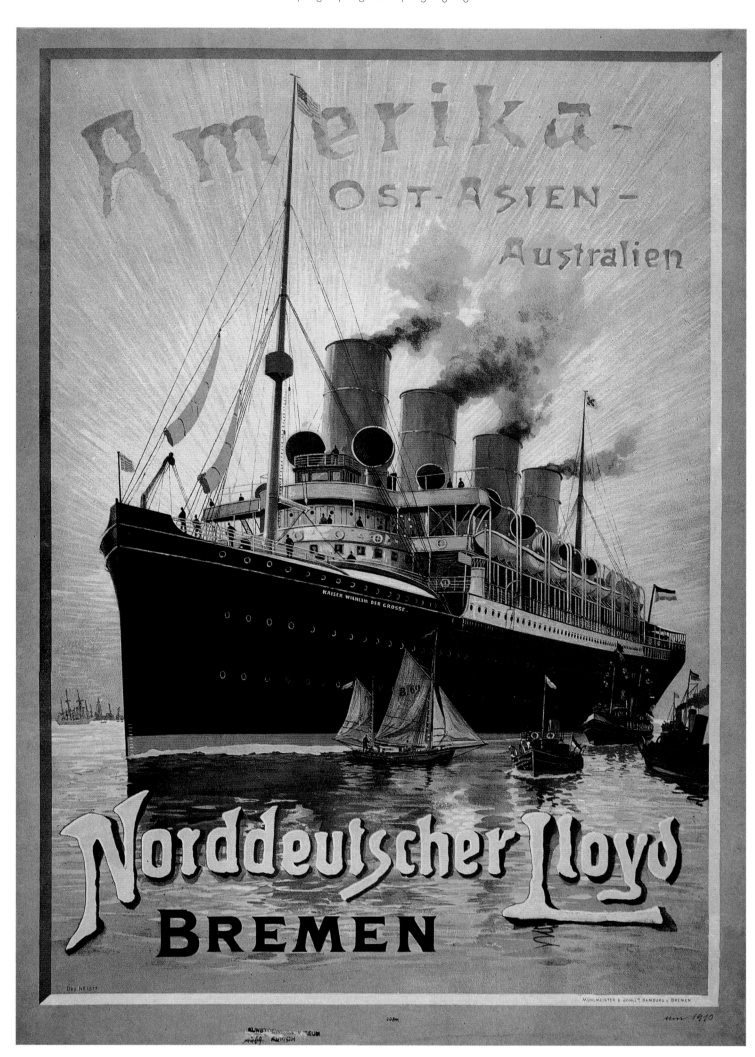

Compagnie Générale Transatlantique,
c.1901, Gray Litho. Co., New York
Ship: *La Lorraine*
75.2 x 106cm

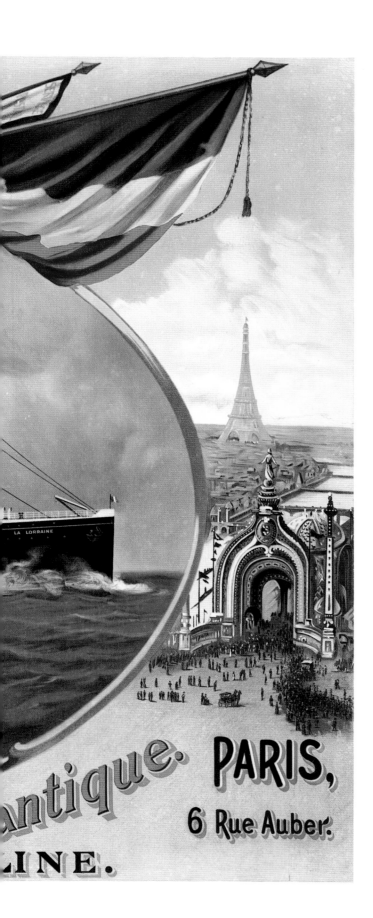

The Beginning of the Twentieth Century: The Early Giants of the Sea

F rom the beginning of the twentieth-century until the outbreak of the First World War, there was a mammoth escalation in the building and refitting of ocean liners. This was interlinked with the burgeoning employment of designers to ensure that the ships expressed the appropriate visual national identity in their interiors and on their posters to attract the most prestigious customers. America, Britain, France, Germany, Holland and Italy vied for domination of the oceans, and the North Atlantic in particular. The most tangible symbol of domination was the winning of the Blue Riband prize, awarded annually for the fastest trans-Atlantic crossing, which was a real attraction for ocean liner passengers. The editor of the Shipping Section of the *Magazine of Commerce and British Explorer*, R.A. Fletcher, commented: 'The public demand for speed and safety in vessels of great size entails the provision of expensive luxuries as an inducement to the public to patronise the vessels in which the demand is met.' (Fletcher 1913: 239) But what style was most appropriate? The vogue for the French Beaux Arts was prevalent for the growing trade in the interior design of hotels and country houses. However, the years leading up to the First World War also witnessed a marked increase in German activity. This meant that there were innovative liners in Rococo revivalist style by Poppe, Beaux Arts interiors by Mewès and Davis and more modern designs by Bruno Paul and Alexander Schroder. In response, Cunard employed designers for the first time to decorate their prestigious trio of ships, *Lusitania*, *Mauritania* and *Aquitania*, in a largely Beaux Arts style. This was closely followed by the launch of White Star's *Olympic* and *Titanic* in 1911 with even more grandiose fittings by the decorating firm of Aldam Heaton & Co. The one characteristic which all of the interiors shared, beyond their French inspiration, was a denial of their nautical function; just as the 'nineteenth-century bourgeoisie turned the home into a palace of illusions, which encouraged total dissociation from the world immediately outside', so the interiors of liners of this period were modelled on palaces, country houses or luxury hotels (Forty 1986:101). The posters of this era also reflected the jostling national rivalries and became much more colourful and complex as they tried to attract an increasingly educated and sophisticated public.

The French Line's *La Lorraine* (pp.30 and 31) displays the importance of links between the national identities of France and the United States of America. The ship is depicted in an ornate oval frame, topped by the French and American flags. The Compagnie Generale Transatlantique (C.G.T.), also known as the French Line, was founded in 1861 as a result of a mail contract with Napoleon II's government, and provided a service from Le Havre to New York from 1864 onwards. The line also sailed to Mexico and the West Indies. *La Lorraine* entered the French Line's service in 1899. It was fairly modest, compared to the might of the *Kaiser Wilhelm der Grosse*, at only 11,146 gross tons; there was accommodation for 446 First Class, 116 Second Class and 552 Third Class passengers. Emigration to Canada was also booming by this time, and the Allan Line, founded in 1854, provided transport between Liverpool, Glasgow, Le Havre and various Canadian ports. The company was merged with

31

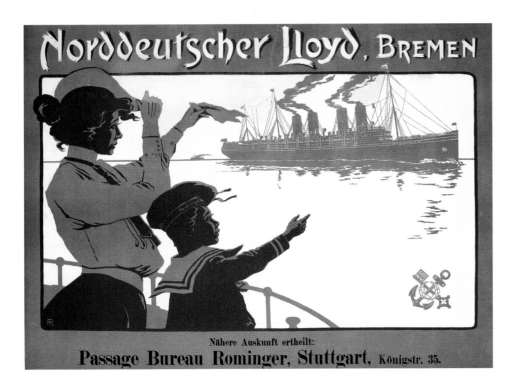

Bremen, Norddeutscher Lloyd,
Frederich Rehm, 1903
Ship: *Kaiser Wilhelm II*
65 x 84.3cm

32

Canadian Pacific in 1917, and the *Pretorian* transferred to that fleet (pp.36 and 37). The poster depicts, in modern, simplistic style, the *Pretorian* sailing past a boat signalling the presence of Red Island, near Newfoundland.

National rivalries were at a peak during the lead up to the First World War, but there were also intra-nation rivalries, for example between N.D.L. and the Hamburg-American Line. The Hamburg-American Line built the *Deutschland* (pp.38 and 39) to try to take back the Blue Riband, won by the *Kaiser Wilhelm der Grosse*, and in 1900 the newer ship was successful. Larger than its rival, the interiors were overseen by the Hamburg-American's Director, Albert Ballin. This included a massive first class dining room which reached up through three decks and was lit from overhead by means of giant skylights, whilst a further sense of space was created by mirrors. The room could seat some 425 diners – almost the entire First Class. The Hamburg-American line also sailed to Central and Southern America, as this poster proudly boasts, the H.A.P.A.G. flag almost planted amongst the exotic vegetation (p.41).

The rivalries between the two German companies raged on, and N.D.L. won the Blue Riband back in 1904 with the brand new *Kaiser Wilhelm II* (p.40). A gigantic 19,361 tons, the ship sailed between Bremen, Southampton, Cherbourg and New York. The interiors were again designed by Poppe in German Baroque Revival style. The First Class dining room on board this ship could sit an amazing 554 passengers simultaneously on its three levels. Painted in white and gold, the balconies and ceiling were richly decorated with flags, shields and cartouches. The first poster accentuates the sheer scale of the ship, whilst the second (p.32) is on a more intimate scale, with what appears to be a sorrowful farewell from a young mother and son in monotone. A more playful image is that of the *Madonna* for the Compagnie Francaise de Navigation, a Vapeur Cyprien Fabre & Compagnie line (p.33). This was a company formed in 1881 to provide a service between Marseilles and North and South America as well as sailings to New Orleans.

Cunard was flexing its muscles and beginning to rise to the challenge set by the German shipping companies. In 1905 they introduced the *Carmania* and *Caronia* to their service for the trans-Atlantic route (p.43). The poster echoes the representation of the *Kaiser Wilhelm der Grosse*, with the ship being depicted from a low angle, plunging through the waves towards the viewer. The tonnage and length of the two ships is also emphasised in the text as a major selling point: 20,000 tons and 676ft long. However, it was not until three years later that the Blue Riband was to return to Cunard with the launch of the *Lusitania* in 1907.

The *Victorian*, an Allan Line ship of 10,635 gross tons, was built in 1904 and was the first North Atlantic liner with triple screws and turbine engines (p.45). She could carry 346 First Class, 344 Second Class and 1,000 Third Class passengers on her voyages to Quebec and Montreal from Liverpool and Le Havre. The three colourways of the poster depict the simplified outlines of the ship and a man rowing a boat in the foreground, complete with an elegant Belle Époque woman on board,

perhaps being taken to the ship. A less glamorous woman is depicted on the French Line 1906 poster for the Le Havre to New York route (p.42). Attired in traditional Normandy dress, she is waving a white handkerchief as the ship departs; perhaps she is the wife of a sailor on board, or a husband immigrating to North America. The French Line sailed four ships on this route, *La Provence*, *La Lorraine* (also depicted on pp.30 and 31), *La Savoie* and *La Touraine*.

The British based Orient-Royal Mail Line specialised in transporting mail and passengers to Australia. The company built up a reputation for using designers at an early stage and the poster illustrated here is an adventurous Art Nouveau depiction of the *Ophir* from 1906 (p.44). Unusually for a British company at this time, the Orient-Royal Mail Line employed a professional architect to design the first class interiors of its fleet. The Aesthetic Movement architect, J.J. Stevenson, was selected, perhaps as he had family connections with the founders of the Orient Line through his wife; he designed interiors for five of the ships, including the *Ophir*. He created a double-storey dining room for First Class with a barrel-vaulted glazed ceiling. Much of the decoration consisted of carved wood panelling with inlays and panels by the Aesthetic Movement illustrator, Walter Crane.

More conventional in appearance is the poster for Canadian Pacific's *Empress of Britain* from 1906 (p.50). A fairly modestly sized ship at 14,189 gross tons, she sailed from Liverpool to Quebec and was the fastest ship on that route at the time. The company was originally a passenger service for the Great Lakes in Canada, and later provided a service from Vancouver to Japan and Hong Kong. The company then expanded into the trans-Atlantic route, with scheduled sailings from Liverpool to Montreal. The Red Star Line again commissioned more avant-garde designs for its two adverts for travel on the *Vaderland, Zeeland, Kroonland* and *Finland* from c.1907 (pp.46 and 47). The posters use a more restricted palette than that of Canadian Pacific, and have a generalised representation of the ship, rather than a detailed painting. The effect is modern and fresh.

Germany's new found success in trans-Atlantic travel challenged Britain's dominance as a maritime nation, and Cunard set about building two 'New, Fast Steamers' which it hoped would regain British supremacy and the Blue Riband. Cunard gained funding from the British government for the construction of the ships, not only to resurrect national pride but also to make sure that Cunard remained British. J. Pierpont Morgan's new shipping enterprise, International Mercantile Marine (I.M.M.) had taken financial control of White Star, Cunard's main rival, in December 1902. Morgan also had financial interests in both German lines and the full support of the Kaiser. Therefore, on 30 September 1902 the Prime Minister, Arthur Balfour, announced that Cunard would be granted a government loan of £2.6 million on very favourable terms to build the two new ships as long as the company remained British. Cunard then began the process of building the *Mauritania* and *Lusitania*. The *Lusitania* was built in Glasgow, and the interiors were designed by James Miller.

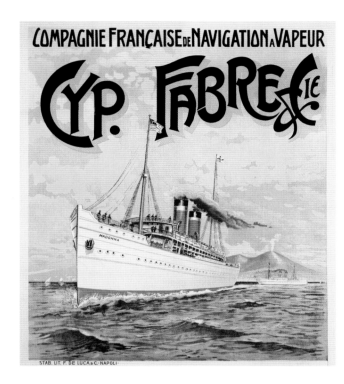

Cyprien Fabre & Co.,
c.1905, F. De Luca, Naples
Ship: *Madonna*
77.2 x 68.2cm

The main aim was to build two ships which would be faster and larger than the German rivals, so both were driven by quadruple screw turbine machinery, to reach the desired top speed of 24 and one half knots. The two ships were the largest ever to be built at that time, at some 31,000 tons and 790ft in length. Cunard visited the N.D.L. liners *Kaiser Wilhelm der Grosse* and *Kronprintz Wilhelm* to study the competition. The German baroque revival interiors were heavily criticised by Cunard: 'They are of a type particularly unsuitable to the situation, which demands an absence of restless forms and refined richness of style. These decorations are bizarre, extravagant and crude, loud in colour and restless in form, obviously costly, and showy to the most extreme degree.' Therefore, Cunard opted for a more simple style for the interiors of the two ships, favouring the Louis XVI revival style, with white panelling and gilded, carved details for the First Class dining room. Cunard also added veranda cafes on both ships so passengers could enjoy outdoor refreshments.

The ships were launched with great imperialist vigour and on her second outward voyage the *Lusitania* won the Blue Riband from the German *Deutschland*. The ship made the journey in 4 days 19 hours and 52 minutes. The *Mauritania* won the Blue Riband for its eastward journey in 1907, and westward in 1909, which was retained until 1929, when it won by the *Bremen*. The second poster for the *Lusitania* emphasises the sheer scale of the ship, by juxtaposing it beside a cheering crowd (p.48). The two liners provided a super-fast, reliable service across the Atlantic (p.49) until the outbreak of the First World War, when they were deployed by the British government. Sadly, the *Lusitania* was sunk in 1915.

The French company of Messageries Maritimes had taken over Compagnie Francaise de l'Est Asiatique and Compagnie Nationale de Navigation in 1904 in order to expand its operations. Here we see the new ship,*Gange*, in an advert for cargo ships, with an eye catching scene of a train being loaded on board (p.51). Messageries Maritimes offered voyages around the globe to Australia and Japan, and also around the Mediterranean. Here we see an ocean liner against the backdrop of a Middle Eastern scene, contrasted in the foreground with a traditional dhow (p.35).

The Orient Line, which specialised in voyages from Britain to Australia, also began to feature destinations in its posters (p.53). The *Otranto*, illustrated here against a Middle Eastern scene, was a 12,124 gross ton ship, with a length of 535.3ft and twin screw power ensured a speed of 18 knots. There was passenger accommodation for 280 First, 130 Second and 900 Third Class, in addition to a crew of 350. Her first sailing was in October 1909 from London to Suez, Melbourne, Sydney and Brisbane.

The Koninklijke Paketvaart-Maatschappij (K.P.M.) was a leading Dutch shipping company that maintained the sea connections between the islands of Indonesia, at that time a Dutch colony, formerly know as the Netherlands East Indies (N.E.I.). The company then expanded to offer lines to Australia, New Zealand and Africa. The *Rumphius* was built for the company in 1908, and is pictured here in a setting reminiscent of Indonesia (p.62).

The best known story relating to the history of ocean liners is of course, the sinking of the *Titanic* on its maiden voyage in 1911. The British based shipping line of White Star had a reputation for providing voyages to America for which the emphasis was on comfort rather than speed. Cunard had regained the Blue Riband, but White Star was more interested in luxury. The decision was therefore taken to build the *Olympic, Titanic* and *Britannic* in 1907, partly in response to the Cunard challenge (p.52).These were huge ships, at 45,000 tons and one and a half times longer than the *Mauritania* and *Lusitania*. The investment which made the building of this trio possible came from J.Pierpoint Morgan's International Mercantile Marine Company (I.M.M.), which had bought out White Star in 1902. *Titanic* was designed using the same plans as *Olympic*, which was built 4-6 months ahead of *Titanic* at the Harland and Wolff shipyard in Belfast. As such, lessons learnt from the design of the *Olympic* were applied to the *Titanic*, and extra effort was applied to the design of the First Class accommodation. White Star tried to copy the lavish style of Cunard's *Mauritania*, but did not employ a professional architect, using decorating firms instead; the resulting effect was one of uncoordinated yet luxurious period styles. The technical might and gargantuan proportions of the ships was matched by the lavishness of the interiors, and the sheer quantity of styles employed. On the *Olympic* the range of period styles used ran the gamut of possibilities – from Louis XIV, XV and XVI to Empire, Italian Renaissance, Queen Anne and 'Old Dutch'.

Lessons were learnt from the first voyages of the *Olympic*, and changes were made to the *Titanic* before it joined the White Star service between Southampton and New York. The number of state rooms was increased, and the premium parlour suite rooms on Deck B were extended into the promenade deck. These elite passengers had a private promenade deck which was half-timbered in mock Tudor style further aft. On the same deck, the former promenade deck for Second Class passengers was converted into the Café Parisien for First Class passengers. The space was decorated in trellis work with climbing ivy and plants, much in the same vein as the veranda cafés on the *Mauritania* and *Lusitania*. The main dining room was converted to take additional First Class passengers up to a maximum of 550. Also in imitation of the Hamburg America ships, the *Oceanic* and *Titanic* had an à la carte restaurant on Deck C, just beside the Café Parisien.

The history of the *Titanic* and its first tragic crossing of the Atlantic has reached mythical proportions. The *Olympic* is overshadowed by the myth, but it did successfully offer a trans-Atlantic service until the outbreak of the First World War. After this, its lavish interiors were removed and it was used as a troop ship, along with the *Britannic*, the third of the White Star ships. The *Britannic* was finished too late to enter civilian service, and went straight into service as part of the fleet of requisitioned ocean liners, including the *Olympic, Mauritania* and *Lusitania*, to help with the war effort.

In 1912 the Compagnie Générale Transatlantique (C.G.T.) introduced its largest

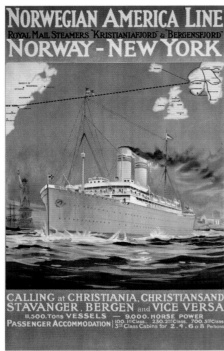

Norway-New York,
Norwegian-American Line, 1913
Ships: *Kristiniafjord, Bergensfjord*
99.8 x 62cm

Paris-Lyon-Mediterranean,
Compagnie des Messageries Maritimes,
E. d'Argence, 1909,
Atelier F. Hugo d'Alesi, Paris
One of the series of ships: *Atlantique,
Chili, Cordillère, Magellan, Tourane,
Amazone, Tonkin*
104.7 x 75.6cm

34 and most prestigious ship to date, the *France*. With the launch of the *France*, the company was firmly established alongside Britain, Germany and Holland as a provider of trans-Atlantic passenger transport (pp.4 and 57). The *France* was built at the major French dockyards at Saint-Nazaire, specially created to build ships for C.G.T., and the interiors drew on the past traditions of eighteenth-century luxury. The *France* was small at 23,769 tons, compared to the *Aquitania* at 45,647 tons. She was also not the fastest ship to cross the Atlantic, with a cruising speed of 24 knots, but her impressive four funnels feature heavily on the three posters here. Her ambience of Gallic *grande-luxe*, co-ordinated by Nelson, a French *ébéniste-décorateur*, and carried out by Establishment Remon, made her popular with both the French and the Americans who could afford to travel First Class in luxury.

For example, the Grand Salon on the *France* drew heavily on Louis XIV period decoration. The room was panelled in white gilded wood, punctuated by ornate pilasters and oval portraits of French aristocracy. There was an imposing portrait of Louis XIV by Hyacinthe Rigaud, copied from the original in the Louvre over the fireplace at one end of the room. At the other, hung a painting of the sun king, copied from an original by Van der Meulen in the museum at Versailles. The ceiling was also white and gold, with a central dome surrounded by four lunettes. The main First Class public rooms reflected France's regal past, but the Moorish saloon or 'Salon Mauresque' reflected France's colonial interests and vogue for the Orient. The exotic saloon, tucked in a corner beneath a First Class staircase, was tiled with oriental ceramics and there was an Algerian fresco by Poisson at the top of the walls. There were Turkish rugs scattered across the floor on which stood luxurious sofas, pouffes and tiny occasional tables for coffee. A fountain continuously sprayed cool water and the stewards would dress in Turkish costumes when they served passengers in the evening.

It was not only France, but also Norway which began to provide a trans-Atlantic service at this point. The Norwegian-American Line was established in 1910 to provide a crossing for passengers and cargo between Norway and America. Illustrated on p.34 are the new *Kristiniafjord* and *Bergensfjord* from 1913. However, the main rival to Britain's dominance of the Atlantic was still Germany. The Hamburg-American Line continued to build bigger and faster ships, with historic interiors by Charles Mewès, working with his German partner, Bischoff for the design of the *Imperator*, which entered service in 1913 (p.58). At 51,969 tons, the ship could carry

5,500 people, with 908 First Class, 592 Second and 1,772 in Steerage. The record-breaking size of the ship was a feature which dominated the advertising for the ship. Note also the huge eagle on the bow of the ship, added to give extra length and to ensure the ship was bigger than anything in the Cunard fleet. The First Class interiors by Mewès and Bischoff were in styles derived from those of the British and French, which did attract some German criticism. The smoking room was Tudor in appearance, with dark wooden pillars and a white ceiling, decorated with heavy carving. The swimming pool, the first to appear on a giant liner, was modelled on the remarkable Pompeian bath designed by Mewès and Davis for the Royal Automobile Club in Pall Mall, London, built 1908-11. The water area was 39ft by 21ft, and it was surrounded by Doric order mosaic columns. Like the RAC Club, there was also a Turkish bath. This really was luxury afloat on a grand scale.

Cunard's *Aquitania* was launched in 1914 with the First Class interiors designed by Charles Mewès' British partner, Arthur Davis (p.60). It offered a tasteful, Louis XVI and Tudor revival experience. By using restrained designs constructed from luxury materials, Cunard aimed to provide a contrast to the perceived gaudiness of the German liners. The distribution of First, Second and Third Class on board a classic liner such as this is amply demonstrated in the cutaway illustration on the poster (p.61). The wealthy First Class passengers enjoyed spacious luxury on the top decks, with plenty of light, whilst the Third Class were crowded together near the waterline. Unlike the *Lusitania*, the *Aquitania* enjoyed a long service for Cunard, and was only eventually withdrawn from service in 1950 with the launch of the *Queen Elizabeth*.

The Scandanavian-American Line was founded in 1898 to provide a service from Copenhagen to New York, which continued until the 1930s, when the passenger trade declined. The *Frederik VIII* first sailed on this route in 1914 and continued until 1935 (p.59). Rotterdam Lloyd was founded in 1875 and specialised in voyages to the Dutch East Indies and China. It is shown in this 1915 poster as having destinations such as Egypt, Ceylon, Sumatra and Java from Rotterdam, Amsterdam, Antwerp and Marseilles (p.63).

In summary, by the outbreak of the First World War in 1914, every major European country offered at least one, if not two, shipping companies that traversed the world, supporting trade and immigration on a global scale. The posters developed during this time from simple depictions of the liners, to scenes which allude to the place of destination in an extra attempt to entice potential passengers.

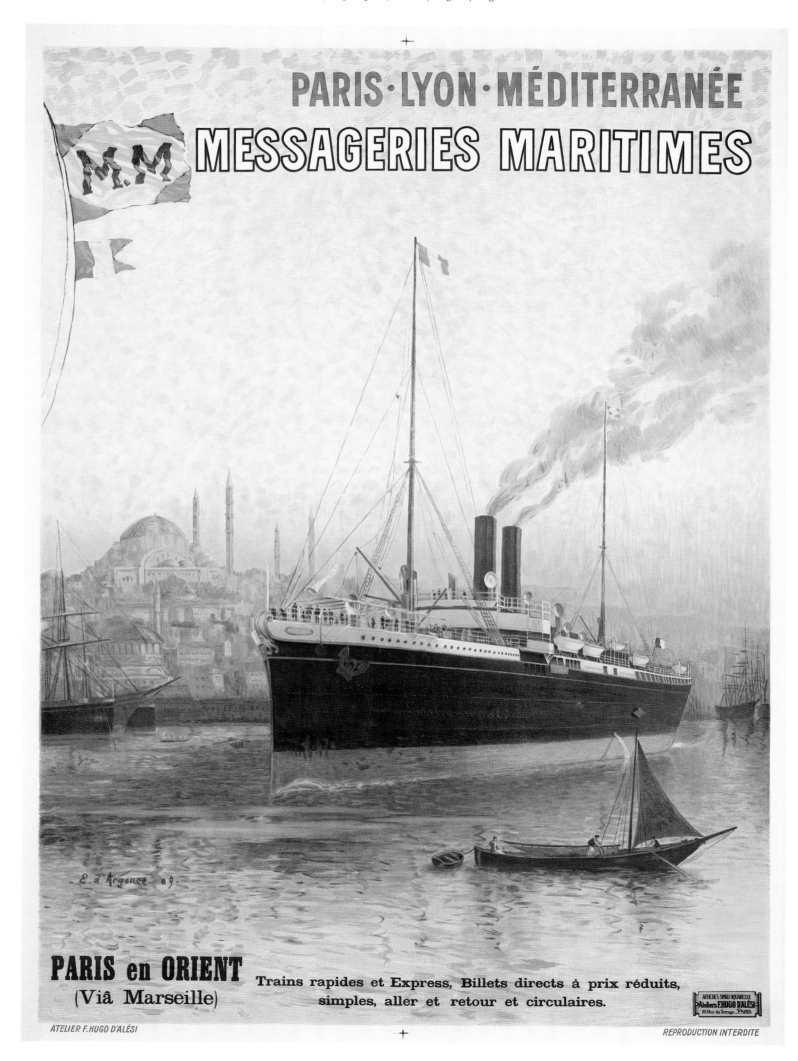

36

Le Havre-Canada, Allan Line,
Norman Wilkinson, c.1901, Hart & Co.,
Fullwood's Rents, W.C.
Ship: *Praetorian*
63.6 x 101.7cm

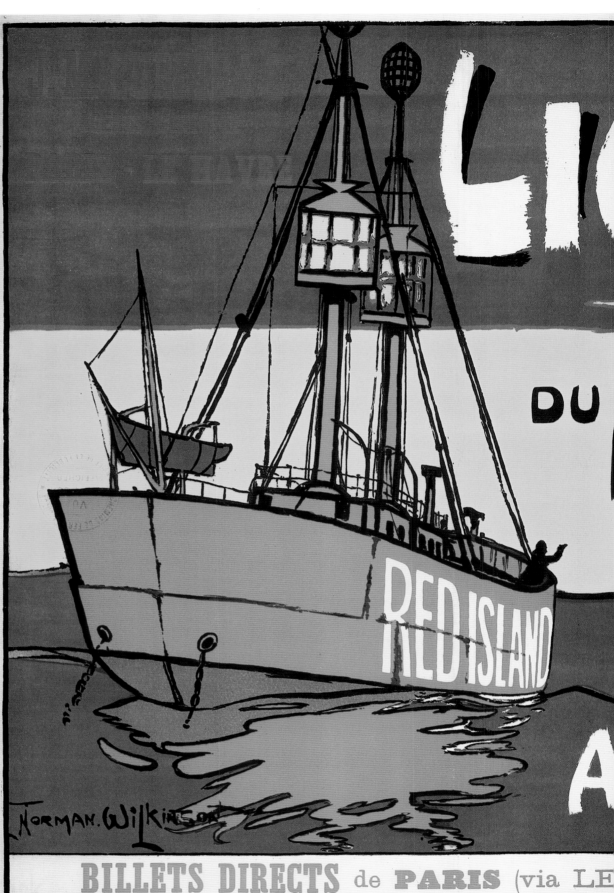

HART & C? Folwoods Rents W.C.

(AVRE) pour le **CANADA** et les **ETATS-UNIS**

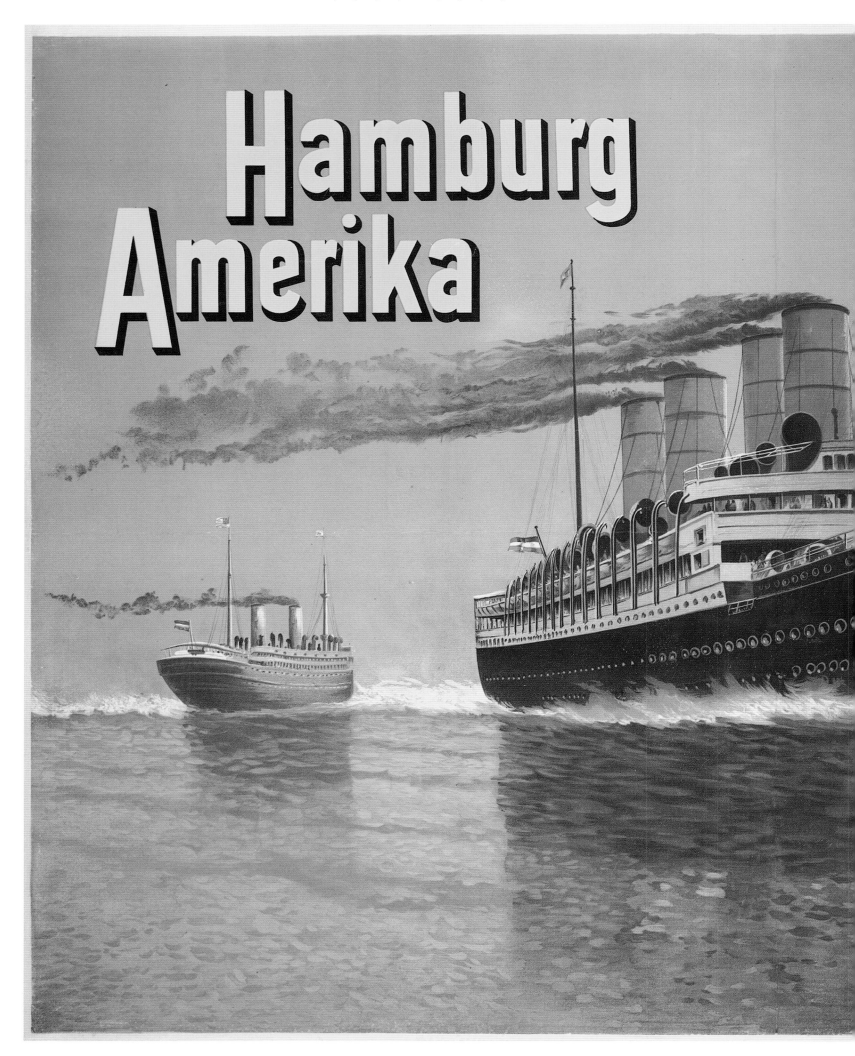

Hamburg
Amerika

Hamburg-America, c.1901
Ship: *Deutschland*
65 x 93.5cm

39

40

Norddeutscher Lloyd Bremen,
Themistokles von Eckenbrecher, 1903,
Wilhelm Jöntzen, Bremen
Ship: *Kaiser Wilhelm II*
48.6 x 73.1cm

Hamburg-American Line, Hans Bohrdt,
1903, Mühlmeister & Johler, Hamburg
Ship: *Prinz August Wilhelm*
92.5 x 68.4cm

42

Le Havre-New York, Compagnie Générale
Transatlantique, F. Le Quesne, 1906,
C. Verneau Printing & Publishing
Company, Paris
Ships: *La Provence, La Lorraine,
La Savoie, La Touraine*
99.5 x 70.0cm

Cunard Line, Edward Wright, c.1905
Ships: *Carmania, Caronia*
99.7 x 62.3cm

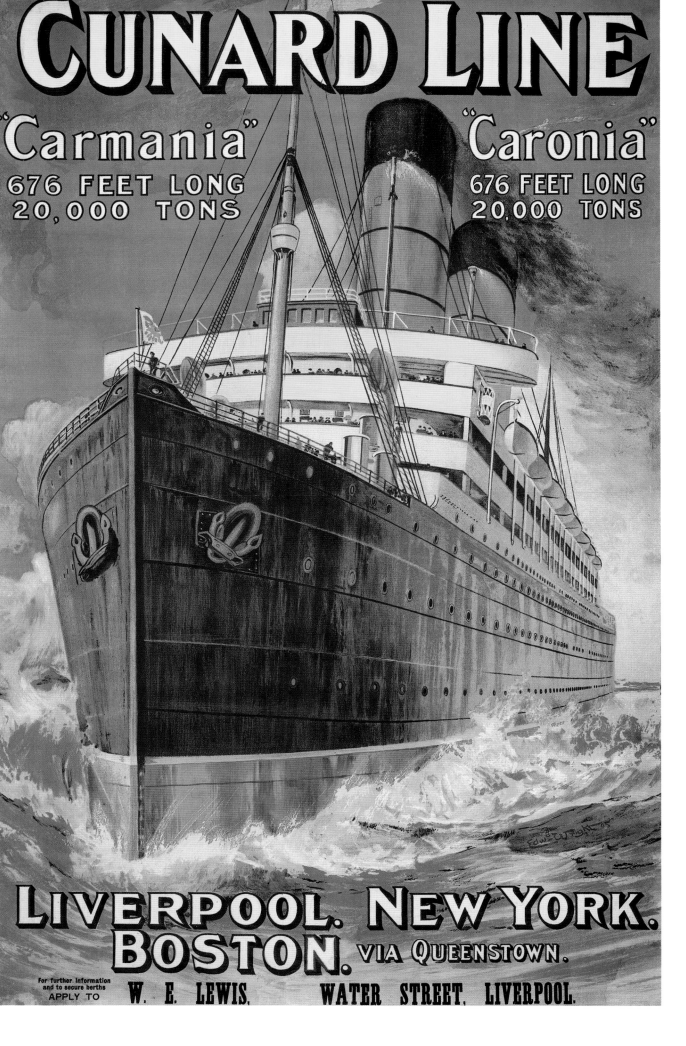

43

44

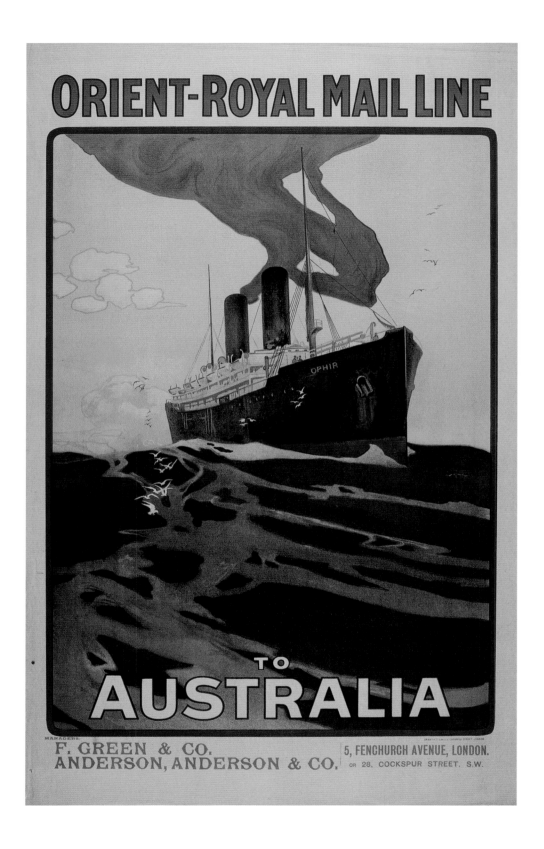

'To Australia', Orient-Royal Mail Line,
c.1906, Grant & Co. Ltd, London
Ship: *Ophir*
101 x 63cm
Museum für Gestaltung Zurich,
Poster Collection

Le Havre-Canada, Allan Line, c.1905
Ship: *Victorian*
101.8 x 63.8cm

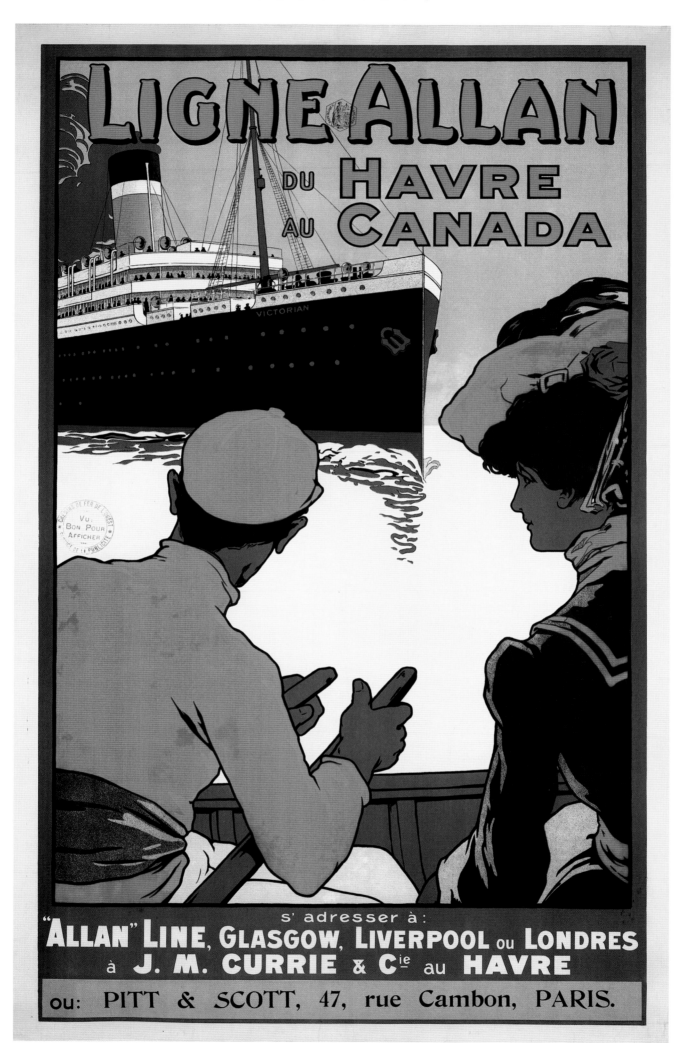

46

Red Star Line

REGELMÄSSIGE DIREKTE LINIEN ZWISCHEN

: **Antwerpen-NewYork** :
Antwerpen-Philadelphia
: **Antwerpen-Boston** :

Doppelschrauben-Dampfer von 13000 tonnen

Finland · Kroonland
Vaderland · Zeeland

MAN WENDE SICH AN DIE DIREKTION IN ANTWERPEN ODER DIE AGENTEN

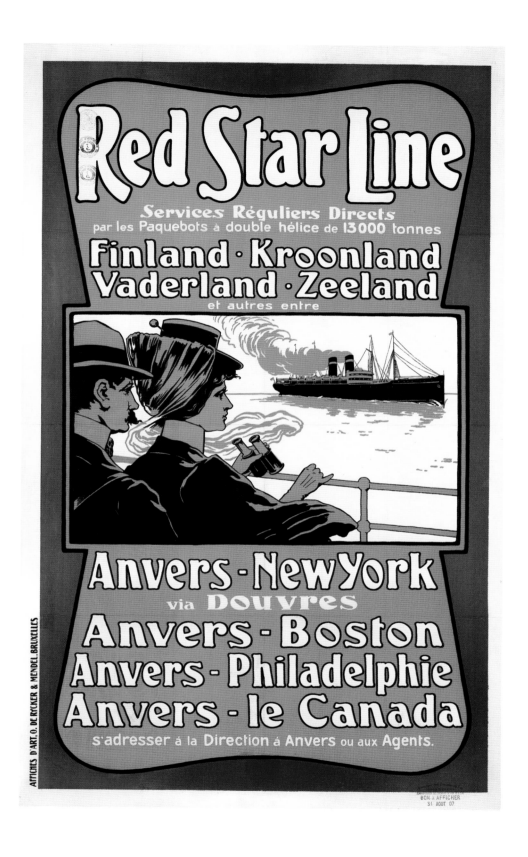

Red Star Line, 1907,
Affiches d'art
O. De Rycker & Mendel, Brussels
Ships: *Finland, Kroonland, Vaderland,
Zeeland*
101.7 x 62.5cm
Museum für Gestaltung Zurich,
Poster Collection

Red Star Line, 1907,
Affiches d'art
O. De Rycker & Mendel, Brussels
Ships: *Finland, Kroonland, Vaderland,
Zeeland*
101.7 x 62.5cm

CUNARD LINE

Liverpool, New York, Boston via Queenstown.

T. FORMAN & SONS, NOTTINGHAM, LIVERPOOL, LONDON & GLASGOW.

Cunard Line, 1907,
T. Forman & Sons, Nottingham, Liverpool,
London and Glasgow
Ship: *Lusitania*
101 x 63cm
Museum für Gestaltung Zurich,
Poster Collection

Europe-America, Cunard Line, 1908,
T. Forman & Sons, Nottingham, Liverpool,
London and Glasgow
Ships: *Lusitania, Mauritania*
100.6 x 62.8cm

50

"Empress" Steamers to Canada,
Canadian Pacific, 1906, Eyre &
Spottiswoode Ltd,
H.M. Printers, London
Ship: *Empress of Britain*
101 x 63cm
Museum für Gestaltung Zurich,
Poster Collection

French Cargo Boats,
Compagnie des Messageries Maritimes,
Henri Hudaux, 1908,
Affiches artistiques E. Dauvissat, Paris
Ship: *Gange*
104.5 x 73.5cm

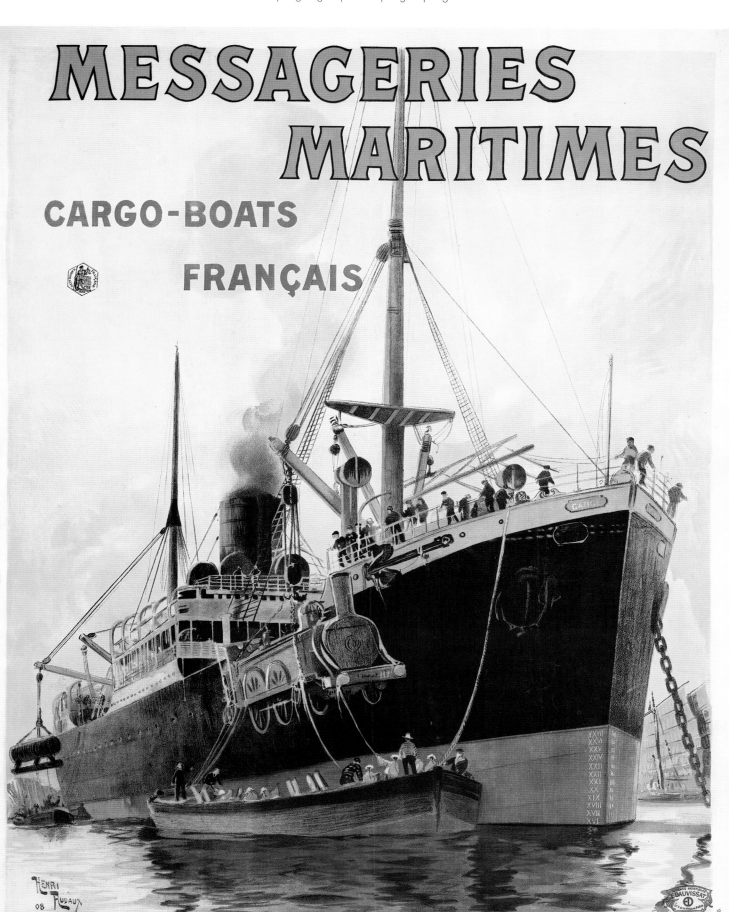

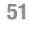

THE LIVERPOOL PRINTING & STATIONERY COMPANY, LIMITED.

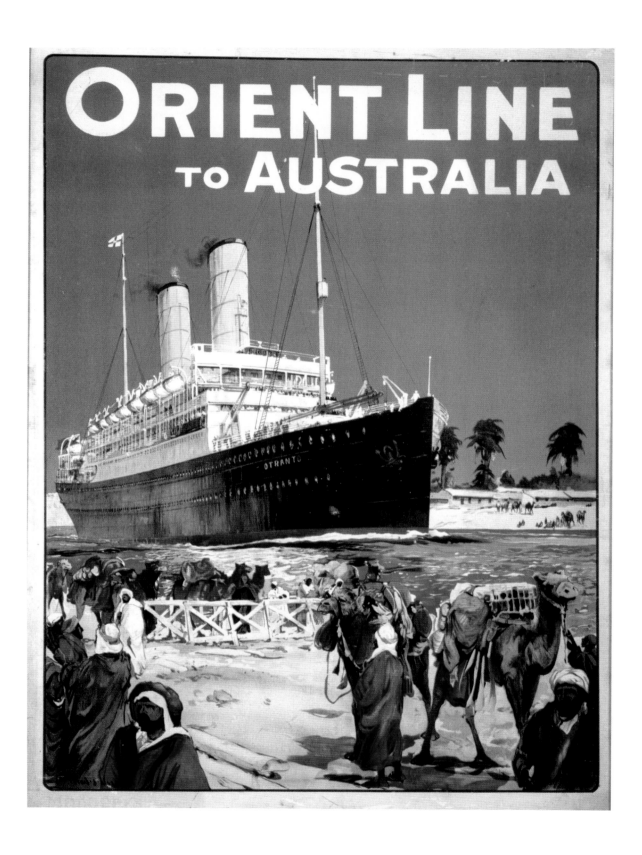

'To United States and Canada',
White Star Line, 1912, The Liverpool
Printing & Stationery Company Ltd
Ships: *Olympic, Titanic*
100 x 61.7cm

'To Australia', Orient Line,
Charles Dixon, c.1909
Ship: *Otranto*
86.7 x 63.1cm
P & O Heritage Collection

Cᴵᴱ Gᴸᴱ TRANSATLANTIQ[UE]

PARIS ✧ HÂVRE

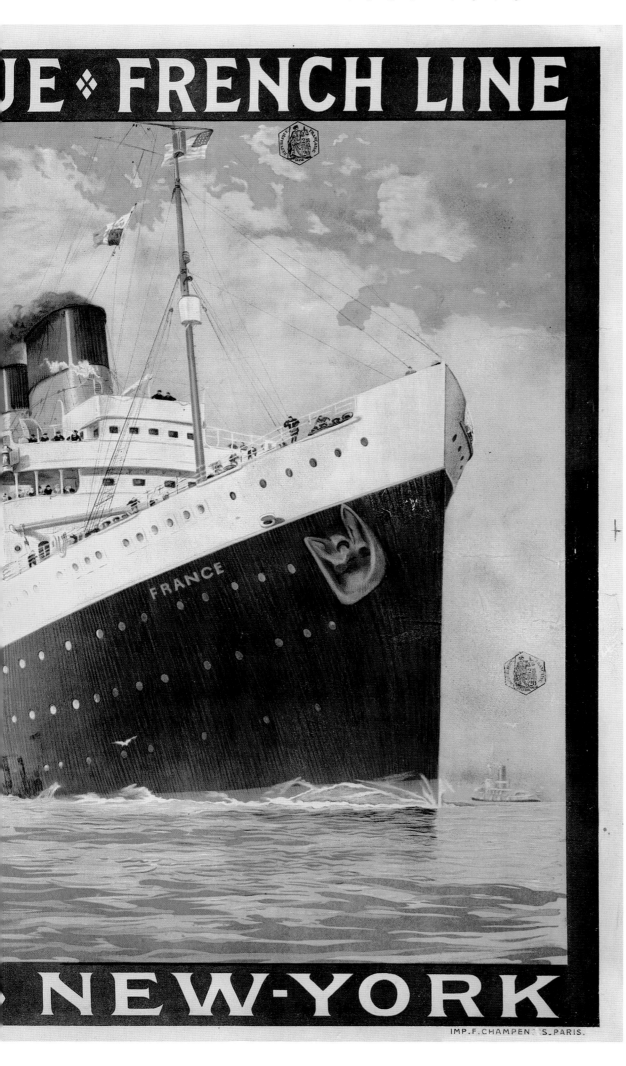

Paris-Le Havre-New York,
Compagnie Générale Transatlantique,
Albert Sebille, 1912,
Printing F. Champenois, Paris
Ship: *France*
78 x 108cm

55

56

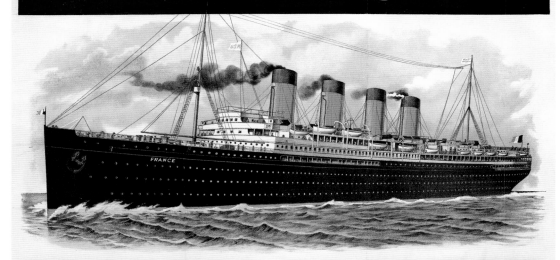

New York-Le Havre-Paris,
Compagnie Générale Transatlantique,
1912, Albert J. Leon Litho, New York
Ship: *France*
105.8 x 72cm

Le Havre-New York-Le Havre-Canada,
Compagnie Générale Transatlantique,
A. Triel, c.1912,
Art. Institut Orell Füssli, Zurich
Ship: *France*
101.5 x 76cm

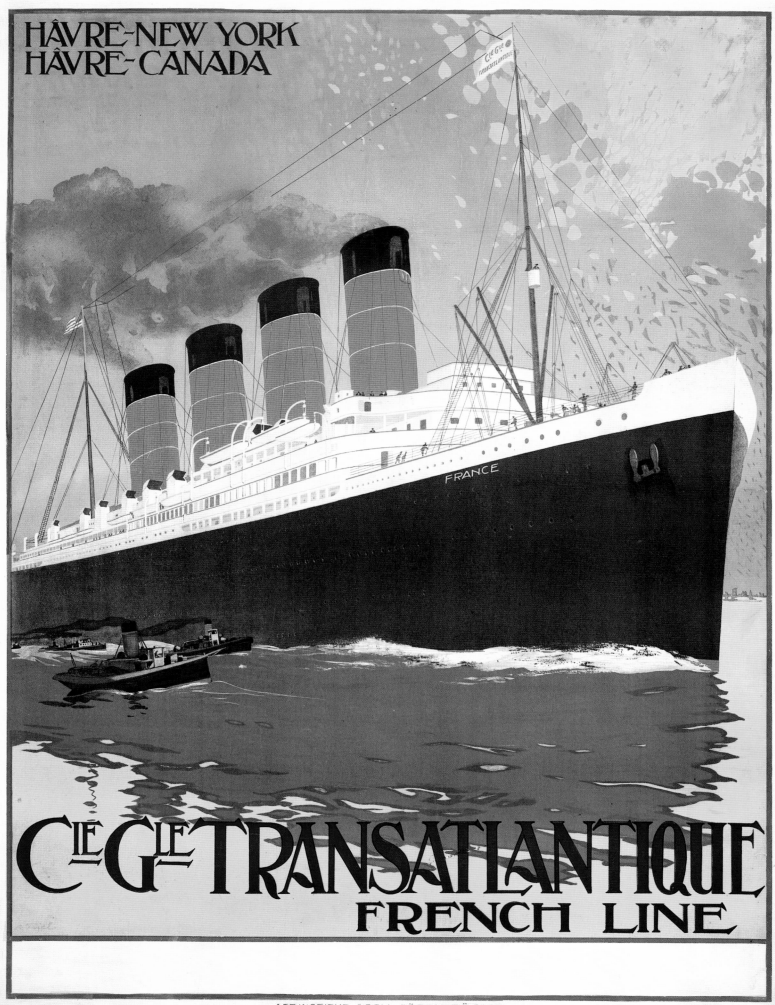

58

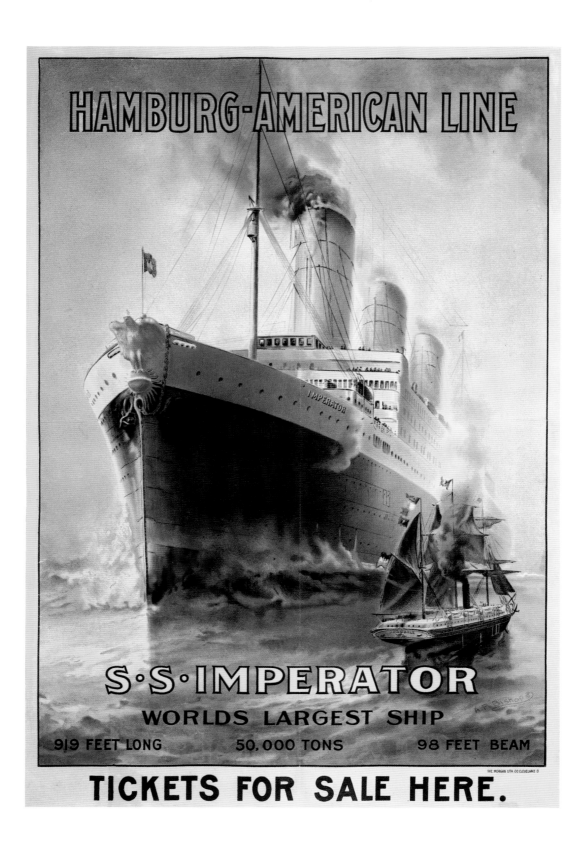

'S.S. *Imperator*', Hamburg-American Line, A.F. Bishop, 1913, The Morgan Lith. Co., Cleveland, Ohio
Ship: *Imperator*
58 x 39cm

New York direct to Scandinavia, Scandinavian-American Line, c.1914, American Lithographic Co., New York
Ship: *Frederik VIII*
97.7 x 64.5cm

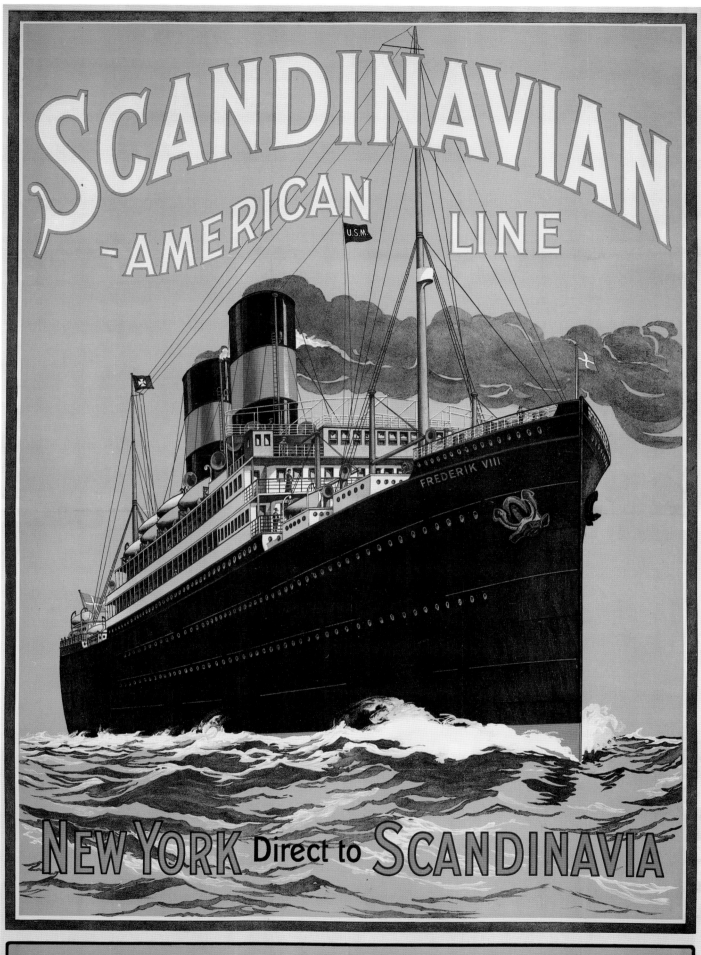

60

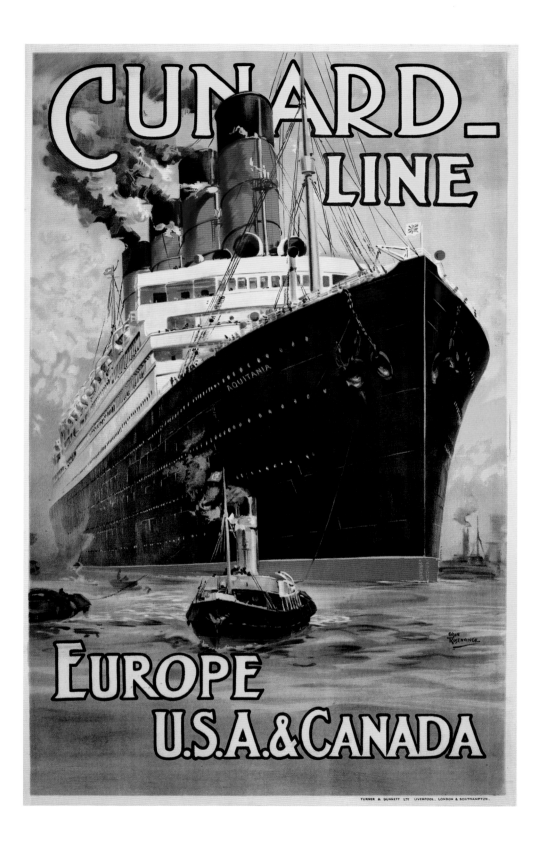

Europe-U.S.A.-Canada,
Cunard Line, Odin Rosenvinge, 1914,
Turner & Dunnett Ltd., Liverpool, London
and Southampton
Ship: *Aquitania*
101.5 x 63.5cm

'To All Parts of the World',
Cunard Line, c.1914, T. Forman & Sons,
Nottingham, Liverpool and London
Ship: *Aquitania*
101.1 x 63.7cm

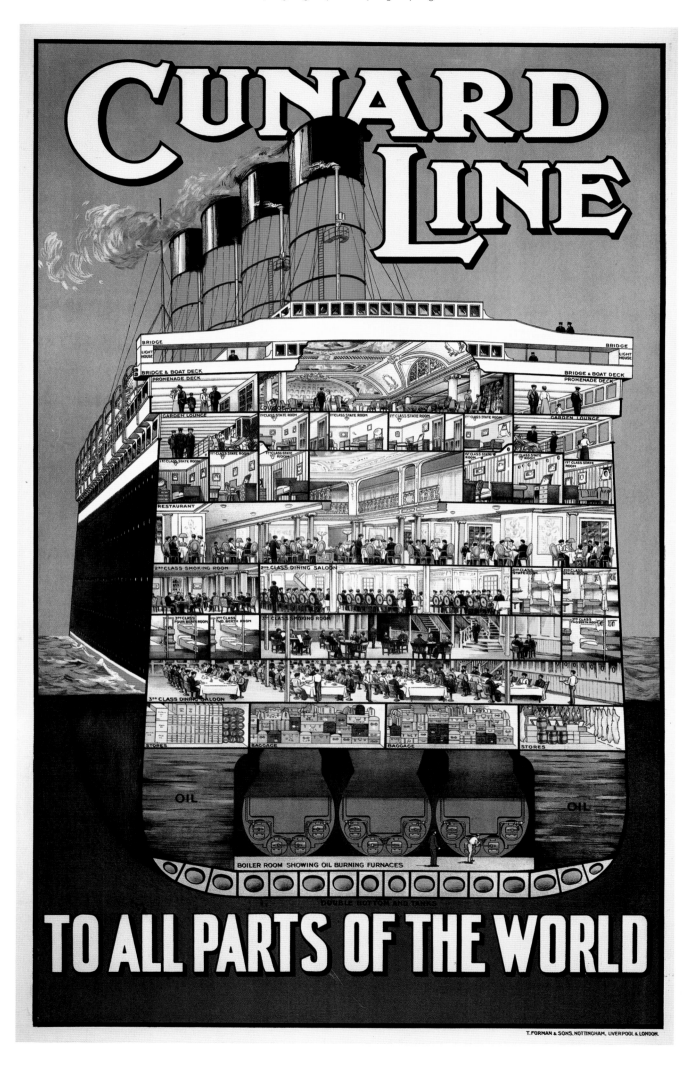

CUNARD LINE

TO ALL PARTS OF THE WORLD

T. FORMAN & SONS, NOTTINGHAM, LIVERPOOL & LONDON.

62

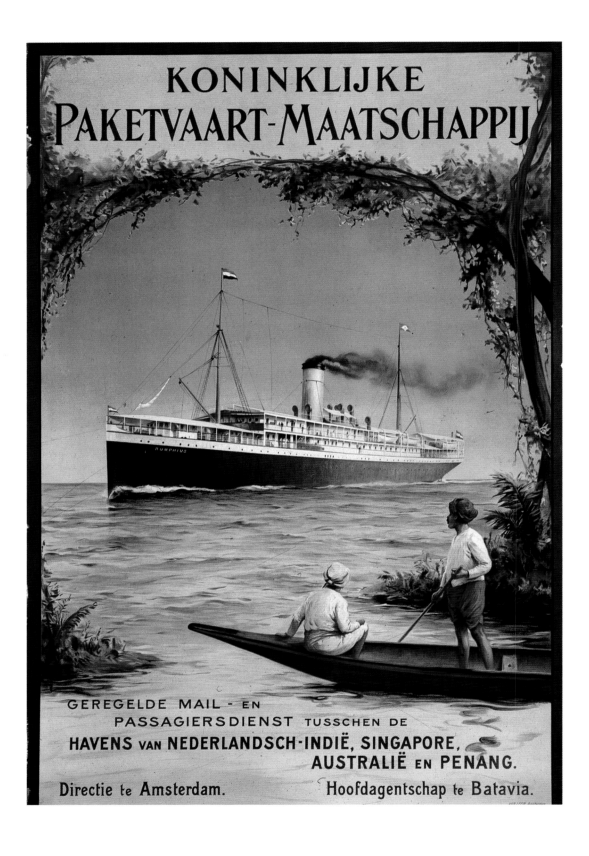

Koninklijke Paketvaart-Maatschappij,
c.1910, L. van Leer & Co., Amsterdam
Ship: *Rumphius*
103 x 69cm
Maritime Museum, Rotterdam

Rotterdam Lloyd, 1915,
Devambez, Paris
Ship: *Insulinde*
101.5 x 71.5cm
Maritime Museum, Rotterdam

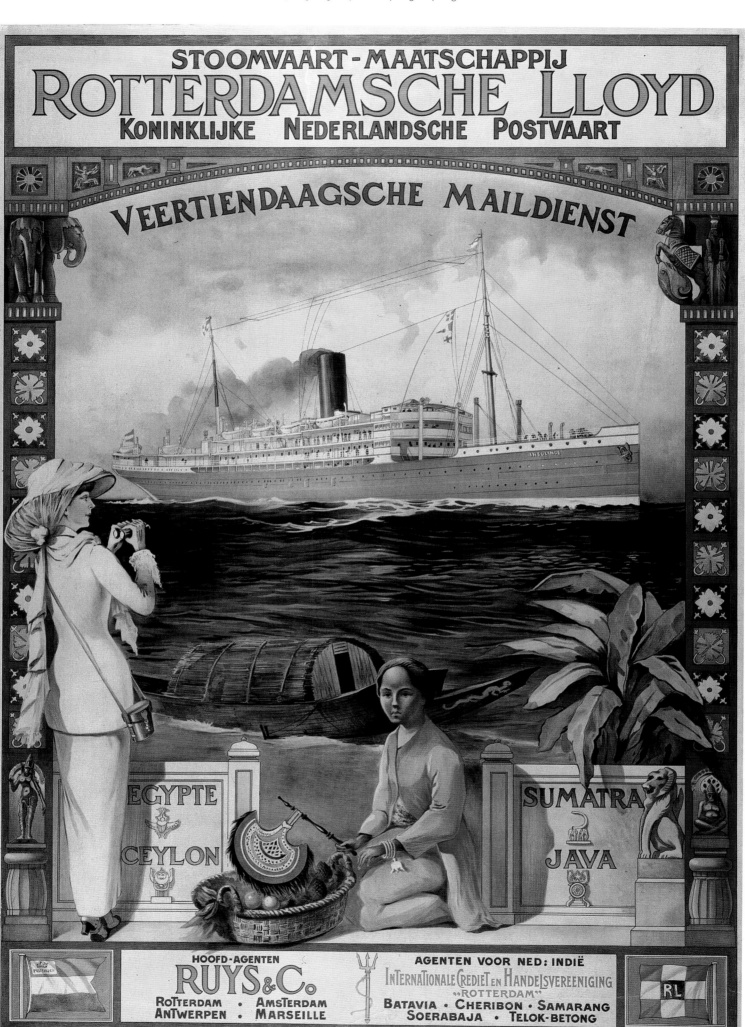

LEVANT . EXTRÊME ORIENT
AUSTRALASIE
MADAGASCAR

MESSAGERIES
MARITIMES

E. DAUVISSAT. Imp. 65. Rue de la Victoire. PARIS.

1919-1929
The Twenties:
The Rebirth of
Maritime Transport

Fabre Line, 1920
Ships: *Patria, Providence*
50.5 x 65.2cm

Levant-Far East-Australia-
Madagascar, Messageries Maritimes,
Gilbert Galland, c.1919,
Printing E. Dauvissat, Paris
Ship: *Porthos*
105.8 x 74.8cm

F ollowing the First World War, competition between the major shipping nations
escalated, with America and Italy also joining the fray. The sumptuous days of First
Class travel around the globe were halted with the outbreak of the First World War
in August 1914, and the ships which had been built as part of an international
contest were put to the service of war, mainly as troop carriers, so the finest furniture
and fittings were removed and put into storage. The war saw the loss of many ships,
including Cunard's *Lusitania*, *Laconia* and *Franconia*, White Star's *Britannic* and P&O's
Persia. Following the end of war in 1918, Britain and America requisitioned the three
giants of the Hamburg–American line – the *Imperator*, the *Vaterland* (renamed the
Leviathan following American seizure in 1917) and the unfinished *Bismarck*. America
retained the *Leviathan*, Cunard was awarded the *Imperator* and White Star the *Bismarck*,
which was finally completed in 1922 by Blohm & Voss.

America emerged from the war in a mood of growing isolationism and
introduced an act in 1921 which limited the number of immigrants to the country.
The Emergency Quota Act, also known as the 'Three Percent Act', restricted the
admission of immigrants by three per cent of that nationality already resident in the
US, based on figures yielded by the 1903 census. This had a massive impact on trans-
Atlantic travel, by significantly reducing the volume of passengers travelling west in
Steerage, which had, until then, been highly profitable for the shipping lines. In the
five years leading up to the First World War, there had been 700,000 immigrants
annually to the United States. With the introduction of the quota system, this
dropped to only 230,000 in 1922. The European shipping lines then had to adjust
their ships to carry fewer lucrative Steerage passengers, more First and Second Class,
and an additional higher quality Tourist or Third Class. Hence, the emphasis changed
to providing more distinctive, stylish accommodation for the upper echelons,
particularly North Americans, who were enjoying an unprecedented level of
prosperity and had the leisure time to travel to Europe. And it was a matter of status
for the European nations to provide luxurious ships for the prestigious trans–Atlantic
route. During this period, Art Deco and Modernism emerged as expressions of a
new era; this was seen both on board the ocean liners and in the posters which
advertised them.

The French Messageries Maritimes line rejoined the trans–Atlantic trade in 1919.
The *Porthos* had been built during 1915 and then used by the government until 1919.
After this she sailed the Marseilles to Japan route and then resumed the Saigon,
Haiphong service (p.64). Also sailing from Marseilles was the 11,885 gross ton *Patria*
for the Fabre Line. The ship carried up to 140 First Class, 250 Second Class and 1,850
Third Class passengers (p.65). Her maiden voyage from Marseilles to Naples, Palmero
and New York took place on 16 April 1914, was a service she continued to offer
until 1932, when she was used by Messageries Maritimes for their Marseilles, Eastern
Mediterranean services.

The America Line, based in Philadelphia, was founded in 1872 and ran passenger

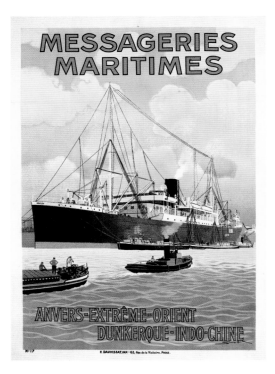

Antwerp-Far East-Dunkerque-
Indo-China, Messageries Maritimes,
Sandy Hook, c.1920,
Printing E. Dauvissat, Paris
Ship: *Capitaine Faure*
107.5 x 76.5cm

66

and cargo services between Queenstown and New York. The Red Star Line then acquired the company, and was itself taken over by the International Mercantile Marine Company in 1902. The *Mongolia* sailed between New York and Hamburg, Antwerp and Southampton from 1920 (p.70). In contrast to the full colour illustrations used for the first three posters in this section, is the haunting monochrome image used by Messageries Maritimes to advertise the route to the Far East with the ship *Docteur Pierre Benoit* which joined the service in 1918 (p.69). One poster advertising similar routes, but in more colourways, is shown here for the *Capitaine Faure* which joined the service one year earlier (p.66).

The Cunard Line continued to operate the fastest service between Southampton and New York with the *Mauritania* and *Aquitania* (pp.72-74). Particularly striking is the authentic, period atmosphere depicted in on page 72, with a fashionably dressed crowd waving to the departing ship. The poster does not include a route, merely the name of Cunard in an early example of corporate branding. The poster of the *Aquitania* (p.74) shows the juxtaposition between the extreme technical might and modernity of the Cunard ship, contrasted with the age-old tying of sails by two boys.

Lines to South America continued to attract passengers. The Koniglicher Hollandischer Lloyd was founded in 1899 to provide transport for cattle and cargo from Amsterdam to South America. This was discontinued in 1903 due to the outbreak of foot and mouth disease in Argentina in 1906. The company then diversified, offering voyages for emigrants from Amsterdam to Buenos Aires, calling at Boulogne, Plymouth, Coruna, Lisbon, Las Palmas, Perrnambuco, Bahia, Rio de Janeiro, Santos and Montevideo. The *Zeelandia* (p.75) sailed on this line from 1910 until 1935, when passenger services ceased.

An express mail service between Belgium and the former Belgian Congo was provided by Cie Maritime Belge du Congo on the *Elisabethville* (p.76). Destinations included Casablanca, Tenerife and Dakar. By the early 1920s, the impact of Modernism was evident in many aspects of art and design. The abstract representation used by the Royal Mail Steam Packet Company (R.M.S.P.) (p.78) is in direct contrast to the representative style of the Cie Belge du Congo's posters. R.M.S.P. had its roots in the nineteenth century and the mail contract between Great Britain and the West Indies. This poster advertises a new route for the company to South America, introduced in 1921, with the *Arlanza*, *Andes*, *Alcantara* and *Almanzora*.

Canadian Pacific certainly did 'Span the World', as the strap line of this 1922 poster claims, offering voyages to Canada, America, Japan, China, Australia and New Zealand (pp.77 and 89). The improbably named *Empress of Scotland* was originally the Hamburg-American Line ship, the *Kaiserin Auguste Victoria*, the biggest ship in the world when she was launched in 1905. She was laid up in Hamburg during the Second World War, and then sold to the Canadian Pacific Line in 1921, who renamed her. She travelled between Southampton and New York, then Southampton and

Quebec throughout the 1920s. She was then sold for scrap when the new *Empress of Britain* was introduced.

Another ship to be effected by the events of the First World War was the *Cap Polonio* (p.67). She was built in 1914 but did not sail until 1919, when she was surrended to Britain. In 1921 she was bought by the Hamburg-Sudamerikanische Dampfischfahrrts-Geschellschaft (H.S.D.G.) for voyages to South America. She was eventually scrapped in 1935. The Holland-Amerika Line emerged from the First World War severely depleted. Never again to vie for dominance of the trans-Atlantic route with British lines, the company concentrated on services to South America and Asia. In 1922 the company purchased the *Holsatia* from the Royal Holland Line and offered a service to Cuba and Mexico, before the ship was scrapped in1928 (p.67). The *Munsterland* was a new ship in 1921 and was introduced for the route to Asia (p.71).

Hamburg-American Line had lost its most prestigious, trans-Atlantic liners, including the *Bismarck*, as a result of the First World War. 'The World's Largest Ship' (p.81) now belonged to the White Star line, who took delivery of the completed *Bismarck* from a dispirited workforce at Blohm & Voss in Hamburg. In 1922 the ship was delivered to White Star and renamed *Majestic*. At 56,551 tons this was the biggest liner afloat, and added to the trans-Atlantic fleet with *Olympic*. As is shown by the poster, White Star capitalised on the ship's size in their publicity.

The British India Steam Navigation Company can trace its origins back to 1856, but they merged with P&O in 1914, though each company kept their original name. The company obviously specialised in voyages to India, and here we see the *Matiana* of 1922 in soft, muted pastels and an exotic setting (p.79). Another change of ownership came for a German ship following the First World War: the *Yang Tse* was formerly the *Remschied*, originally built for N.D.L. but awarded to Messageries Maritimes in 1920 (p.80). Employed on the route to India and the Far East, the ship was seized by the Germans in 1940, returned to her original owner and renamed *Markobrunner*. At the end of the Second World War it was returned to Messageries Maritime and renamed *Yang-Tse* for a second time.

Whilst post-war reclamation and refitting was taking place, C.G.T. built a second prestige ship to follow the *France*; this was the *Paris*, completed in 1921 (p.82). At 34,569 tons it was larger than its predecessor. The ship was designed to carry 560 First Class, 530 Second Class and 840 Third Class passengers. The décor of the First Class displayed a transition from the conventional period styling to an Art Deco look, as France sought to once more become a global fashion leader. This culminated in the 1925 Paris Exposition Internationale des Arts Décoratifs et Industriels Modernes, the planning of which was well underway by this date. France seized the initiative for leadership in modern design from humiliated and war torn Germany, who had begun to introduce more contemporary styling to their liners just before the First World War.

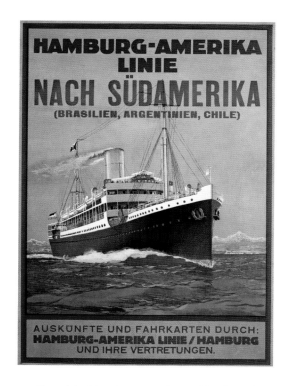

South America,
Hamburg-Amerika Line,
c.1922, Mühlmeister &
Johler, Hamburg
Ship: *Holsatia*
70.5 x 50cm

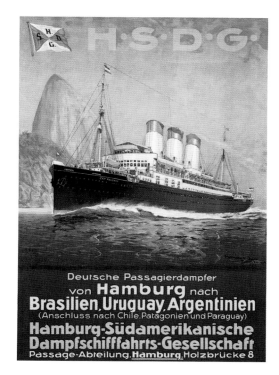

H.S.D.G., Hans Bohrdt,
c.1922, Mühlmeister & Johler,
Hamburg
Ship: *Cap Polonio*
101 x 70cm
Museum für Gestaltung Zurich,
Poster Collection

The original interiors were designed by the architect Richard Bouwens Van der Boijen, son of the Second Empire architect of the first Paris office of the Credit Lyonnais (1876), William Bouwens Van der Boijen. The cabins were designed by Art Deco designers Louis Sue, Andre Mare, Paul Follot and René Prou. There were traditional cabins to suit accepted tastes, but Art Deco design was also introduced. The intricate ironwork in the foyer was designed by Edgar Brandt and consisted of a wrought iron staircase. More unusually, wrought iron was also used for the columns supporting the cupola, the balcony and mezzanine in a style which bridged Art Nouveau and Art Deco. However, the poster designs did not reflect this new style.

The *Resolute*, pictured here (p.84 and 85), was originally the *William O'Swald*, built for the Hamburg–American Line, but never sailed under her original name. She was taken by Holland in 1916 and renamed the *Brabantia*. Following that, she was sold to the United American Line and renamed the *Resolute* in 1922, the date of this fairly traditional poster. In direct contract, the poster for the *Albert Ballin, Deutschland, Resolute* and *Reliance* (p.86) was far more avant garde, with its abstract representation of the ship and the sea.

The *Doric* was launched by White Star in 1923 for the voyage from Liverpool to Montréal and Quebec (p.87), and the *Belgenland* in the same year for the Red Star Line (p.68). The latter had originally been built for White Star, but was taken over by Red Star in 1923.

The Anchor Line, founded in 1852, specialised in sailing from Glasgow to New York and Canada. A smaller scale company than Cunard and White Star, it did encourage modern design. The poster advertising its services (p.6) is modern in treatment, using a flat pattern of shapes and limited colours instead of a representative painting of the ship. The fleet advertised here consisted of the *Cameronia, Tyrrenia, Tuscania* and *California*. The latter was the flagship and she was remodelled in the late 1930s to reflect modernist taste.

The poster for the American Line's *Kroonland* and *Finland* is similarly modern, with restricted colourways and a simple outline (p.88). The *Kroonland* had been originally built for the Red Star line in 1902 for sailing between Antwerp and New York. She was used to carry troops during the First World War, and then resumed service for the American Line in 1923 on the route between New York and Hamburg. The *Columbus* was built for N.D.L. before the First World War and was then named the *Hindenburg* (p.89). Following the War she was launched and renamed, and in 1923, she began offering a service between Bremen and New York. The poster makes great capital from the name *Columbus*, contrasting the fifteenth-century explorer with a modern liner.

Rotterdam Lloyd continued to offer voyages from Rotterdam to Africa, Singapore, Ceylon and Java (p.83). The poster is a simplified representation of the *Patria*, a giant white liner, being sighted by one of the indigenous population wearing a fez and standing in a small traditional boat.

Navigazione Generale Italiana (N.G.I.) was formed in 1881 and offered sailings from the Mediterranean to New York, Canada, Hong Kong and South America. The new *Duilio* and *Giulio Cesare* (pp.90 and 91) served the route to South America. The influence of Italian Futurism can be seen in the dynamic image used for the poster advertising the South American service with the *Giulio Cesare* (p.91). Another Italian company, Lloyd Sabaudo, offered a service from Genoa and Naples to New York on ships such as the *Conte Rosso* and *Conte Verde*, launched in 1922 and 1923 respectively (p.7). Although the ships were built in Glasgow, their interiors were designed by the Italian based firm, *La Casa Artistica*, who sent their own upholsterers, ironworkers and carpenters to Scotland to fit out the ships.

Another German ship to be repatriated was the *Leviathan* (p.92). It was extensively refitted by the United States Line at Newport News, Virginia with new interiors by Eugene Schöen. The cost of the refit was 8 million dollars, far greater than the cost of its original build by Hamburg–American, and the relaunch of the ship in 1923 brought America into the provision of twentieth-century trans–Atlantic travel for the first time. Note the emphasis on the gigantic size of the ship in the publicity. Hamburg–American's livery of black, yellow, red and white was obliterated by red, white and blue. However, the ship did not match the success of British counterparts. This may have been because the flagship did not have other equivalent ships with which to form a regular and reliable trans-Atlantic service. Also, due to Prohibition, introduced in 1919, the United States Line could only offer a 'dry' (alcohol free) service; it is possibly this which is referred to in the poster on p.93 with the slogan: 'The American Way to America'.

Cunard, meanwhile, refitted the *Imperator* and renamed her the *Berengaria*, after the wife of Richard the Lionheart; the ship was also refitted on Tyneside in 1922 (pp.94 and 95). The interiors retained the Mewès & Davis flavour, with the 'Olde English' smoking room and French style public rooms. The Pompeian swimming bath remained in tact. The Prince of Wales travelled on the ship in August 1924 in one of the two Imperial suites, which were largely unaltered from the pre–War era. The *Berengaria* serviced the Liverpool to New York route alongside the *Aquitania*, pictured here framed between two New York skyscrapers (p.96) in one of Cunard's most famous posters.

The Compagnie de Navigation Sud Atlantique was established in 1910 to provide the mail service and passenger transport to South America which had previously been provided by Messageries Maritimes. The *Massilia* was completed in 1920 for the service, represented here in these evocative, Art Deco images (pp.98 and 99). Also serving South America was the German Hamburg–South America Line. The company had to slowly rebuild its fleet after the First World War, and the *Montes Sarmiernto* and *Monte Olivia* (p.97) joined in 1924 and 1925 respectively.

Messageries Maritimes continued to provide a service on most major routes in the inter-war period. The *Paul Lecat*, illustrated here, was built in 1911, but caught fire

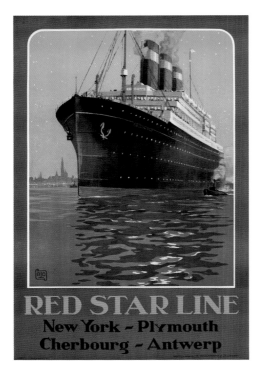

New York-Plymouth-Cherbourg-
Antwerp, Red Star Line, c.1923,
E. Stockmans & Co., Antwerp
Ship: *Belgenland*
99 x 65cm

Antwerp-Far East,
Messageries Maritimes,
Sandy Hook, c.1920,
Printing F. Champenois, Paris
Ship: *Docteur Pierre Benoît*
101 x 71.3cm

68

in Marseilles in 1928 and was subsequently scrapped (pp.100 and 101). The Red Star Line chartered the *Pennland* (first launched in 1920 as the *Pittsburgh*) from the America Line in 1925 (p.102). In 1926, she travelled under the new name from Antwerp to Southampton, Halifax and New York.

The *Asturias* and *Alcantara* were built for the Royal Mail Steam Packet Company in 1925 and 1926. They sailed to South America throughout the late 1920s and 1930s. It is interesting to note the sweeping Art Deco lines in the background of this poster (p.103).

The Hamburg-American line began to resurrect itself during the 1920s with four new ships for the Hamburg and Southampton to New York route. These were the *Albert Ballin, Deutschland, Hamburg* and *New York* (p.104). This striking poster uses only a section of two funnels to advertise the line and is likely to have been influenced by the modernist graphic design of this type emanating from the Bauhaus in Germany at that time.

The Hamburg-South America Line had lost all its ships as a result of the First World War, and so started to rebuild the service with new ships in the 1920s. That is possibly why the poster illustrated proudly makes reference to the 'New *Cap Arcona*' with sailings to Rio de Janeiro and Buenos Aires from 1927 (p.105).

Messageries Maritimes reflected the exotic destinations of its lines with this 1928 poster for its 'Extreme-Orient' sailings (p.106) which refers to the *D'Artagnan* and *Athos*. The latter had travelled on her maiden voyage in 1927 from Marseilles to the Far East, and for the next nine years sailed between Marseilles, Malaya, Indo-China, Hong Kong, Shanghai, Kobe and Yokohama. The Italian line, Lloyd Sabaudo, launched its biggest ship yet, the *Conte Grande* in 1928 for the Genoa to New York route. (p.108) The interiors were again designed by La Casa Artistica and featured a three-storey ballroom in both Moorish and Art Nouveau styles. The other major

Italian shipping line, Navigazione Generale Italiana (N.G.I.) launched the *Augustus* in 1926, at the time, it was the world's largest passenger motor ship (p.108). Her maiden voyage was from Naples to Buenos Aires, she then sailed the Genoa, Naples to New York route from 1928 until 1931.

Avant-garde design was starting to make an impact on ocean liner posters, and the design for the United States Line's *Leviathan* by A.M. Cassandre is groundbreaking (p.109) when compared to those produced three years earlier (pp.92 and 93). The ship is represented by only three elongated funnels, echoed by the Art Deco typography and ingenious use of colour. Cassandre applied the same techniques to the poster he designed for the Holland-America Line's new ship, the *Stadendam* in 1928 (p.110). This is in direct contrast to the more traditional approach used for the same ship by different, less avant-garde designers (pp.2 and 111).

The British White Star Line was still using rather less modern design for their posters; the long-serving *Olympic* is featured here, which entered service before the First World War (p.107). The famous poster by M. Ponty for the Navigation Paquet is far more in the style of Cassandre, with simple colourways and bold, abstract forms (p.113). Lastly, the Panama Pacific Line employed a far more American, Hollywood glamour styling to their posters (p.112). The *California, Virginia* and *Pennsylvania* are represented in simple silhouette against a starry sky and fluid typography.

By the end of the 1920s, most nations offering long distance passenger sailings had recovered from the losses of the First World War. The growing market for luxury and comfort, in contrast to the decline in mass emigration, had had an impact on the design of ocean liners and the posters which advertised them. Most notable is the transformation from pictoral representation of the ships or their destinations, to more abstract, modern imagery pioneered by artists such as Cassandre and Max Ponty.

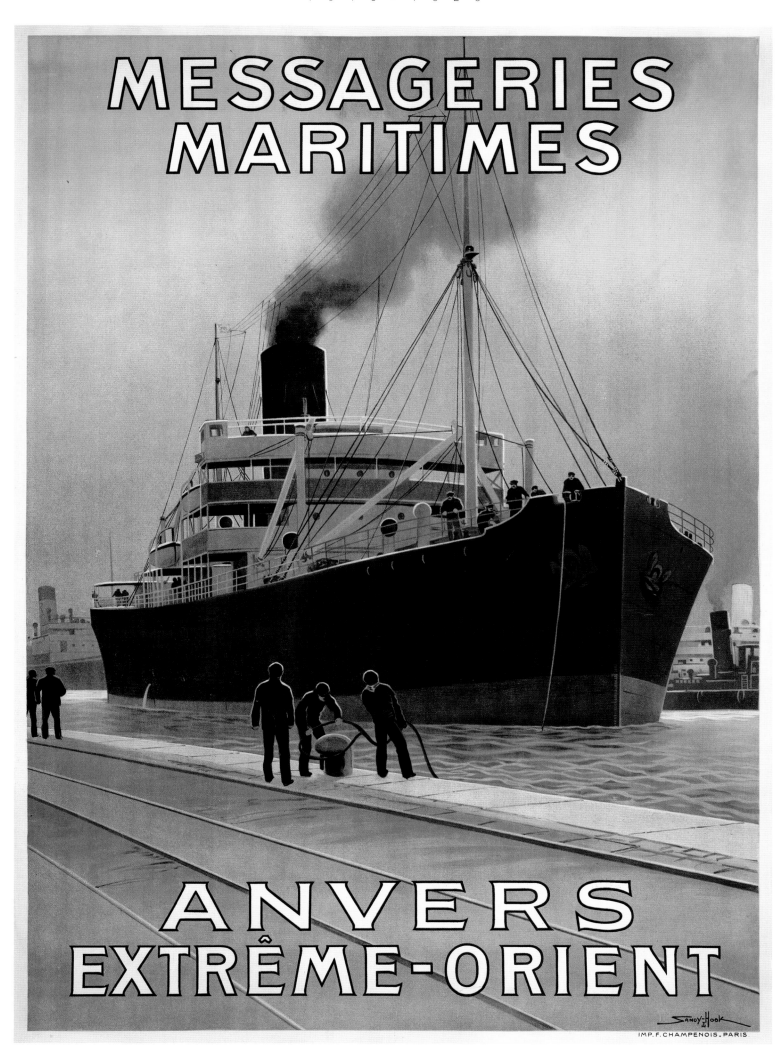

70

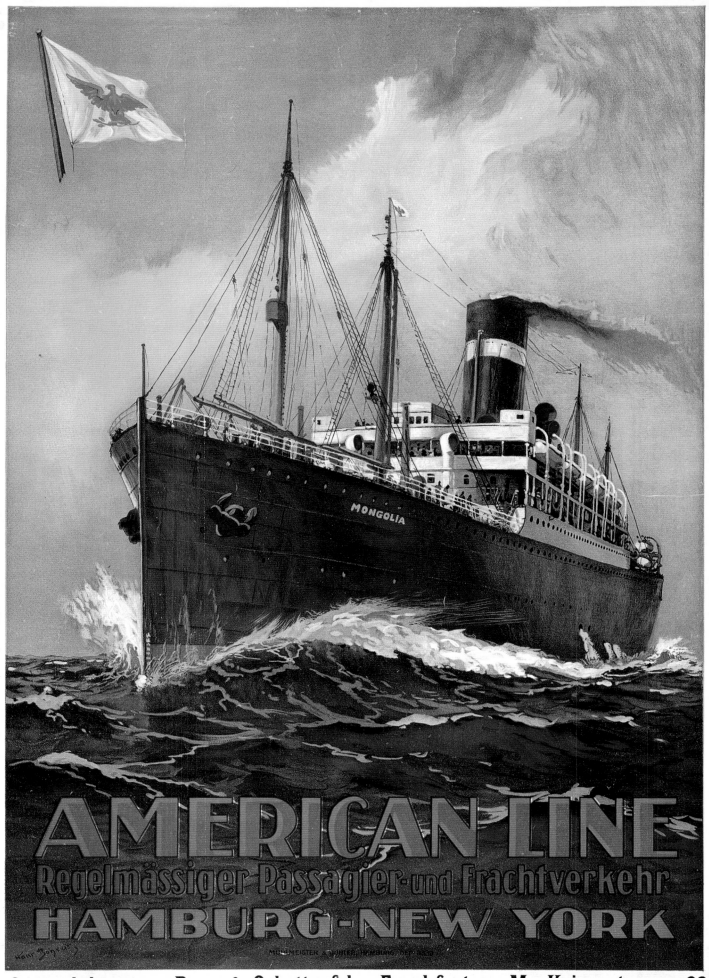

General-Agentur: Born & Schottenfels, Frankfurt a. M., Kaiserstrasse 69

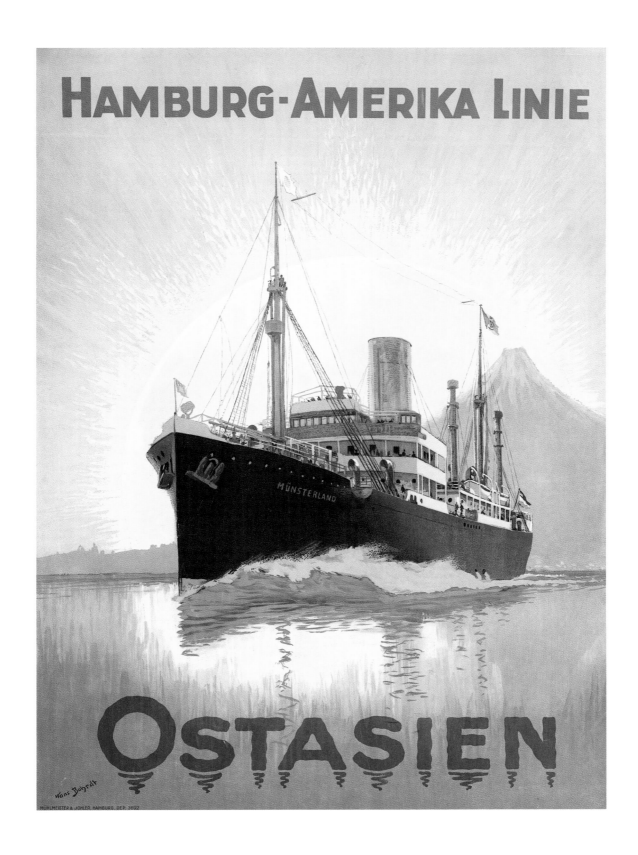

Hamburg-New York, American Line,
Hans Bohrdt, c.1920,
Mühlmeister & Johler, Hamburg
Ship: *Mongolia*
69 x 47cm
Museum für Gestaltung Zurich,
Poster Collection

Asia, Hamburg-Amerika Line,
Hans Bohrdt, c.1922,
Mühlmeister & Johler, Hamburg
Ship: *Münsterland*
70 x 52.1cm

72

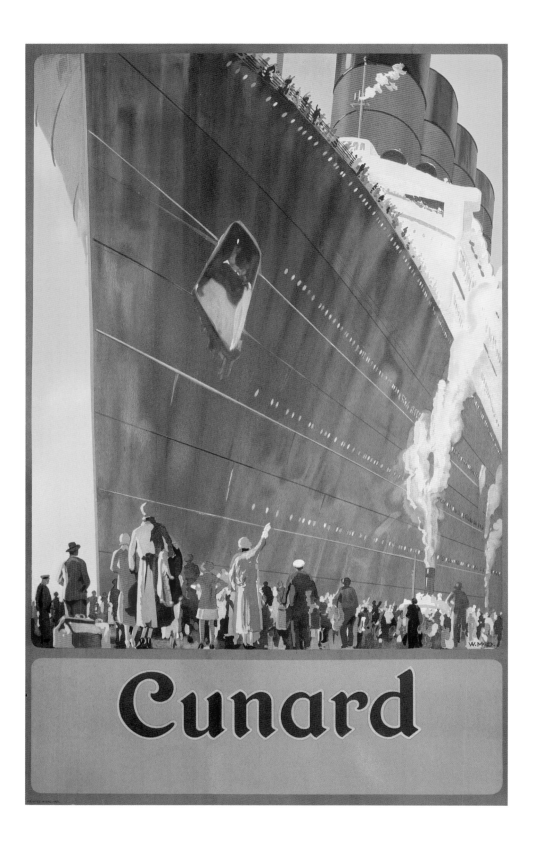

Cunard, W. McDowell, c.1920,
printed in Great Britain
Ship: *Mauritania*
100.5 x 61.8 cm

USA & Canada, Cunard, F.H. Mason,
c.1920, Alf Cooke Ltd,
Leeds and London
Ship: *Mauritania*
99.3 x 61.2cm

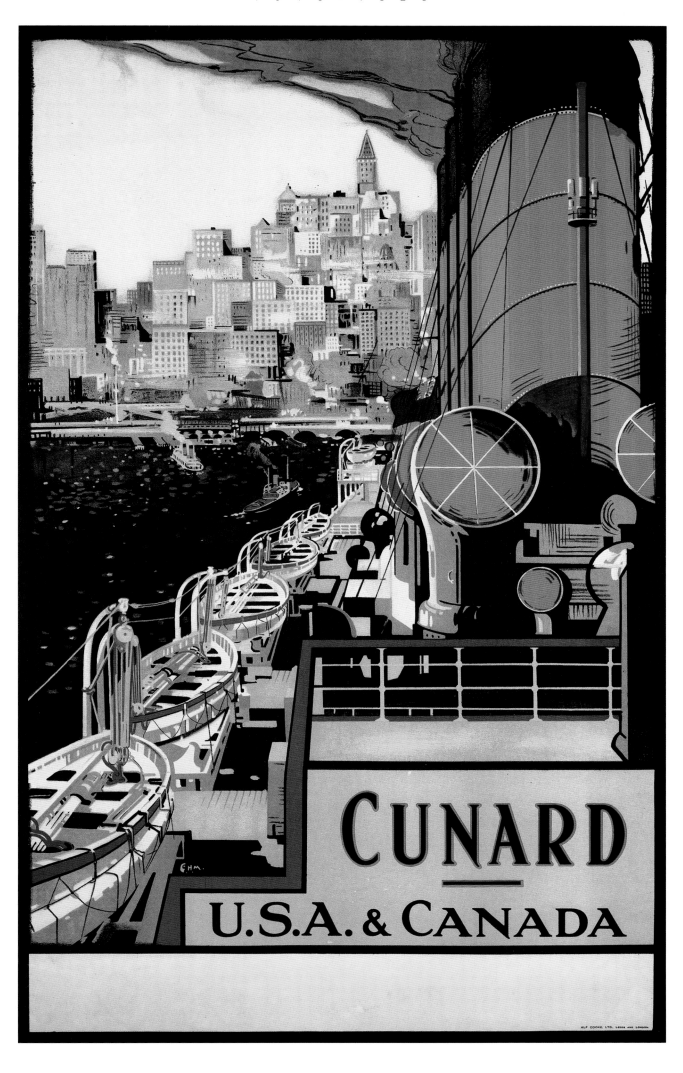

74

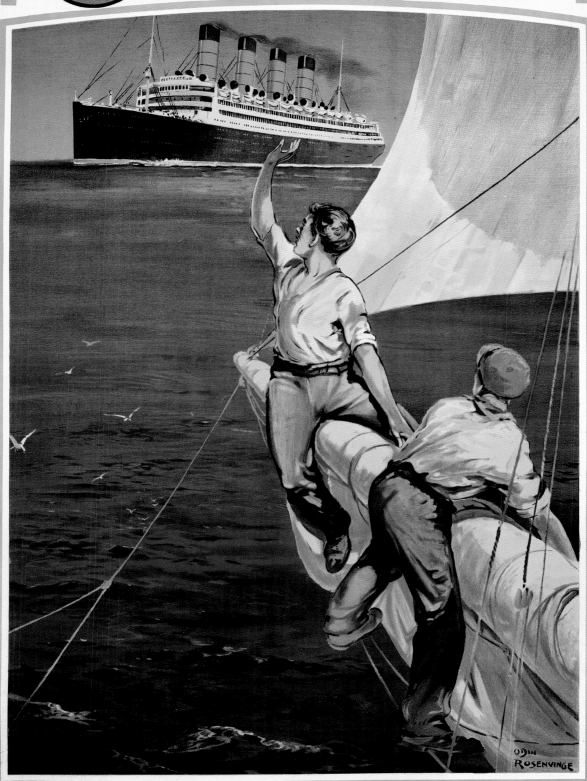

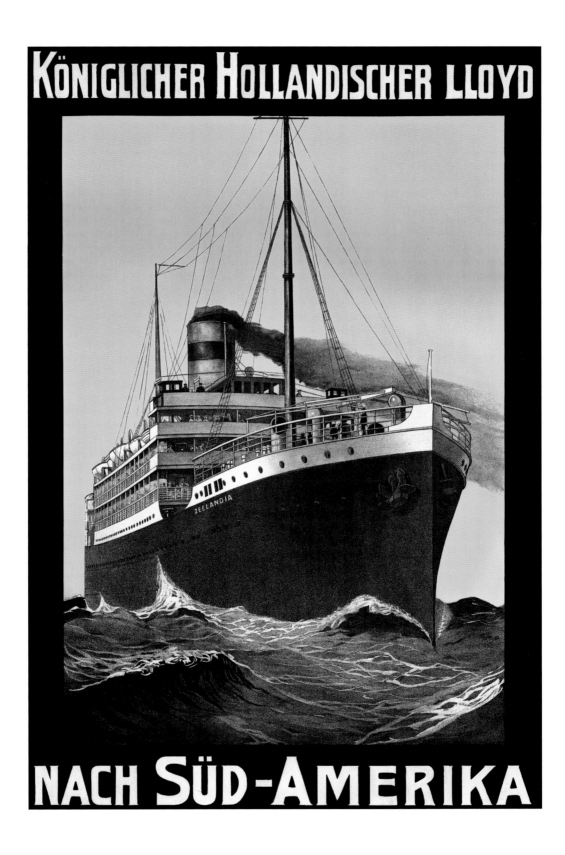

KÖNIGLICHER HOLLANDISCHER LLOYD

NACH SÜD-AMERIKA

Europe-America, Cunard,
Odin Rosenvinge, c.1920,
Turner & Dunnett Ltd, Liverpool,
London and Southampton
Ship: *Aquitania*
101.7 x 63.7cm

South America,
Königlich Holländischer Lloyd,
Johan Kesler, c.1920,
J.H. de Bussy, Amsterdam
Ship: *Zeelandia*
101 x 65.5cm

76

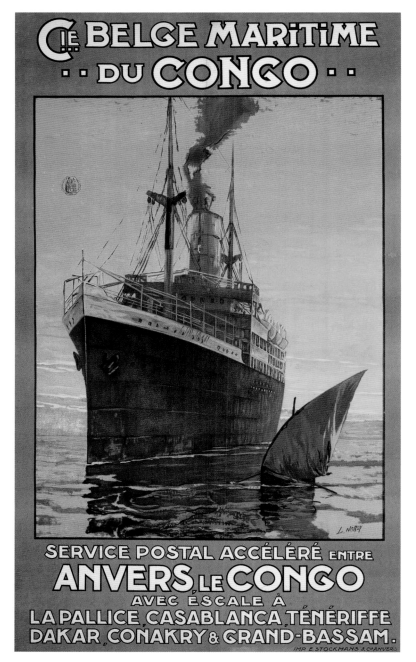

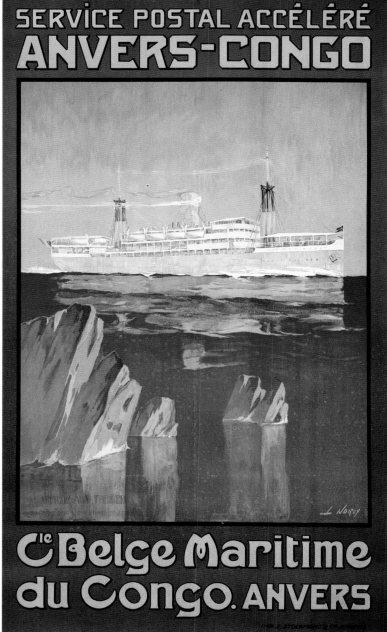

Antwerp-Congo,
Compagnie Maritime Belge du Congo,
L Noroy, 1921,
Printing E. Stockmans & Cⁱᵉ, Antwerp
99.8 x 58cm

Antwerp-Congo,
Compagnie Maritime Belge du Congo,
L Noroy, 1921,
Printing E. Stockmans & Cⁱᵉ, Antwerp
Ship: *Elisabethville*
98.5 x 57.8 cm

'Canadian Pacific Spans the World',
Canadian Pacific, B. Gribble, c.1922,
Eyre & Spottiswoode Ltd, London
Ship: *Empress of Scotland*
101.5 x 63.2cm

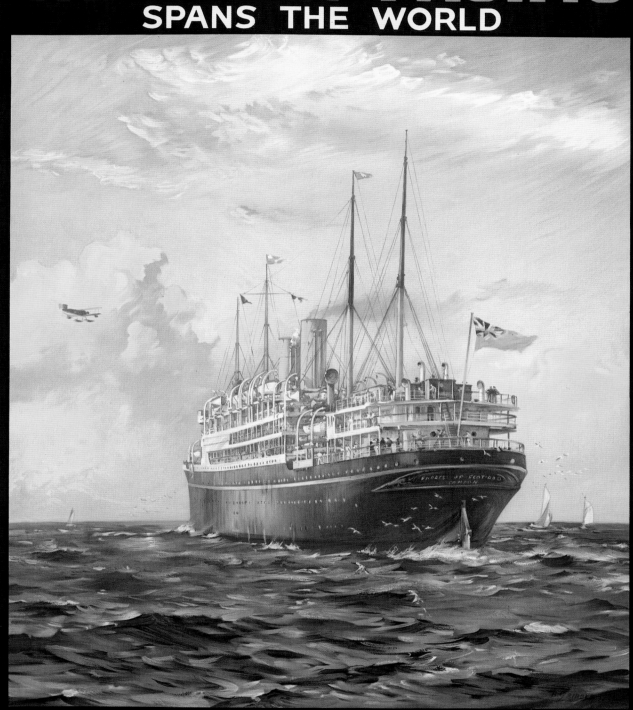

CANADIAN PACIFIC
SPANS THE WORLD

MOST CONVENIENT ROUTE TO
CANADA — U.S.A. — JAPAN — CHINA,
NEW ZEALAND & AUSTRALIA.

APPLY :-

R · M · S · P
SOUTH AMERICAN
SERVICE
THE ROYAL MAIL STEAM PACKET CO
ATLANTIC HOUSE MOORGATE LONDON E·C·2

Ref. S.A. No. 1 Poster

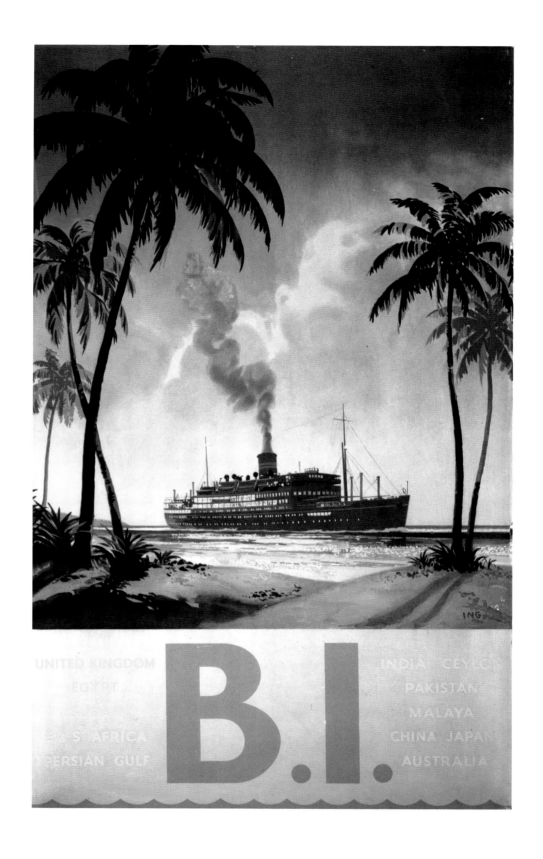

'R.M.S.P. South American Service',
The Royal Mail Steam Packet Co.,
Herrick, c.1921,
The Baynard Press, London
Ship: a vessel from the series *Arlanza,
Andes, Alcantara,* and *Almanzora*
101 x 62.8 cm

B.I., British India Steam Navigation Co.,
Ing, c.1922
Ship: *Matiana*
97.2 x 58.9cm
P & O Heritage Collection

80

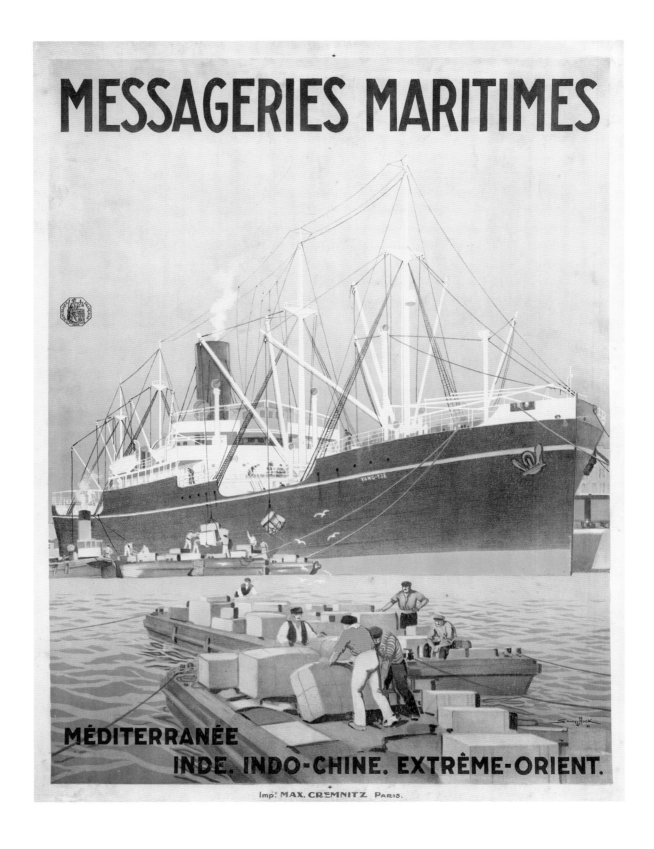

Mediterranean-India-Indo-China-Far East,
Messageries Maritimes,
Sandy Hook, 1922,
Printing Max Cremnitz, Paris
Ship: *Yang-Tse*
78.5 x 59cm

'*Majestic*, The World's Largest Ship',
White Star Line, W.J. Aylward, 1922,
O. De Rucker, Brussels-Forest
Ship: *Majestic*
72.5 x 47.2cm

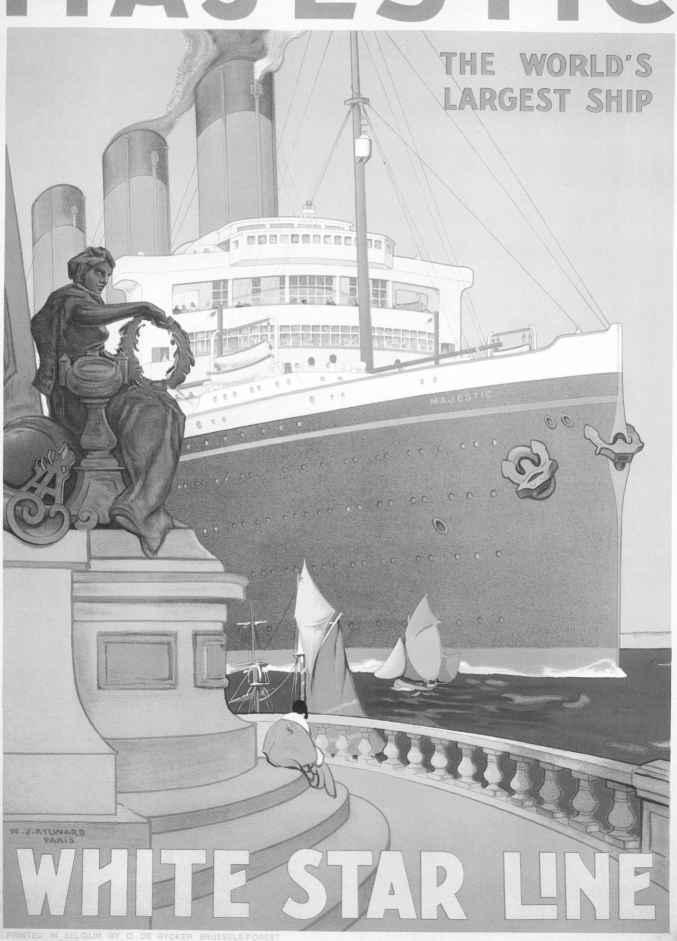

82

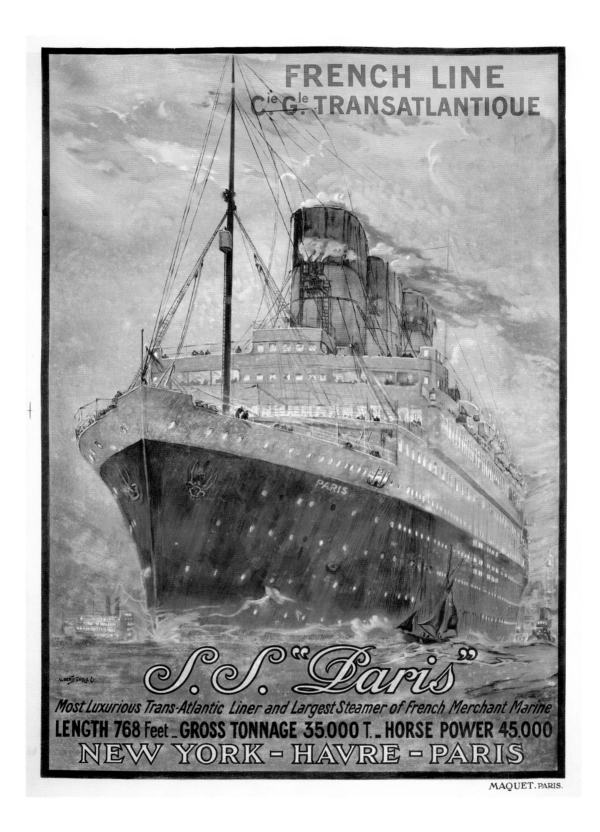

'S.S. Paris',
Compagnie Générale Transatlantique,
Albert Sebille, 1922, Maquet, Paris
107 x 74.7cm

Rotterdam Lloyd, Jos Rovers, c.1924,
Emrik & Binger, Haarlem
Ship: *Patria*
71 x 47.5cm
Maritime Museum, Rotterdam

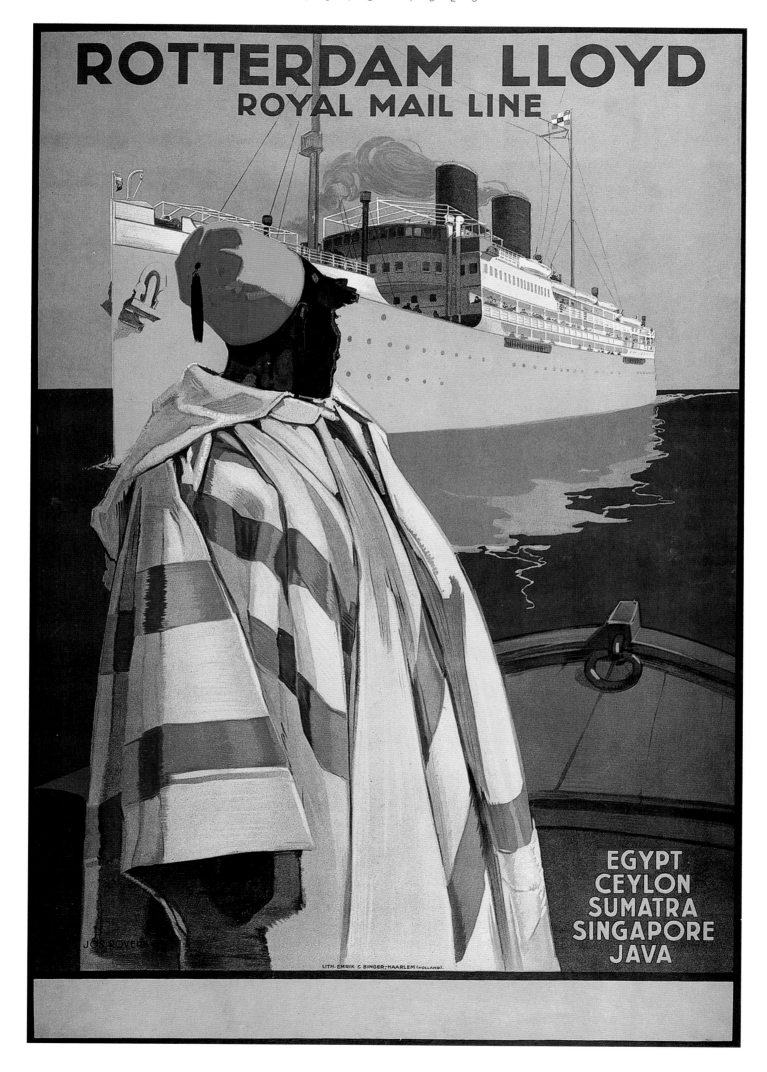

HAMBURG-AME
GEMEINSAMER DIEN
UNITED AMER

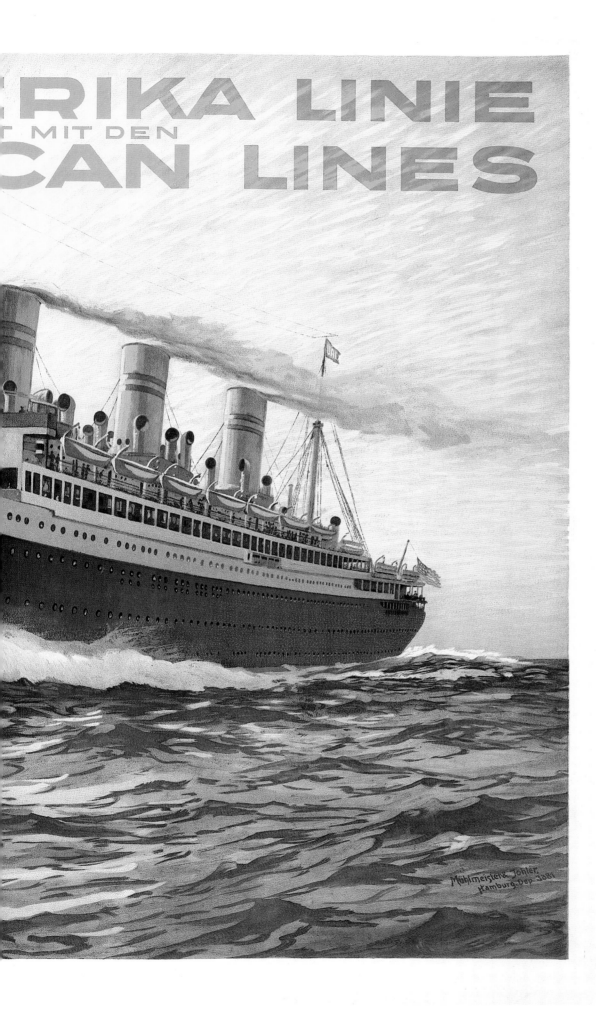

RIKA LINIE
MIT DEN
CAN LINES

Hamburg-America Line,
United American Lines, Hans Bohrdt,
c.1922, Mühlmeister & Johler,
Hamburg
Ship: *Resolute*
74.8 x 111.5 cm

85

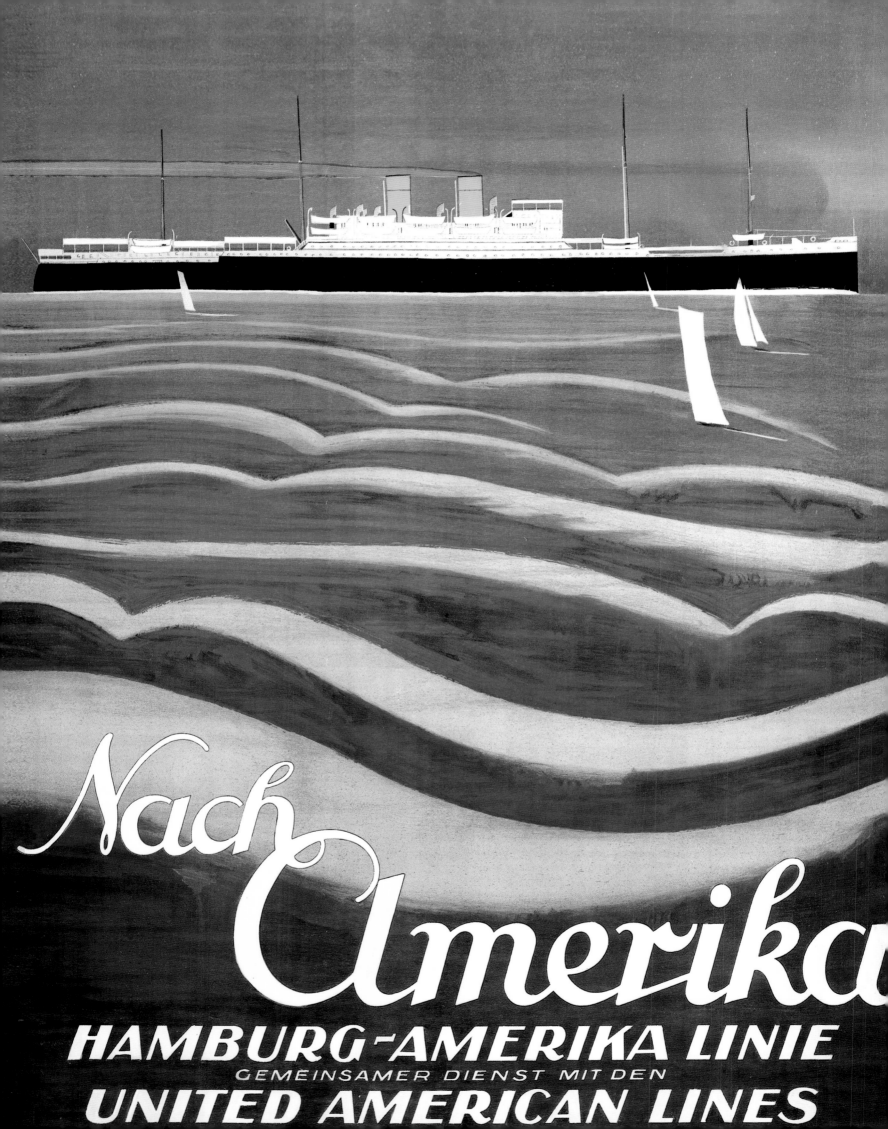

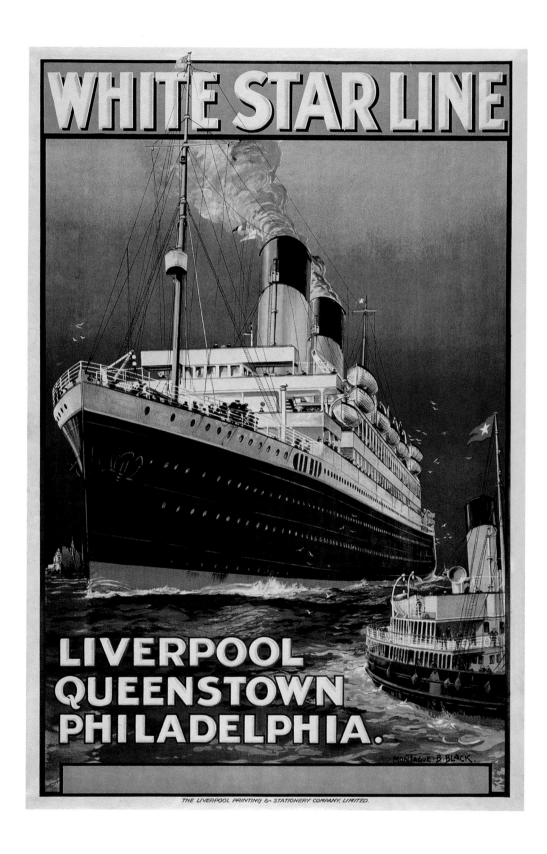

'To America', Hamburg-Amerika
Linie-United American Lines, c.1923,
Mühlmeister & Johler, Hamburg
Ships: *Albert Ballin, Deutschland,*
Resolute, Reliance
101 x 70.3cm

Liverpool-Queenstown-Philadelphia,
White Star Line, M.B. Black, 1923,
The Liverpool Printing & Stationary
Company Ltd
Ship: *Doric*
101 x 64cm
Museum für Gestaltung Zurich,
Poster Collection

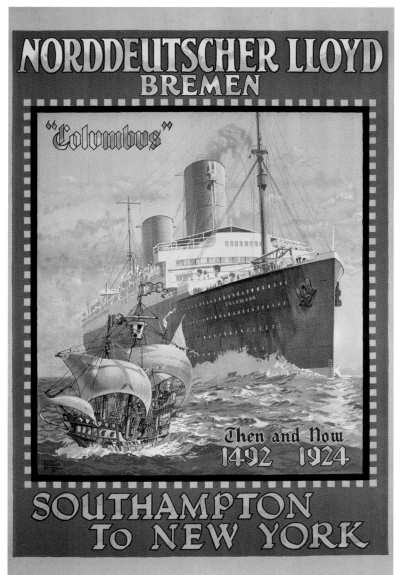

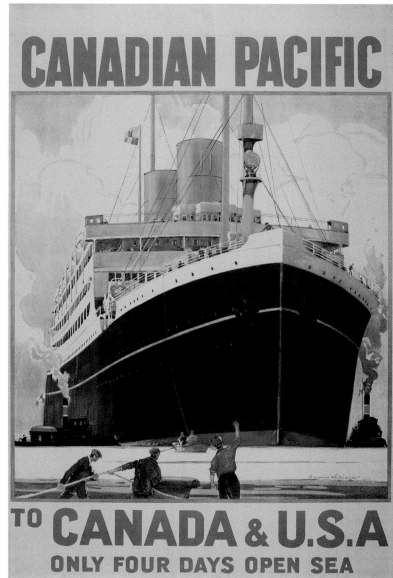

89

'With the American Line to America',
American Line, Anton, c.1923,
Huss & Schröder, Hamburg
Ships: *Kroonland, Finland*
64.2 x 44.8 cm

Southampton-New York,
Norddeutscher Lloyd, Bremen,
Harry Hudson Rodmell, 1924,
Ronald Massey, London
Ship: *Columbus*
100.7 x 64.8cm

'To Canada and U.S.A.',
Canadian Pacific, Norman Wilkinson,
1923, Eyre & Spottiswoode Ltd.
H.M. Printers, London
Ship: *Empress of Scotland*
101 x 64cm
Museum für Gestaltung Zürich,
Poster Collection

90

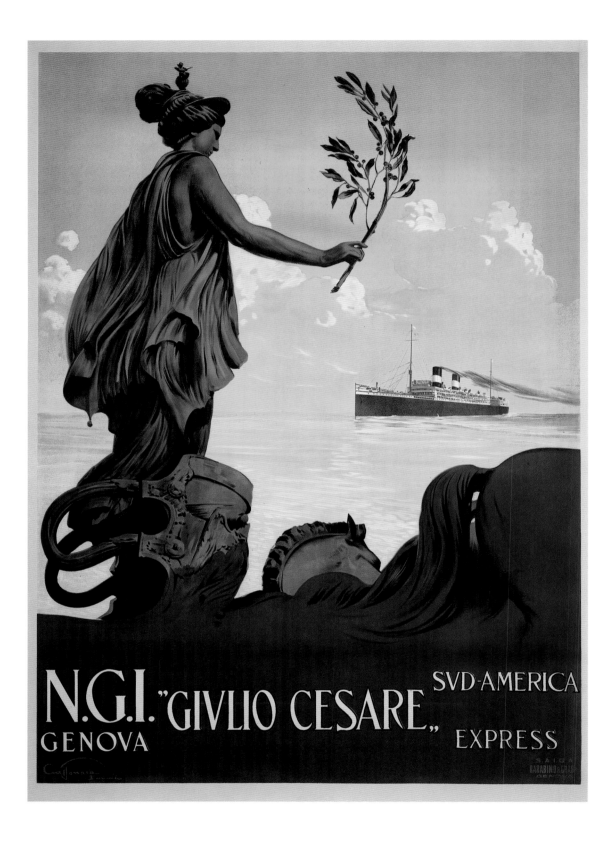

Giulio Cesare, Navigazione Generale
Italiana, Aurelio Craffonara, c.1924,
SAIGA Barabino & Graeve, Genoa
136.3 x 95.7cm
Alessandro Bellenda, Galerie
L'IMAGE, Alassio

Navigazione Generale Italiana,
Giuseppe Minonzio, c.1924,
Bozzo & Coccarello, Genoa
Ship: *Giulio Cesare*
139 x 97cm
Alessandro Bellenda, Galerie
L'IMAGE, Alassio

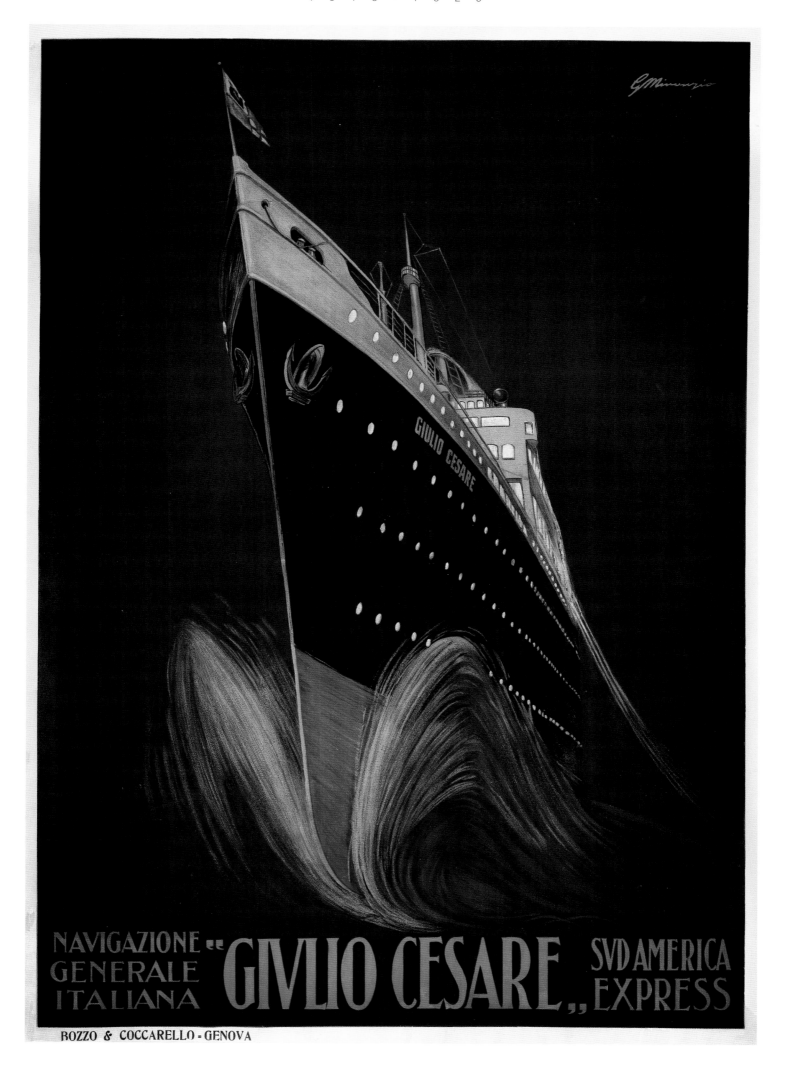

92

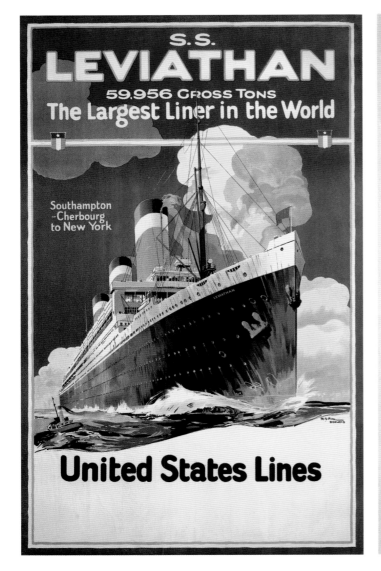

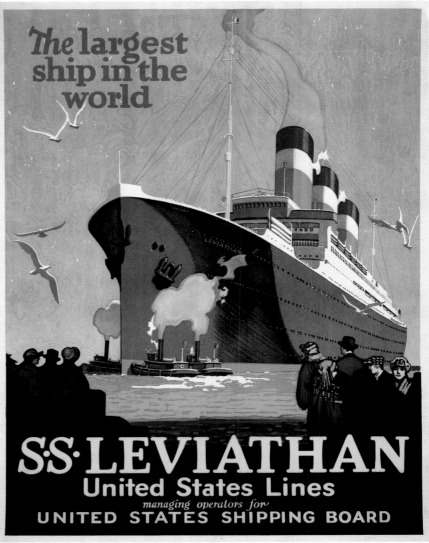

S.S. *Leviathan*, United States Lines,
R.S. Pike Dorland (August Pike Dorland),
c.1925
Ship: *Leviathan*
98.3 x 60.2cm

'The largest ship in the world',
United States Lines, c.1925
Ship: *Leviathan*
69.6 x 53.5cm

'The American Way to America',
United States Lines,
R.S. Pike (August Pike Dorland), c.1925
Ship: *Leviathan*
101.5 x 63cm

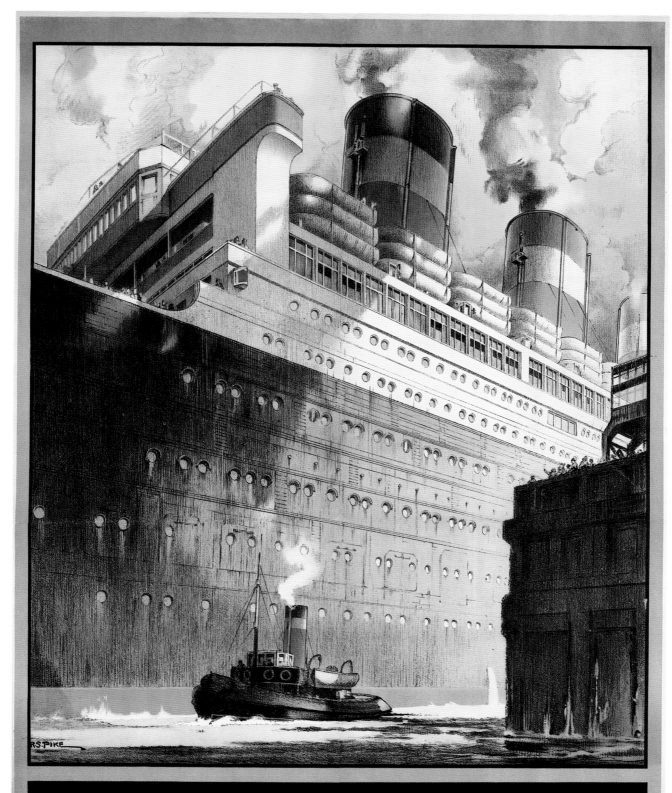

94

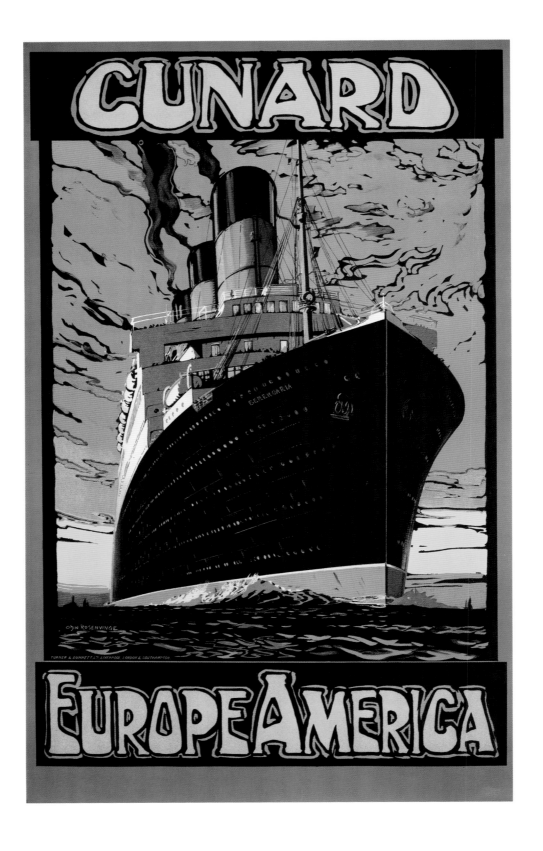

Europe-America, Cunard Line,
Odin Rosenvinge, c.1925,
Turner & Dunnett Ltd, Liverpool,
London and Southampton
Ship: *Berengaria*
101.2 x 62cm

Cunard Line, c.1925,
printed in Great Britain
Ship: *Berengaria*
102 x 63.3cm

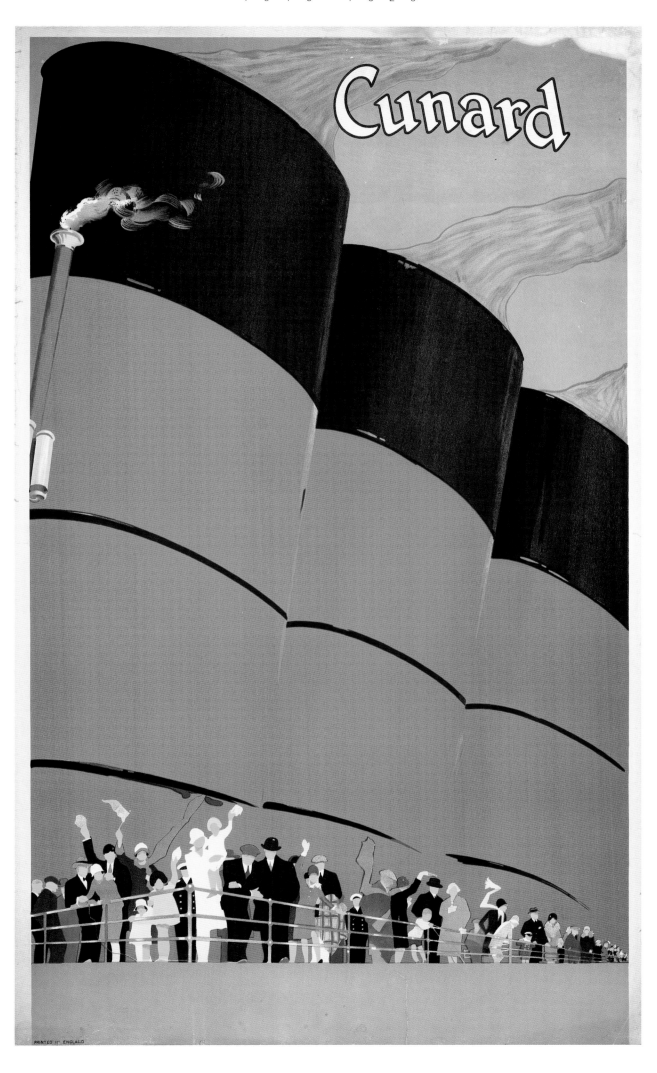

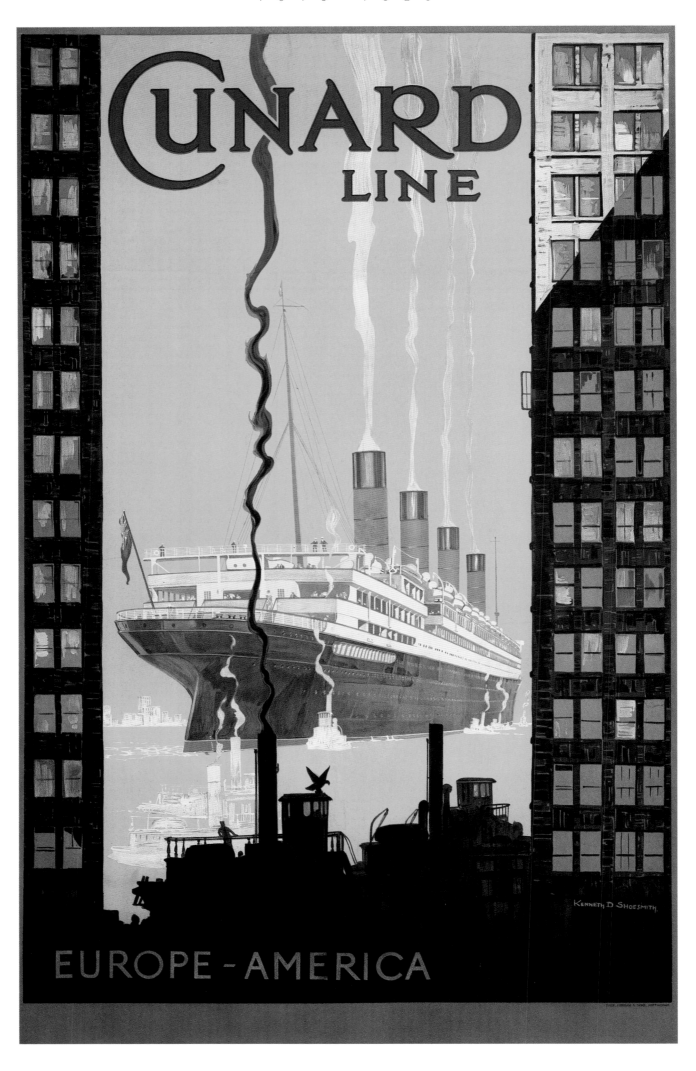

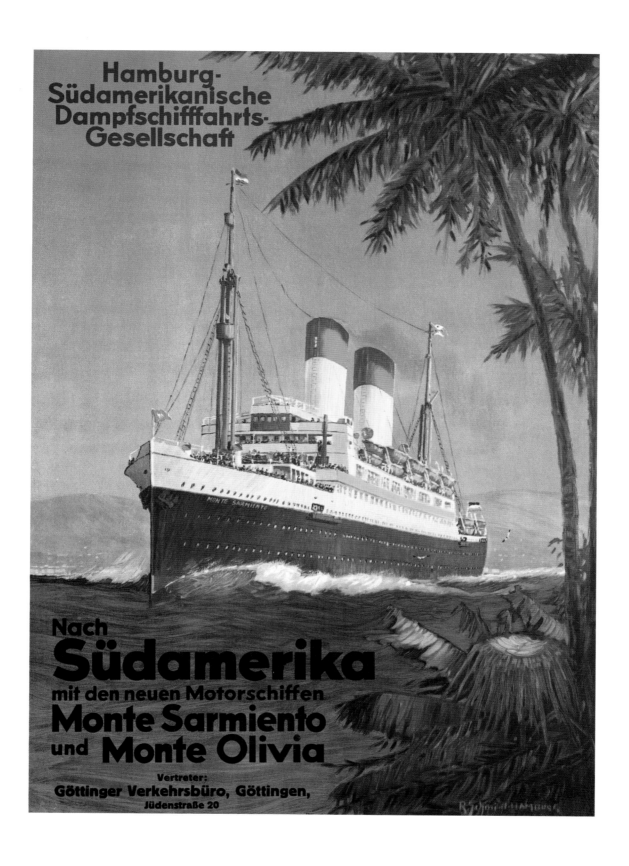

Europe-America, Cunard Line,
Kenneth D. Shoesmith, c.1925,
Forman & Sons, Nottingham
Ship: *Aquitania*
98 x 61.2cm

'For South America',
Hamburg-Südamerikanische
Dampfshiffahrts-Gesellschaft, R. Schmidt,
c.1925, Förster & Borries, Hamburg
Ships: *Monte Sarmiento, Monte Olivia*
56 x 40cm

98

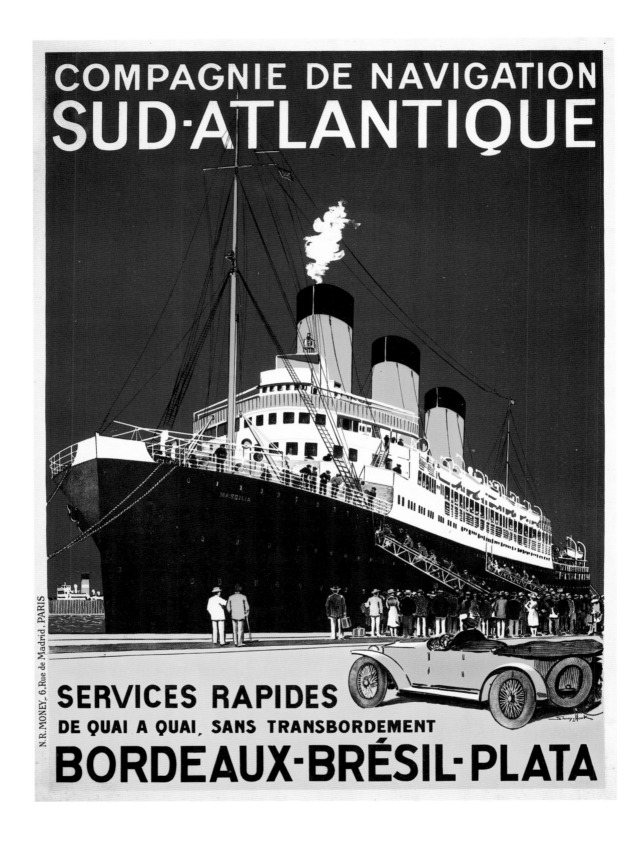

Bordeaux-Brazil-Plata,
Compagnie de Navigation Sud-Atlantique,
Sandy Hook, c.1925, N.R. Money, Paris
Ship: *Massilia*
99.8 x 73.1cm

Brazil-Plata, South Atlantic Chargeurs
Réunis, Sandy Hook, c.1928,
N.R. Money, Paris
Ship: *Massilia*
101 x 73.2cm

BRÉSIL - PLATA

PAR LES COMPAGNIES DE NAVIGATION

CHARGEURS RÉUNIS
SUD - ATLANTIQUE

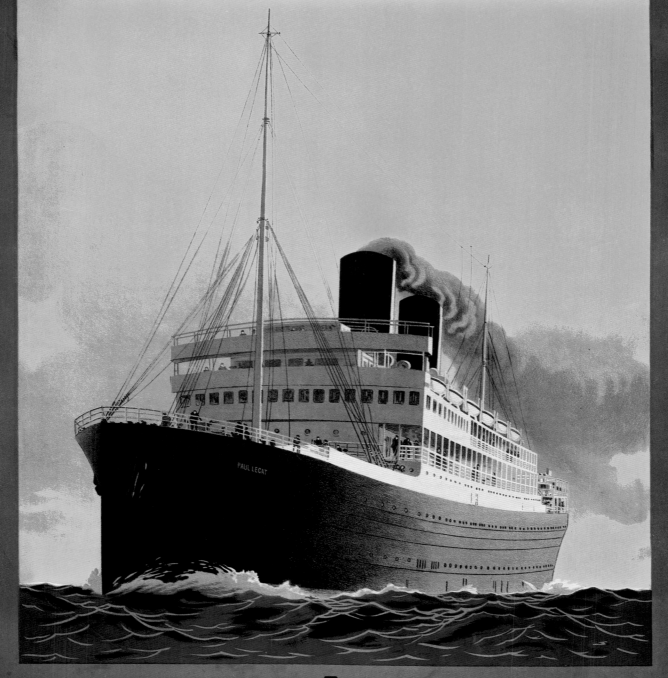

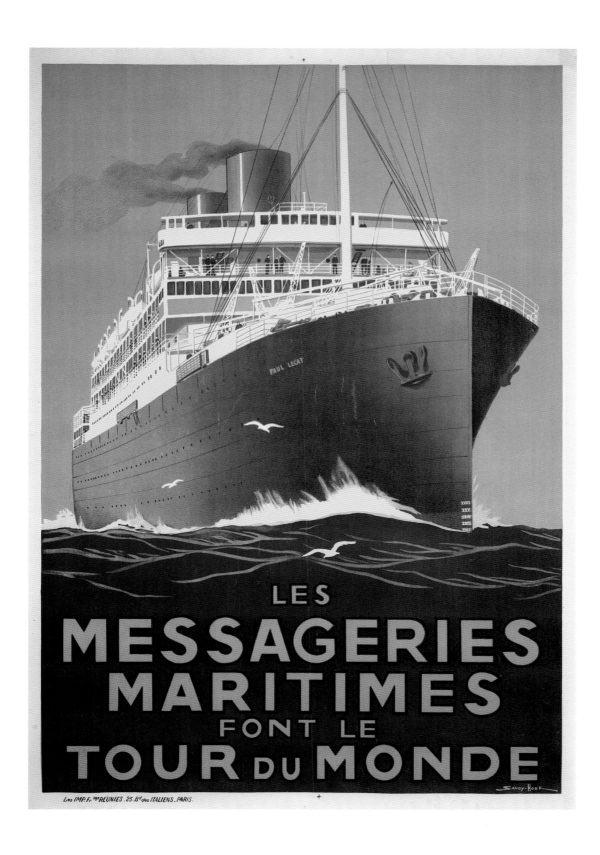

Levant-Far East-Australia-Madagascar,
Messageries Maritimes, Sandy Hook,
c.1925, E. Dauvissat, Paris
Ship: *Paul Lecat*
100.7 x 71cm

'Messageries Maritimes Circumnavigates
the World', Messageries Maritimes,
Sandy Hook, c.1925,
Printing Françaises Réunies, Paris
Ship: *Paul Lecat*
101.6 x 70.2cm

102

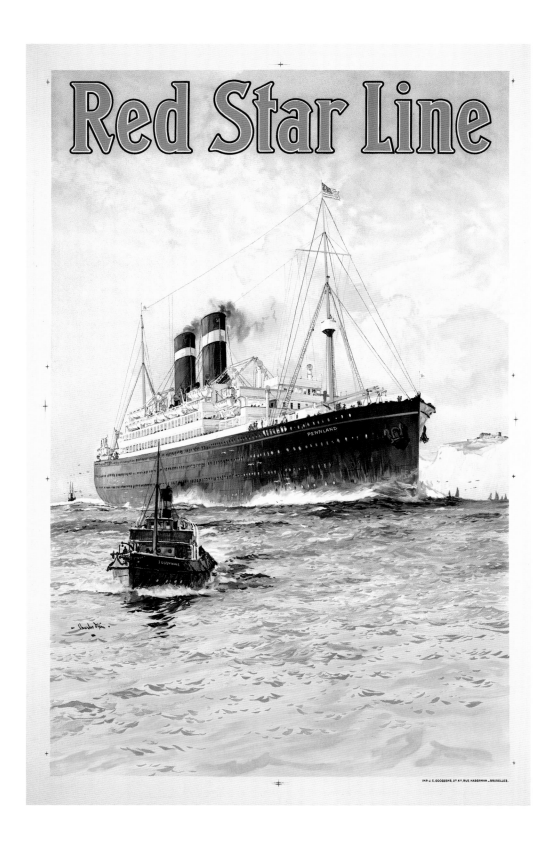

Red Star Line, Charles Dixon, c.1926,
Printing J.E. Goosens, Bruxelles
Ship: *Pennland*
107.4 x 68.6cm

'Royal Mail to South America',
The Royal Mail Steam Packet Company,
Shep, c.1927, Sanders Phillips
and Co. Ltd., The Baynard Press, London
Ships: *Asturias, Alcantara*
100.7 x 63.4cm

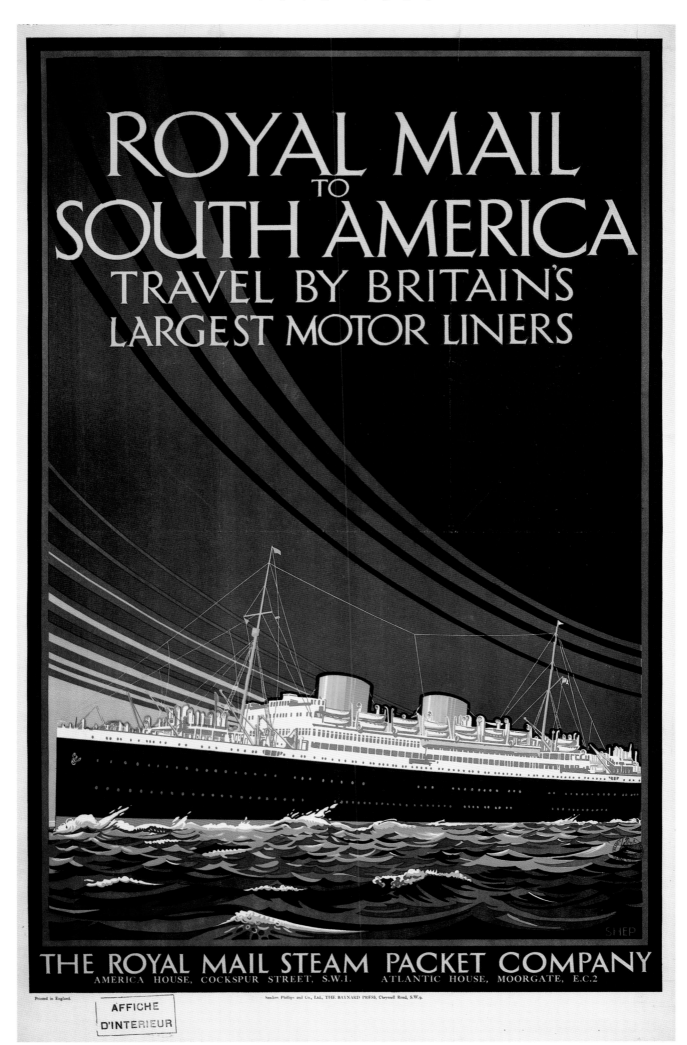

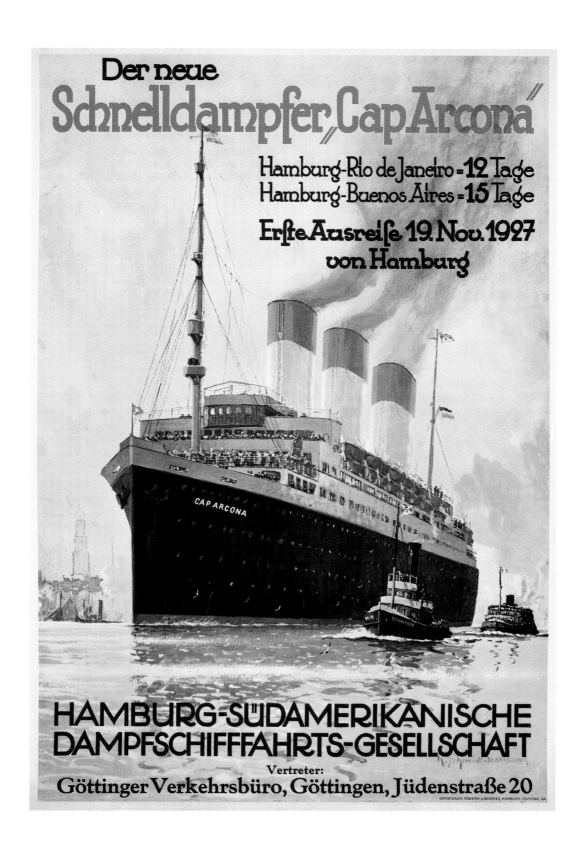

105

'To New York', Hamburg-Amerika Linie,
Etbauer, c.1927
Ships: *Albert Ballin, Deutschland,*
Hamburg, New York
81.7 x 58cm

'The New Cap Arcona',
Hamburg-Südamerikanische
Dampfshiffahrts-Gesellschaft, R. Schmidt,
1927, Offsetdruck Förster & Borries,
Hamburg, Zwickau Saxony
Ship: *Cap Arcona*
67.8 x 45.5cm

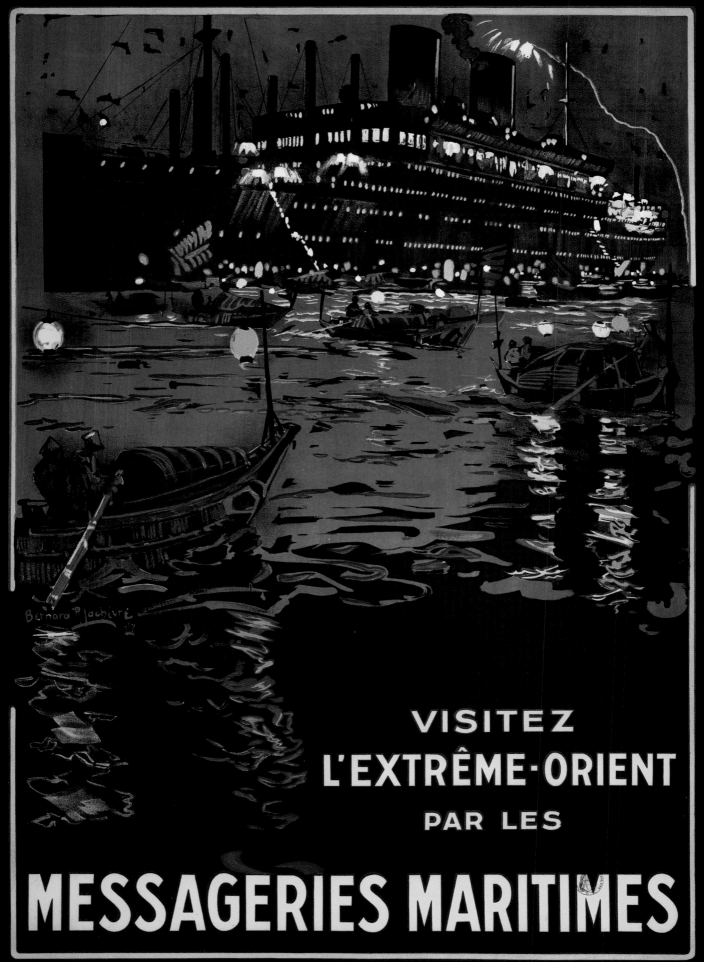

'Visit the Far East',
Messageries maritimes,
Bernard Lachevre, 1928,
Printing Françaises Réunies, Paris
Ships: *D'Artagnan, Athos II*
104 x 73.7cm

Europe-America, White Star Line,
Walter Thomas, c.1929, The Liverpool
Printing & Stationary Co. Ltd.
Ship: *Olympic*
101 x 63cm

108

Conte Grande, Lloyd Sabaudo,
G. Malugani, 1928, Arti Grafiche
G. Schenone, Genoa
Ship: *Conte Grande*
99.5 x 70cm

Augustus, Navigazione Generale
Italiana, Boris, c.1928
Ship: *Augustus*
98 x 68.2cm

United States Lines, Cassandre, 1928,
Société générale de presse et d'édition
Hachard & Cie, Paris
Ship: *Leviathan*
98.3 x 61.2cm

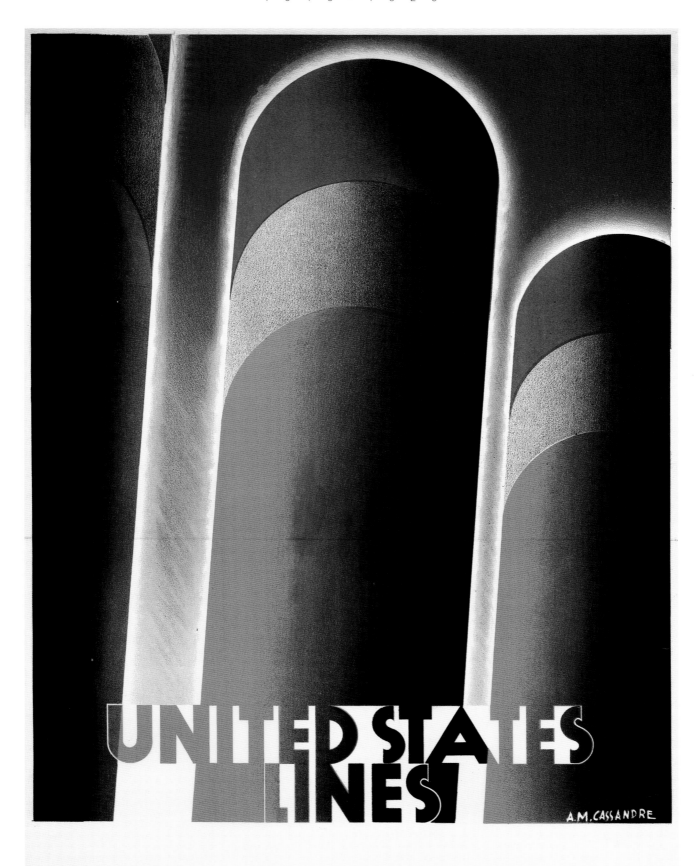

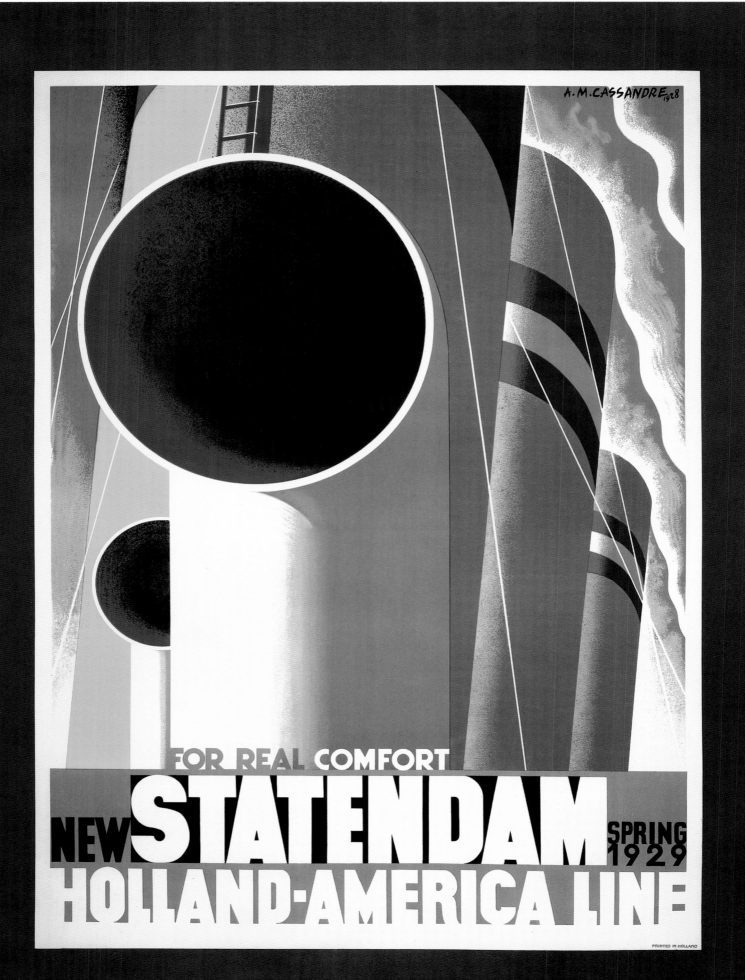

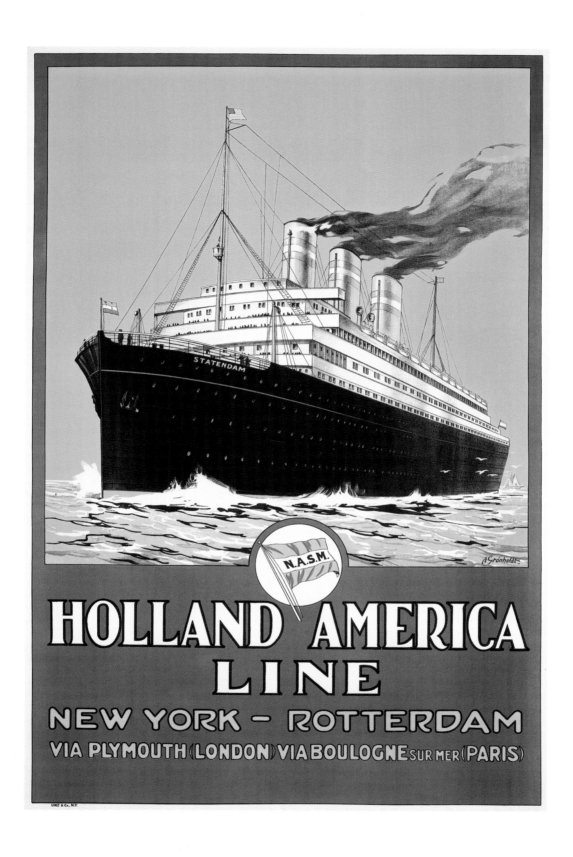

'For Real Comfort: *New Statendam*',
Holland-America Line, Cassandre, 1928,
Nijgh & Van Ditmar, Rotterdam
Ship: *Statendam*
104 x 79.8cm

New York-Rotterdam, Holland-America
Line, A. Gronholdt, c.1929,
Unz & Co., New York
Ship: *Statendam*
95.4 x 62.8cm

112

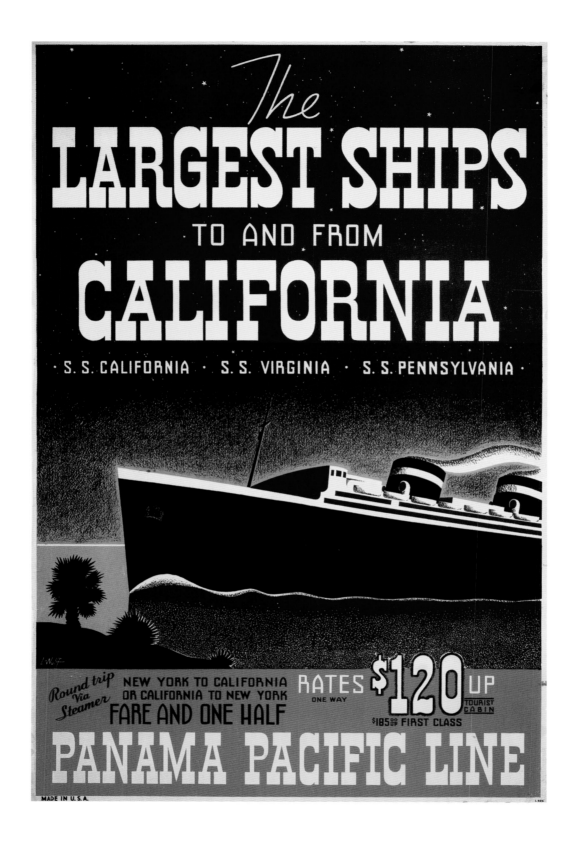

'The largest ships to and from California',
Panama Pacific Line, L. Wulff, 1929,
Printed in the United States
Ships: *California, Virginia, Pennsylvania*
95 x 62.2cm

Morocco, Senegal, Levant & Black Sea via
Marseille, Compagnie de Navigation
Paquet, Max Ponty, 1929,
Société générale de presse et d'édition,
Hachard & Cⁱᵉ, Paris
Ship: *Maréchal Lyautey*
104.6 x 73.7cm

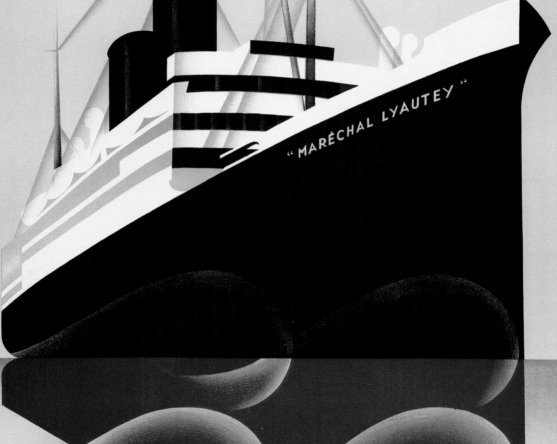

Cⁱᵉ DE NAVIGATION PAQUET

"MARÉCHAL LYAUTEY"

MAROC
SÉNÉGAL
LEVANT &
MER NOIRE
PAR MARSEILLE

M PONTY

113

114

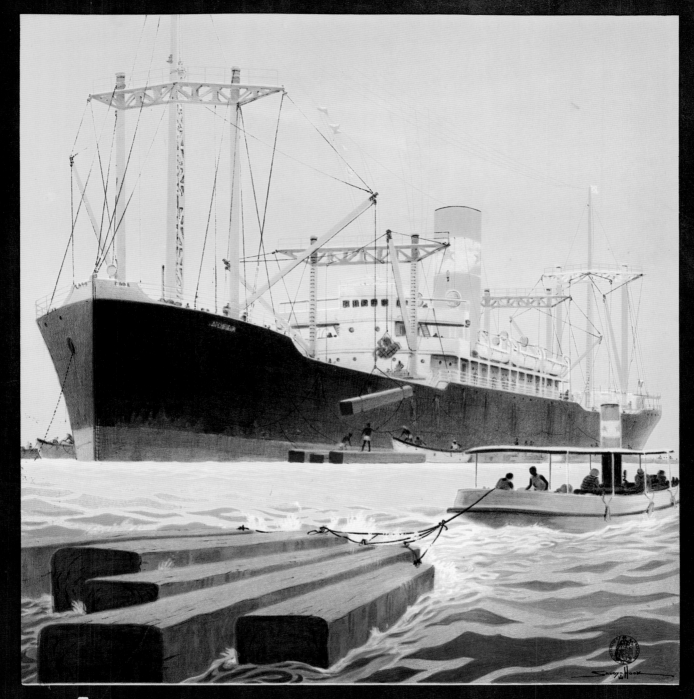

CHARGEURS RÉUNIS

CÔTE OCCIDENTALE D'AFRIQUE

N.R.MONEY_6,Rue de Madrid.PARIS

The Thirties: The Great Age of Ocean Liners

Brazil-Plata-Central America-Algeria,
Société générale des transports maritimes à
vapeur, Albert Sebille, 1930,
Printing Omer Henry, Paris
Ship: *Mendoza*
80 x 58.2cm

West African Coast,
Chargeurs Réunis, Sandy Hook, 1930,
N.R. Money, Paris
Ship: *Adrar*
103.2 x 73.5cm

From 1930 onwards, ocean liner interiors gradually developed away from the revivalism of the earlier twentieth century towards a more modern and self-consciously contemporary style. The same was true of poster design, with the smooth, sleek lines pioneered by designers such as Cassandre becoming the norm for most of this decade. Ships of this period were frequently a blend of Modernism, Art Deco and streamlining with touches of humour and wit, luxury and glamour. As a result of the decline in emigration to North America and the concurrent rise in the popularity of cruising, liner design began to feature permeable divisions between outside and inside, and also between different classes. Beginning with the German *Bremen*, moving through the French *Normandie* and British *Queen Mary*, there was a quest to use designers on behalf of the line owners to express national identities to the world and create the most appealing and fashionable surroundings for travel and leisure in an increasingly competitive market. This was the decade when design and glamour reached its zenith. By the late 1930s, America and Europe had recovered from the Great Depression. However, the storm clouds which were to cause the outbreak of the Second World War were starting to gather, and neither travel by ocean liner or life in general would never be the same again.

The Chargeurs Reunis built the *Adar* in 1920 at St Nazaire for its route to Africa. In 1935, the ship was run aground near Ambun Island, Germany (p.114). The Societe Generale de Transports Maritime a Vapeur built the *Mendoza* in the same year at Tyneside in England (p.115). She sailed from Marseilles to Buenos Aires during the 1920s and 1930s, but was torpedoed by a German submarine in 1942 whilst in service to the British as the *Sassam*.

The East Asiatic Company was founded in 1897 in Copenhagen to offer services from Copenhagen to Bangkok and the Far East. Subsidiary companies offered travel to the Baltic, the Black Sea and the Far East, South Africa and North America. The *Boringia, Erria, Jutlandia, Selendia, Lalandia, Meonia* and *Alsia* were introduced by the company in the later 1920s and 1930s for its vast array of routes. The different destinations form an unusual border to the first poster (p.120). Another poster for the same company contrasts a tawdry junk with the sleek lines of one of East Asiatic Company's new ocean liners (p.121).

The roots of the Italian Cosulich Line lay in the Unione Austriaca Company, which was founded in Trieste in 1903, when it was still part of the Austro-Hungarian Empire. The company ran passenger services from Trieste to Messina, Naples, Palermo and New York from 1904. Just before the First World War the Unione Austriaca Company provided sailings from Trieste to Canada. The company did not operate during the War, and then in 1918 Trieste became part of Italy and the firm was renamed the Cosulich Line, which operated lines from the Mediterranean ports to New York and South America. In this poster, a Native American is pictured as he catches sight of a Cosulich Line ship, either the *Saturnia* or *Vulcania* (p.122). The two ships were introduced in 1928 and were modestly sized at 23,346 and 24,496 tons

115

'To South America',
Hamburg-Amerika Line,
R. Cammann, c.1930,
Mühlmeister & Johler,
Hamburg
Ship: *General Osorio*
82.7 x 61.1cm

116

respectively, with a maximum speed of 19 knots. The interiors were designed by La Casa Artistica, including the lavish Louis XIV ballroom in white and gilt, the Grill Room in Tuscan Renaissance style and the extravagant Pompeian swimming pool.

Germany's North German Lloyd resurrected itself during this decade. The company built two huge liners, the *Bremen* and the *Europa*, which took the Blue Riband from the British Aquitania in 1929 (pp.123-127). At 51,656 gross tons and over 1000ft in length, the ships matched the size of Germany's pre-war giants. The posters emphasise this might, with one boasting of the two '*Grossbauten*', another advertising the 'Fastest Service to New York' and a third reading 'Schnellster Dienst der Welt'. The posters are also modern in style, as were the interiors. The First Class interiors of the *Bremen* were designed by Fritz August Breuhaus de Groot. A modern architect, De Groot reflected the new republican sense of German national identity in his designs, which rejected the past and historical styles. Compared to German liners of the past, the *Bremen* and *Europa* were sleek and uncluttered in their interior design. The interiors of the *Europa* were designed by classical architect, Ludwig Troost, and were in similarly classical modern style, building on the success of his designs for the *Columbus* of 1914.

Even more fantastically abstract are the two posters for the Hamburg-American Line, featuring the *Albert Ballin*, *Deutschland*, *Hamburg* and *New York* (pp.4, 128, 129 and 143). The *St Louis* undertook her maiden voyage from Hamburg to Bologne, Southampton and New York in 1929 and the *Milwaukee* in the same year (p.129). The *General Osorio* served on the Hamburg-American route from 1929, before being transferred to the Hamburg-South America Line in 1936 (p.116).

C.G.T. French had launched the 45,153 ton *Île de France* in 1927 and it was a floating symphony of Art Deco (p.131). The most famous French designers, who had been involved with the 1925 Exposition des Arts Décoratifs et Modernes, contributed to France's new national symbol of modernity. There were 439 First Class cabins, each uniquely created in a signature style. This was chic, luxury and glamour afloat.

The tea salon on the promenade deck was designed by Emile-Jacques Ruhlmann in white ash and silvered bronze panelling, with a white ceiling and lighting which was concealed in six large white Sèvres vases. The red curtains were designed by Ruhlmann to blend with the red and grey carpet and upholstered furniture in grey. Raymond Subes designed an immense octagonal mirror which was placed at the top of the grand staircase, reflecting the whole of the tea room. A large lounge was also placed on the promenade deck and was designed by the Compagnie des Artistes Francais, directed by Louis Süe and André Mare. The coffered ceilings were supported by groups of deep red columns, with concealed lighting hidden behind the gilded mouldings and roses. The sumptuous Art Deco chairs were upholstered in Aubusson tapestry and there was also an Aubusson carpet.

The First Class dining room by Pierre Patout was rather more restrained – it was faced in grey Pyrenees marble and illuminated by 110 Lalique lamps in amber glass.

The dining saloon could seat 700 on distinctive sycamore chairs which were upholstered with Veronese green wool in adventurous, Art Deco patterns. The floor was made from highly polished India rubber and at the centre of the room was a faux fountain, constructed from illuminated chrome tubes. The *Île de France* was a fantastic success for the French, and was regarded as the most glamorous liner of the 1920s and early 1930s, with little competition emanating from Germany or Britain at this time. The aspiration to attract the American traveller was also fulfilled, with passengers including Greta Garbo and Ernest Hemmingway choosing to cross the Atlantic by means of the French liner.

Rotterdam Lloyd launched the *Balorean* in 1930, offering a service to the Mediterranean, Egypt, Ceylon, Java and Australia (p.132). The poster by J.A.W. van Stein is an uncluttered, modern representation of the ship, with its angular reflection in the water, framed by palm trees.

The *Orazio* and *Virgilio* were introduced by the Navigazione Generale Italiana in 1927 and 1926 respectively (p.130). They sailed on the route from Genoa and Palmero to Central America and the South Pacific. Another Italian shipping company, Lloyd Triestino, which had been Austrian before the First World War, but, like the Cosulich Line, was repatriated to Italy in 1918. The company provided links from the Mediterranean to India, the Far East and Africa on ships like the *Victoria*, which was introduced in 1931 (p.133). The poster refers to the destination of Egypt, with the liner providing welcome comfort from the rather threatening abstract sculpture. The French company, Compagnie de Navigation Sud-Atlantique, and this striking Cassandre poster celebrate the new liner, *l'Atlantique* on its journey to South America (p.135).

The Union-Castle Line was created in 1900 by the merger of the Union Steamship Company and the Castle Mail Packet Company. In 1912, it was taken over the Royal Mail group, but due to the financial collapse of the Group in 1931, Union-Castle did not really recover until after the Second World War. Union-Castle specialised in travel to Africa, on ships (all named after castles) such as the *Durban Castle*, *Carnavon Castle*, *Winchester Castle* and *Warwick Castle* (p.117).

The Hamburg-Sud company provided voyages from Germany to South America. The *Monte Rosa*, introduced in 1931, is depicted here against a dark and sultry night, being loaded for the trip back to Germany (p.134).

The Italia Line was created by Mussolini in 1932 following a merger of Navigazione Generale Italiana (N.G.I.), Lloyd Sabaudo and the Cosulich lines. This was part of Mussolini's strategy to modernise and centralise Italian industry and transport, and design played a vital role in this change. The *Rex* had been started by N.G.I., but it became the first new ship of the Italia Line when it was launched in 1932 and the *Conte di Savoia* joined the fleet from Lloyd Sabaudo (pp.136, 137). The *Rex* won the Blue Riband in 1933, travelling at an average speed of 28.92 knots on the westward journey. The interiors of the *Rex* were traditional in style, mainly by Studio

Union-Castle Line, Odin Rosenvinge,
c.1931, printed in England
Ships: *Durban Castle, Carnavon Castle,*
Winchester Castle, Warwick Castle
100.8 x 63.6cm

Ducrot of Palmero. The *Conte di Savoia* had more contemporary interiors, designed by Gustavo Pulitzer who had studied in Germany and admired the pared down look of the *Bremen*'s public rooms. This new, modern image of the Italia Line is also reflected in the posters for the company.

The White Star Line continued to run a service on the route from Liverpool to New York throughout the 1930s using the *Majestic*, which was the repatriated *Bismarck*, and the pre-war *Olympic* (p.138). It was the world's largest liner, but not the fastest or the most stylish, as reflected in this rather dated poster.

The *Neuptunia* was built for the Cosulich Line, but when it was launched in 1932, the company had been merged into the Italia Line, although they maintained their own management. The ship sailed from Trieste to New York and South America (p.139).

The United States Lines continued to offer voyages from New York to Europe throughout the 1930s (pp.9 and 142). The *Manhattan* joined the service in 1931. She was a 24,289 gross ton ship, with an overall length of 705 feet. Interestingly, America was the nation which pioneered the dissolution of the class divisions onboard liners and cruise ships. The *Manhattan* had accommodation for 582 Cabin Class, 461 Tourist Class and 196 Third Class passengers. Her maiden voyage was from New York to Cobh, Plymouth, Le Havre, Hamburg and Southampton. The *Washington* was the sister ship, and was launched in 1933.

Whilst great stylistic innovations were being made in the design of French, German and Italian ships, Britain struggled to compete. Canadian Pacific's monster *Empress of Britain*, introduced in 1931, was 42,348 tons and the largest ship the line had commissioned for travel from Britain to the St Lawrence region. The exterior styling of the ship was striking, painted all white with three buff colour funnels and elegant cruiser stern (pp.140-141). The design of the interiors reflected British attitudes to Modernism, which was not as all-embracing as those encountered in Germany. The *Empress of Britain* was designed to carry three classes of passenger: 465 in First, 260 in Tourist and 470 in Third Class on a total of eight decks. In an attempt to emulate the success of the *Île de France*, Canadian Pacific used a galaxy of quintessentially British artists for the decoration of the First Class public rooms. James Lavery, the society portrait painter designed the First Class ballroom (or Empress Room) with its silvered classical pilasters and rose-coloured ostrich plumes. The quixotic Knickerbocker Bar was a tiny space, which could seat twenty-one people and had a semi-circular bar with bar stools. The walls and ceiling were decorated by British illustrator, W. Heath Robinson, who made an amusing mural illustrating the Legend of the Cocktail. Despite the investment made by Canadian Pacific, the *Empress of Britain* was never a great commercial success, but the interiors did demonstrate a British willingness to embrace contemporary design and add a touch of whimsy and fantasy to the ship's interior.

One of the largest shipping lines in the world, Nippon Yusen Kaisha (N.Y.K.) was

founded in 1885 from the merger of Mitsubishi Shokai with Kyodo Unyu Kaisha. The company expanded quickly, initially in the Far East, and in 1899 introduced a liner service between Japan and London. Later services were expanded to South America, Batavia, Australia, New Zealand, South Africa, the USA and Canada. The *Chichibu Maru* was introduced to the fleet in 1930, her speed being emphasised in this poster (p.144).

One poster for United States Lines is unusual as it does not represent a ship, but simply the open sea and the wash of a vessel which was so speedy that the artist missed it and all that was left was the disturbed water and a plume of steam (p.145). The East Asiatic Company also had an abstract poster, although this did feature a ship, with the wash of the sea being represented by two triangular beams (p.146). The *Amerika, Europa* and *Canada* served the North Pacific route during the 1930s.

Cunard White Star introduced a new *Britannic* in 1930 to serve the route between Liverpool and New York (p.147). The company merged with Cunard in 1934 when the Royal Mail Group collapsed, and became known as Cunard White Star.

Perhaps the best know luxury liner was the C.G.T. *Normandie*, represented here in the famous image by Cassandre (p.149). Capitalising on French *haut décor* C.G.T. employed the full range of French designers and decorators who had been officially supported at the 1925 Paris exhibition to reinforce French national identity. The contract between the French government and C.G.T. stipulated that the new ship 'had to be not less than equal to the best foreign ship in commission or under construction.' (pp.119 and 148-151) The cost of the subsidy from the French government for the construction of the Normandie was more than $60 million. At a gross tonnage of 82,799, this major liner was only surpassed in size by Cunard's *Queen Elizabeth*, at 83,673 gross tons in 1940. The *Normandie* also succeeded in winning the Blue Riband from the *Rex*, making the crossing in 4 days, 3 hours and 14 minutes in May 1935. The ship was designed to carry 750 Cabin Class, 625 Tourist Class and 340 Third Class, with First Class in greater numbers than the other two classes in order to emphasize the ship's luxurious status. This was a party ship, with the emphasis being on artificial lighting rather than natural, dinner rather than *petit dejeuner*, lounging and people watching as opposed to healthy, outdoor pursuits. Even the garden was glamorous; it was inside the ship and included exotic caged birds.

The design work was co-ordinated by two pairs of architects, appointed by CGT in October 1931. The first pair consisted of Pierre Patout and Henri Pacon who had both worked on the interiors of the *Île de France*. They worked on the main entrance hall and dining room, also providing general schemes for the chapel, swimming pool and stairways. The second duo consisted of Roger-Henri Expert and Richard Bouwens van de Boïjen, the latter having a long association with the line; they oversaw the design of the promenade deck.

The most striking features of the *Normandie*'s interior layout were the massive public spaces created by the decision to divide the uptakes from the engines to the

Cunard White Star, Scato, 1935,
Printing Cope, Chatou
Ship: *Queen Mary*
100 x 66.5cm

118

funnels. Hence, the dining room on Deck C, the image of which has become emblematic of the ship, was 305ft long, 46ft wide, 25ft high and could seat 750 people at once. Designed by Patou and Pacon, there was no natural lighting, but the artificial lighting was the aspect of the interior design which made the room so remarkable and enhanced the cathedral-like dimensions. There were 12 luminescent standard lights in an Art Deco design by René Lalique, the effect of which was accentuated by the full-length embossed cast-glass panels behind. More light was provided by the 38 vertical wall lights, which measured 16ft in height. Further illumination came from the two ceiling chandeliers. Constructed from plaster of Paris and treated in gold with indirect lighting inside, the coffered ceiling of the room added to the grandiose feeling, as did the total symmetry of the room.

The smoking room was another daring use of space, as it was traditionally the place for the male passengers to retire after dinner, whilst the women would gather elsewhere, usually the ladies' drawing room or the writing room. This break with tradition was underlined by the fact that First Class passengers had to walk through the smoking room to reach the grand saloon beyond. Bouwens van de Boïjen had known the leading French lacquerist, Jean Dunand since 1914 and asked him to design the interior of the smoking room and of parts of the grand saloon. Dunand submitted several schemes to the architects, but they were rejected for being too innovative, and so he opted to produce a set of gold-lacquer panels in an 'Egyptian' style; these have recently been restored and displayed at the Metropolitan Museum, New York. Each panel was 6m (19ft 6in) high and 5.80m (18ft 9in) across.

The *Normandie* was the apogee of French *haut décor* and for the interiors of the ship, the emphasis was on glamour and comfort. First Class passengers could escape from the outdoors and remain cosseted in the air conditioned restaurant with no view of the sea. As with the majority of ocean liners at this time, the aim was to protect the passenger from the dangers of the sea on the outside, whilst shielding them from the Second and Third Class passengers on the inside.

The *Queen Mary* was designed in direct repost to the art deco splendors of the *Normandie* and to regain the Blue Riband for Britain and for Cunard White Star (pp.118, 152, 153, 154 and 155). As such, Cunard White Star attempted to emulate the success of the showcase interior design of the *Normandie*, but lacked the cachet of French Art Deco. There were no architects in overall charge of the ship's design, as there had been with the *Normandie*, and so there was a lack of design vision from the very beginning. The architect selected for this challenging project was Arthur Davis, who had designed the interiors of the *Aquitania* for Cunard before the First World War and the American, B.W. Morris, overseen by the Cunard Board. The *Queen Mary* was launched in September 1934 and transferred to the dock for fitting out; this was when conflict over the decoration of the ship began between Cunard and the architects.

The ship finally joined Cunard White Star Line's service in May 1936 and won the Blue Riband from the *Normandie* on its sixth round trip in August, traversing the Atlantic from New York to the coast of England in 3 days, 25 hours and 57 minutes. Therefore, one of the government and Cunard's main ambitions was realised. The ship represented a country which could achieve impressive technical feats, with the construction of a ship which measured over 1,000ft with a gross tonnage of 80,733 and world beating engines capable of achieving the phenomenal speed of 28.5 knots. The efficiency of the *Queen Mary* also helped to realise Cunard White Star's ambition of offering a transatlantic service with just two ships, rather than the three that currently offered a service: *Aquitania*, *Mauritania* and *Berengaria*. The ship's interior decoration represented a blend of Art Deco, Modernism and traditional British whimsy.

Previously, British liners had plundered the past to roll out a display inspired by tradition and achievement. The *Queen Mary* was the first Cunard ship not to employ past styles, and marked an attempt to represent the nation with woods from the British Empire and a mixture of American Art Deco with homely or lyrical British touches.

The ship was designed to carry three classes of passenger: First Class was replaced by the new Cabin Class, the equivalent of Second Class was the Tourist Class, and then Third Class remained the same. Although the names had changed, all three classes were kept rigidly apart, as had always been the case with the interior arrangements of ocean liners. Cabin Class occupied the premium parts of the ship with 421 Cabin Class suites. On the very top deck, or sun deck, at the stern of the ship was an area for games with the exclusive Verandah Grill looking out onto it, the decks below and the ocean beyond. This served as the *Queen Mary*'s à la carte restaurant, cocktail bar and nightclub, for which advance booking was required, as well as an extra charge of £1. It was a small space, only 29ft wide and 70ft wide, but the sweep of twenty-two windows on three sides of the room, added a sense of spaciousness.

The *Queen Mary* has remained a popular liner, undertaking sterling service as a troop ship during the Second World War, and only being withdrawn from Cunard White Star's service in 1967, destined to sail to Long Beach, California where it still functions as a hotel and conference venue.

The *Nieuw Amsterdam* was a successful modern design for a national flagship ocean liner (p.157). The interiors were designed by a galaxy of modern Dutch architects and designers, including J.J.P. Oud of the De Stijl movement. The ship was built in Holland with generous subsidies from the Dutch government. At 36,287 gross tons this was the largest ship to be built in Rotterdam at that date, and could accommodate 1,232 passengers in Cabin, Tourist and Third Class; the 568 passengers in Cabin Class all enjoyed en suite facilities – it was the first time that this was offered on a trans Atlantic service.

The *Gripsholm* was built by the Swedish American Line, founded in 1918, to

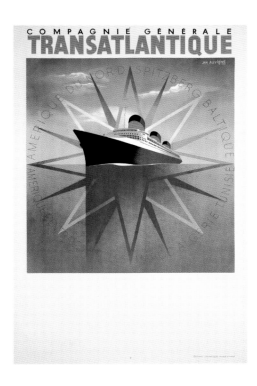

Compagnie Générale Transatlantique,
Jean Auvigne, 1937,
éditions l'Atlantique
Ship: *Normandie*
101 x 67.2cm

provide voyages between Gothenburg and New York (p.156). The ship was introduced in 1925 – she was modestly sized, at 18,815 tons, and was powered by a motor rather than steam.

The Compagnie Maritime Belge was founded in 1895 as the Compagnie Maritime Belge du Congo to operate passenger and cargo services to the Belgian Congo. Until 1930, routes were confined to the Belgium–Congo service, but in 1930 the company was taken over and the name was changed to Compagnie Maritime Belge (Lloyd Royal). Services then expanded to reach North and South America and the Far East. The *Albertville* was launched in 1928 and the *Leopoldville* in 1930 (p.159).

N.D.L. continued to offer voyages to the Far East, and three new ships, the *Gneisenau*, *Potsdam* and *Scharnhorst* were introduced to the route in the mid-1930s (p.158).

The little known Gdynia-America Shipping Line was formed in 1930 by the Polish Government to operate cargo and passenger services between Gdynia, Copenhagen,

Halifax and New York. A service to Rio de Janeiro, Santos, Montevideo and Buenos Aires started in 1936, as well as Mediterranean sailings between Constanza, Haifa and Istanbul. The *Pilsudski* was introduced to the service in 1935 (p.162).

The *Pretoria* and *Windhuk* (pp.160 and 161) served on the Deutsche–Afrika Line from 1936, sailing from Hamburg to Cape Town, advertised in this beautiful red, gold and white poster. The *Boringia*, *Erria*, *Jutlandia*, *Seleandia*, *Lalandia*, *Meonia* and *Alsia* were a group of new liners launched by the Copenhagen based East Asiatic Company in the late 1920s and 1930s for the Europe to North Pacific route (p.163). This abstract image of a single white ship summarises the changes in design, both for the interiors of the ships and the advertising posters. Modernism has now replaced tradition, with sleeker lines, less clutter and recourse to past styles. This was the heyday of the ocean liner. The events of the Second World War decimated many fleets, and the post–war ocean travel was very different; with the introduction of affordable air travel, the days of the ocean liner were numbered.

119

120

'Shipping and Trading',
The East Asiatic Company Ltd.,
Valdemar Larsen, c.1930,
F.E. Bording, Denmark
Ships: *Boringia, Erria, Jutlandia,*
Selandia, Lalandia, Meonia, Alsia
99.7 x 62.9cm

'Regular Passenger and Freight Service',
The East Asiatic Company Ltd., c.1930,
F.E. Bording, Denmark
Ships: *Boringia, Erria, Jutlandia,*
Selandia, Lalandia, Meonia, Alsia
99.2 x 62.7cm

122

Cosulich Line Trieste, A. Dondoli,
c.1930,
Arti Grafiche S.D. Modiano, Trieste
Ships: *Saturnia, Vulcania*
99 x 69.2cm

'Future Ships',
Norddeutscher Lloyd Bremen,
Bernd Steiner, 1929,
Wilhelm Jöntzen, Bremen
Ships: *Bremen, Europa*
132.2 x 96cm

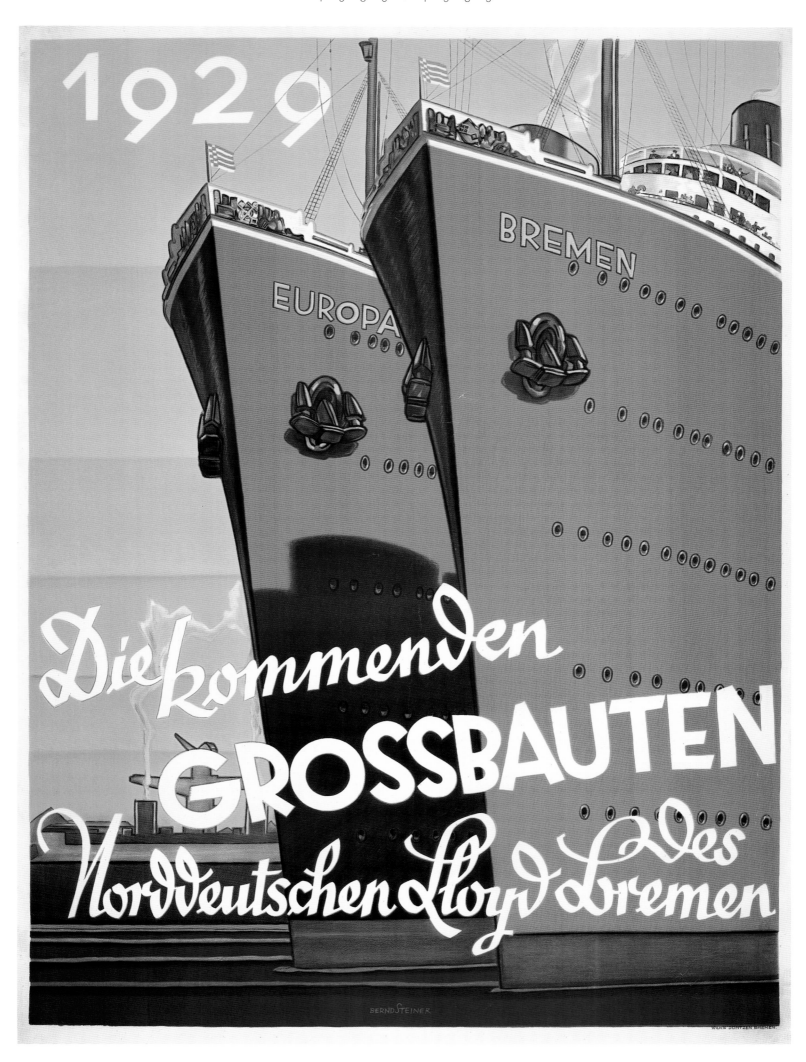

124

Bremen-New York, Norddeutscher Lloyd
Bremen, Willy Kanke, c.1930,
printed in Germany
Ships: *Bremen, Europa, Columbus*
84.9 x 59.7cm

'Fastest Service to New York',
Norddeutscher Lloyd Bremen,
Hugo Feldtmann, c.1930,
Wilhelm Jöntzen, Bremen
Ships: *Bremen, Europa*
101.8 x 62.5cm

126

'Bremen, Europa, Columbus',
Norddeutscher Lloyd Bremen,
Bernd Steiner, c.1930
Ship: *Bremen*
99 x 72cm

'4½ Days Across the Ocean',
Norddeutscher Lloyd Bremen, Arnold,
1939, Wilhelm Jöntzen, Bremen
Ships: *Bremen, Europa*
118 x 83cm

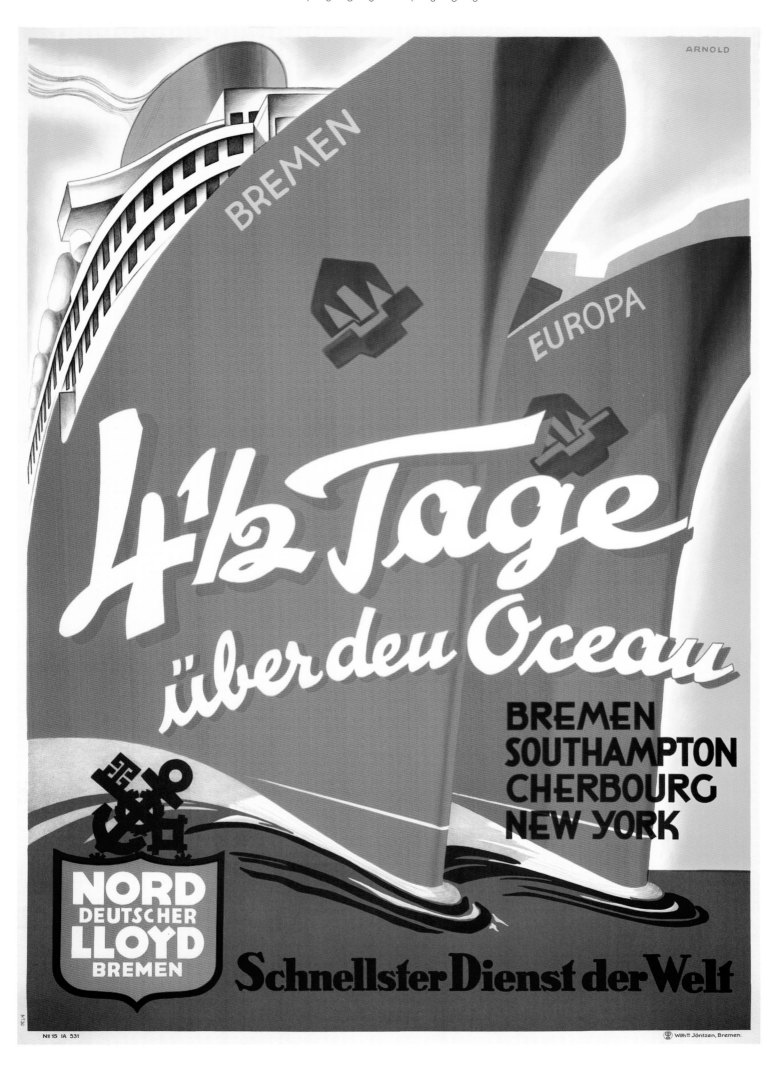

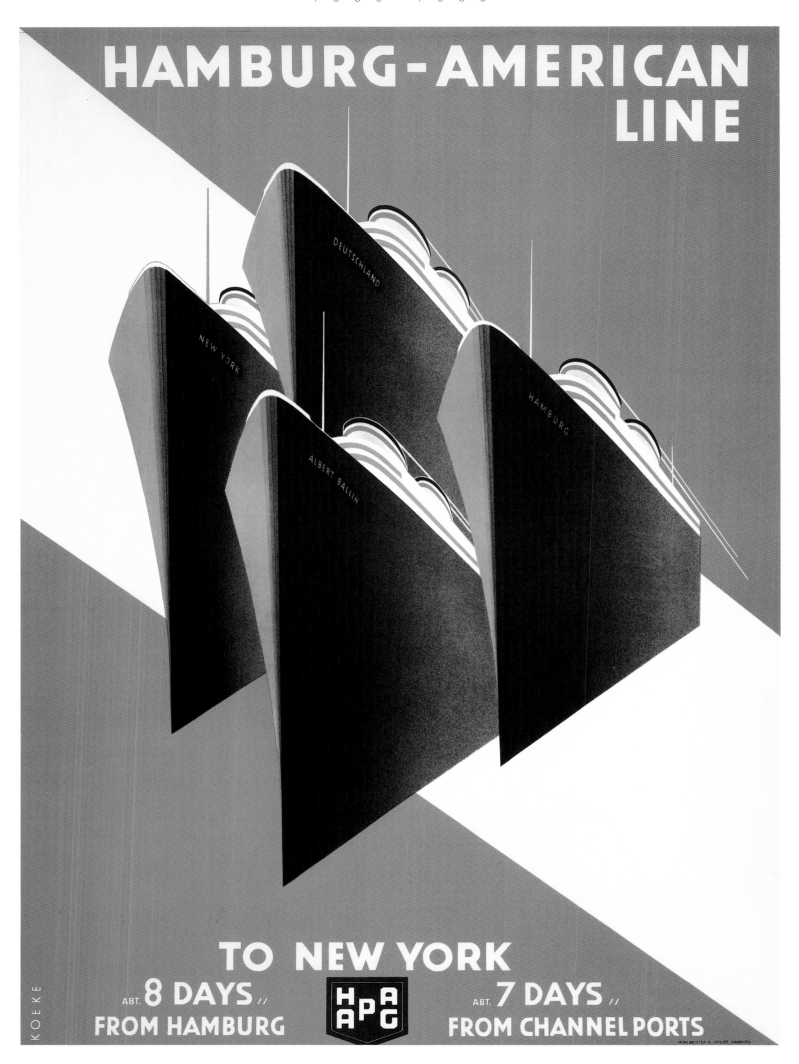

128

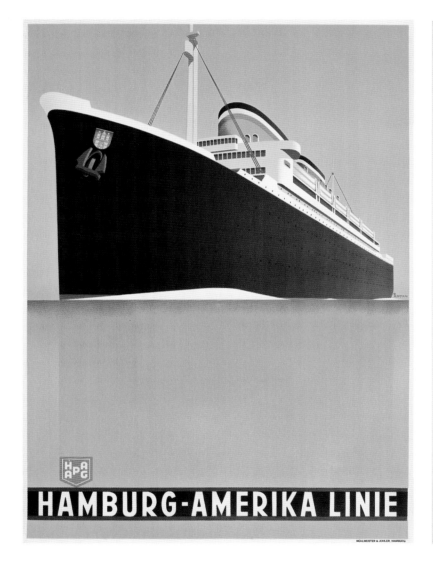

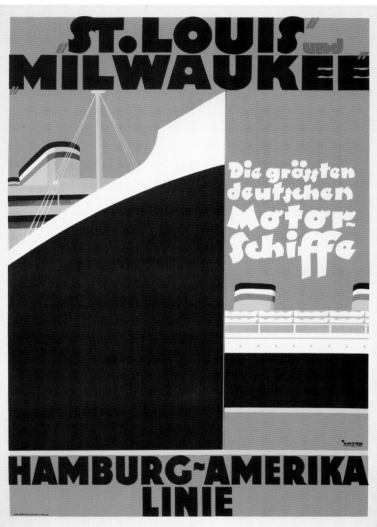

To New York, Hamburg-American Line,
Koeke, c.1930, Mühlmeister & Johler,
Hamburg
Bateaux : *Albert Ballin*, *Deutschland*,
Hamburg, *New York*
84 X 60.8cm

Hamburg-Amerika Linie,
Anton Hamburg (Ottomar Anton), c.1930,
Mühlmeister & Johler, Hamburg
Ship: one of the finest mail steamers,
the *Albert Ballin*
83.7 x 60cm

St. Louis and *Milwaukee*,
Hamburg-Amerika Linie, Anton Hamburg
(Ottomar Anton), c.1930,
Gafudruck G.M.B.H., Halle
Ships: *Saint Louis*, *Milwaukee*
85.3 x 60cm

130

'Orazio and Virgilio',
Navigazione Generale Italiana,
Boris, 1931, Edizione S.I.P., Genoa
Ships: Orazio, Virgilio
100 x 68.4cm

Le Havre-Plymouth-New York,
Compagnie Générale Transatlantique,
Albert Sebille, c.1930,
Printing Crété, Paris, Corbeil
Ship: Île-de-France
99.3 x 62.7cm

132

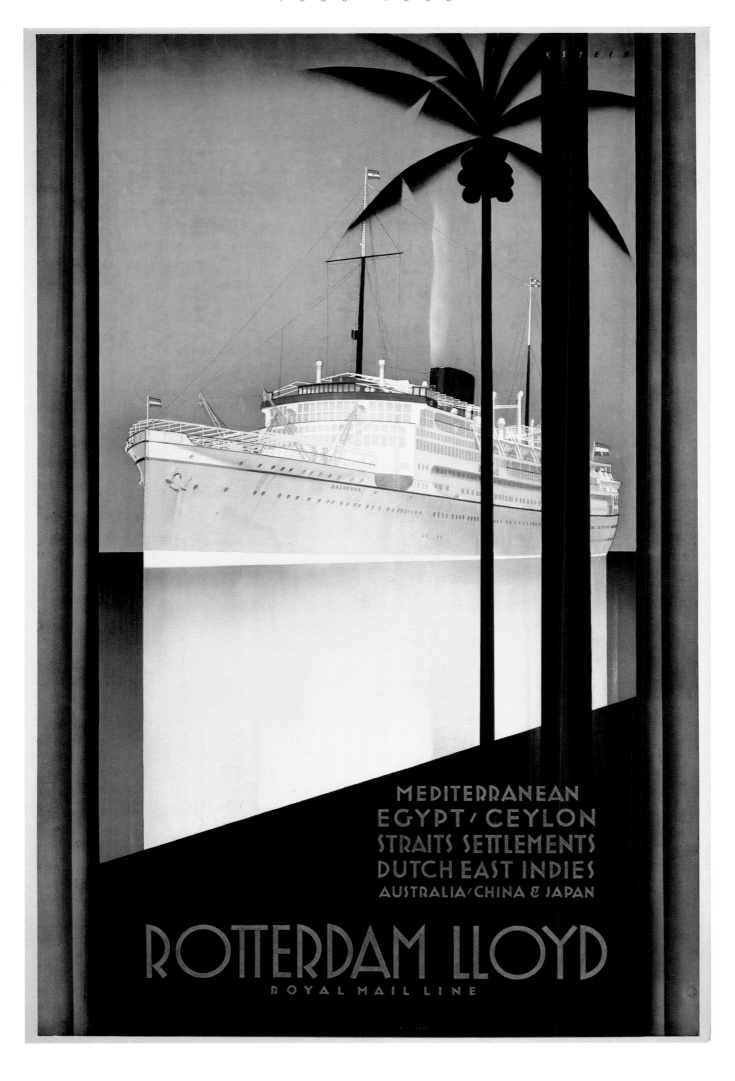

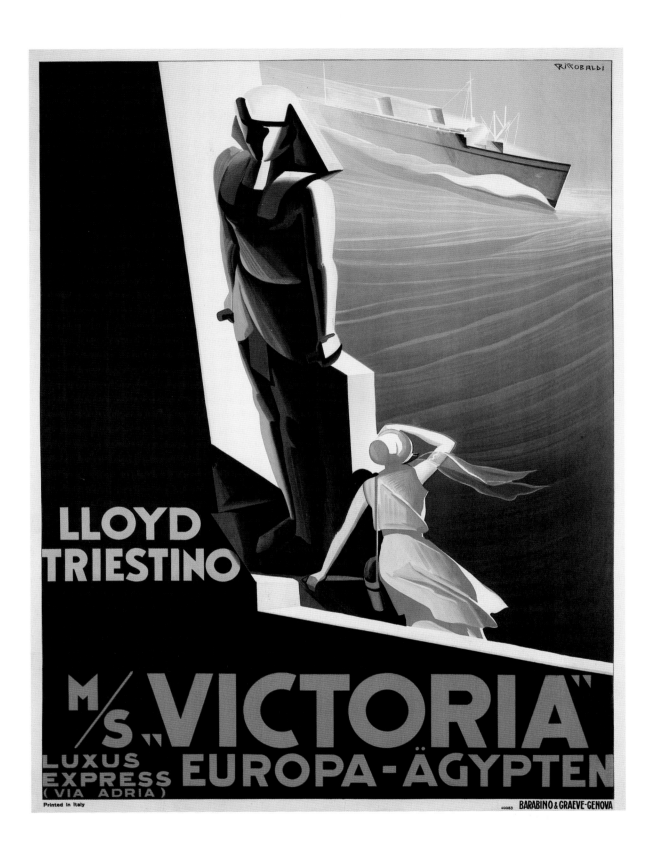

Rotterdam Lloyd, V. Stein,
1931, Hed. Rotogravure My. N.V., Leyde
Ship: *Baloeran*
73.5 x 47.9cm

Victoria, Lloyd Triestino, Riccobaldi,
1931, Barabino & Graeve, Genoa
Ship: *Victoria*
119.4 x 90.5cm
Collection Alessandro Bellenda, Galerie
L'IMAGE, Alassio

134

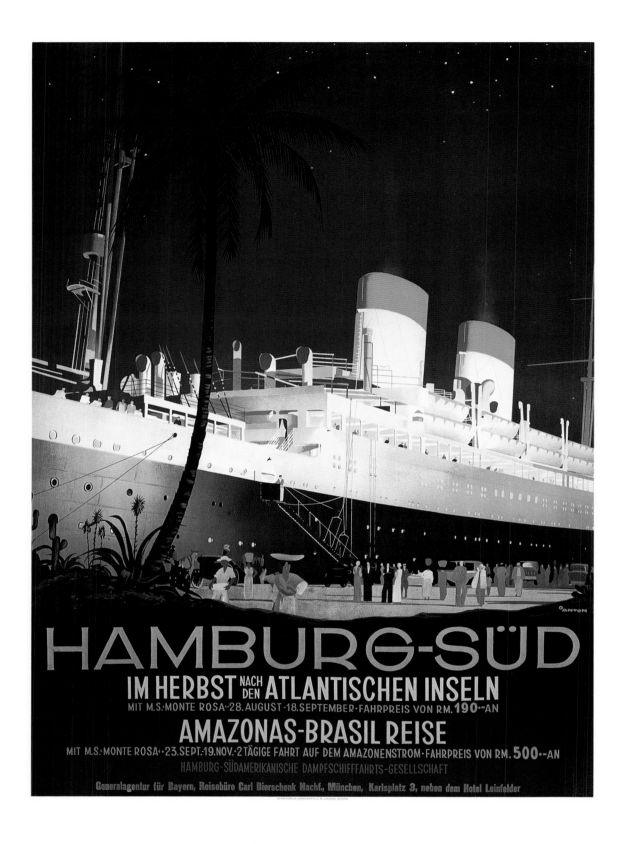

Hamburg Süd, O. Anton, c.1931
Ship: *Monte Rosa*
120 x 90cm
Collection Alessandro Bellenda, Galerie
L'IMAGE, Alassio

L'Atlantique, Compagnie de Navigation
Sud-Atlantique, Cassandre, 1931, Alliance
graphique Loupot-Cassandre, Paris
Ship: *L'Atlantique*
100.3 x 61.7cm

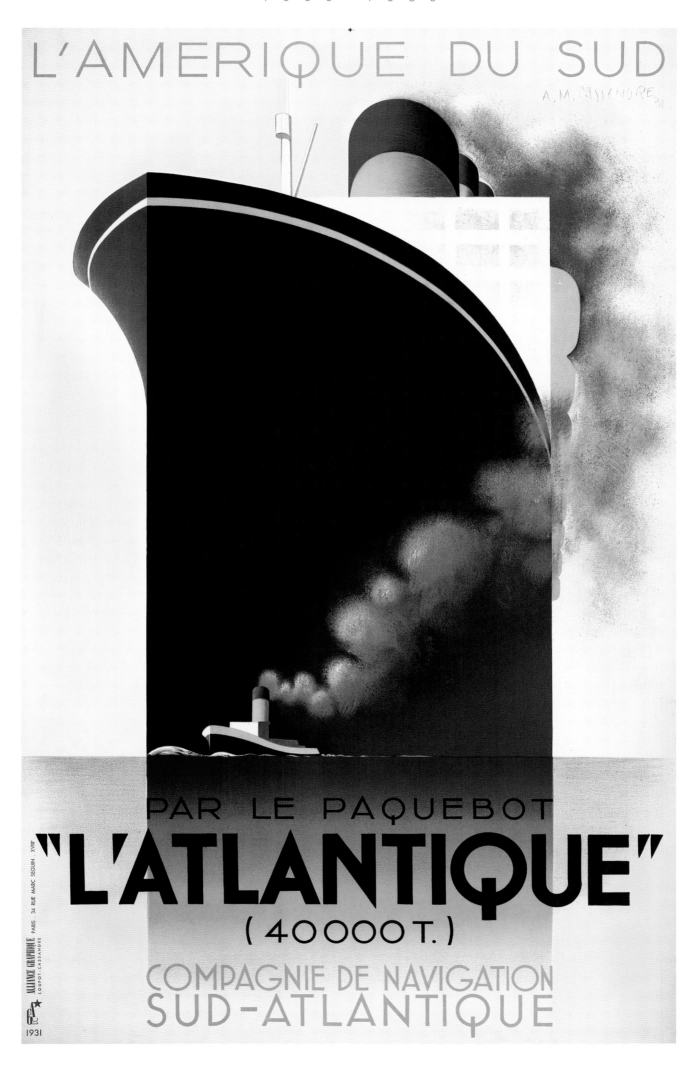

136

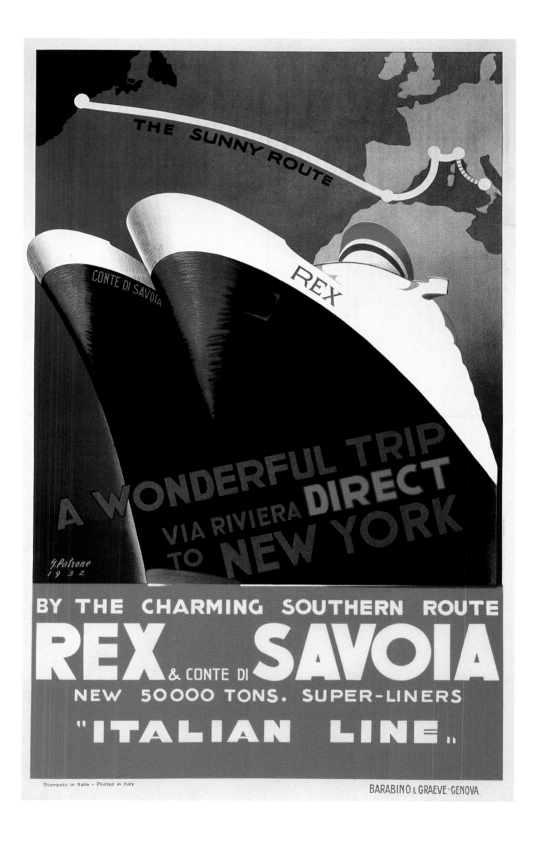

Rex & Conte di Savoia,
Italian Line, G. Patrone, 1932,
Barabino & Graeve, Genoa
Ships: Rex, Conte di Savoia
99 x 61.5cm
Collection Alessandro Bellenda, Galerie
L'IMAGE, Alassio

North America Express,
Italia-Cosulich, Italian Line, Cenni, 1935,
Barabino & Graeve, Genoa
Ship: Rex
94.5 x 63.4cm
Collection Alessandro Bellenda, Galerie
L'IMAGE, Alassio

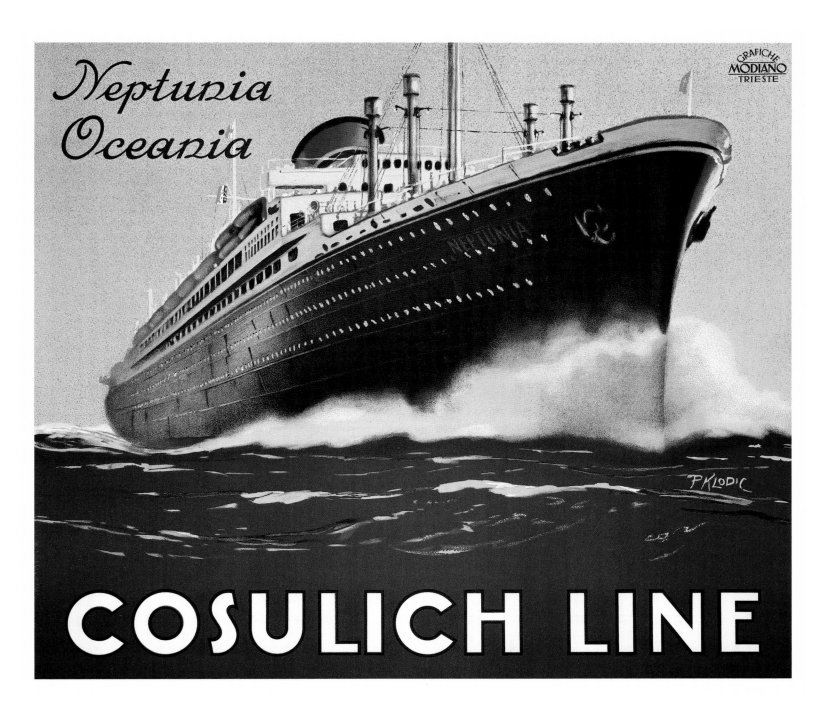

Southampton-Cherbourg-New York,
White Star Line, c.1933,
James Haworth & Bro. Ltd
Designers & Printers, London
Ship: *Majestic*
100.6 x 62cm

Neptunia, *Oceania*, Cosulich Line,
P. Klodic, c.1933, Grafiche Modiano,
Trieste
Ships: *Neptunia, Oceania*
62 x 70cm

140

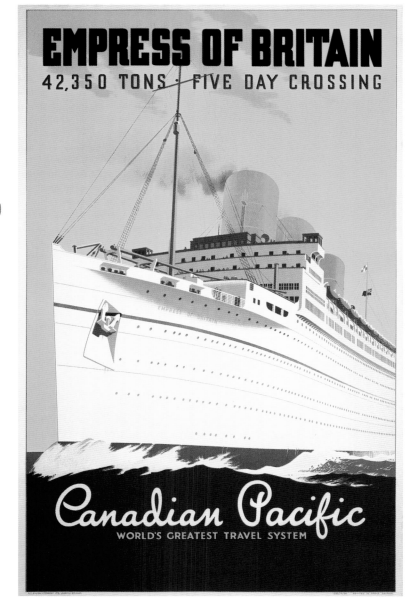

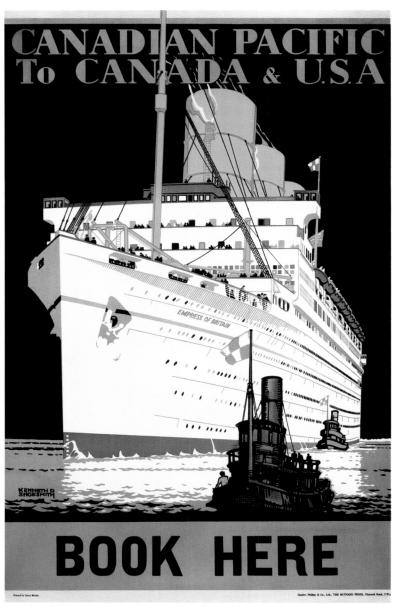

Empress of Britain, Canadian Pacific,
c.1934, S.C. Allen & Company Ltd.,
London and Belfast
101.5 x 63.4cm

'To Canada and USA',
Canadian Pacific, Kenneth D. Shoesmith,
c.1934, Sanders Phillips and Co. Ltd.,
The Baynard Press, London
Ship: *Empress of Britain*
101.3 x 63.7cm

Empress of Britain, Canadian Pacific,
c.1934, Sanders Phillips and Co. Ltd.,
The Baynard Press, London
101 x 63cm
Ship: *Empress of Britain*
Museum für Gestaltung Zürich,
Poster Collection

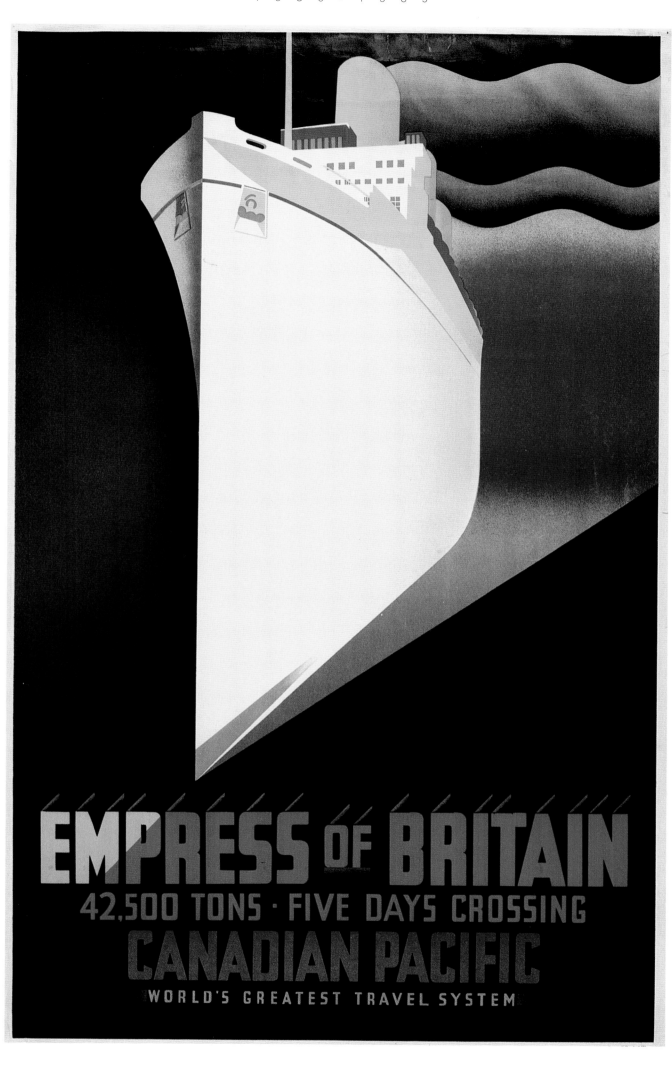

142

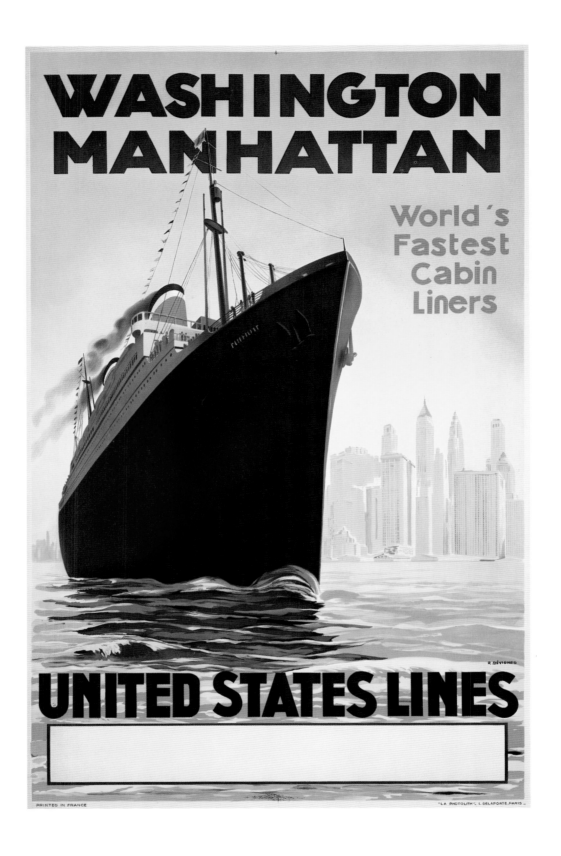

Washington, Manhattan,
United States Lines, R. Dévignes, c.1933,
Photolith. Delaporte, Paris
99.3 x 63.2cm

'To New York', Hamburg-Amerika Linie,
Albert Fuss, c.1935,
Kunst & Werbedruck G.M.B.H., Frankfurt
Ships: *Hamburg, Deutschland, New York,
Hansa*
85.3 x 59.7cm

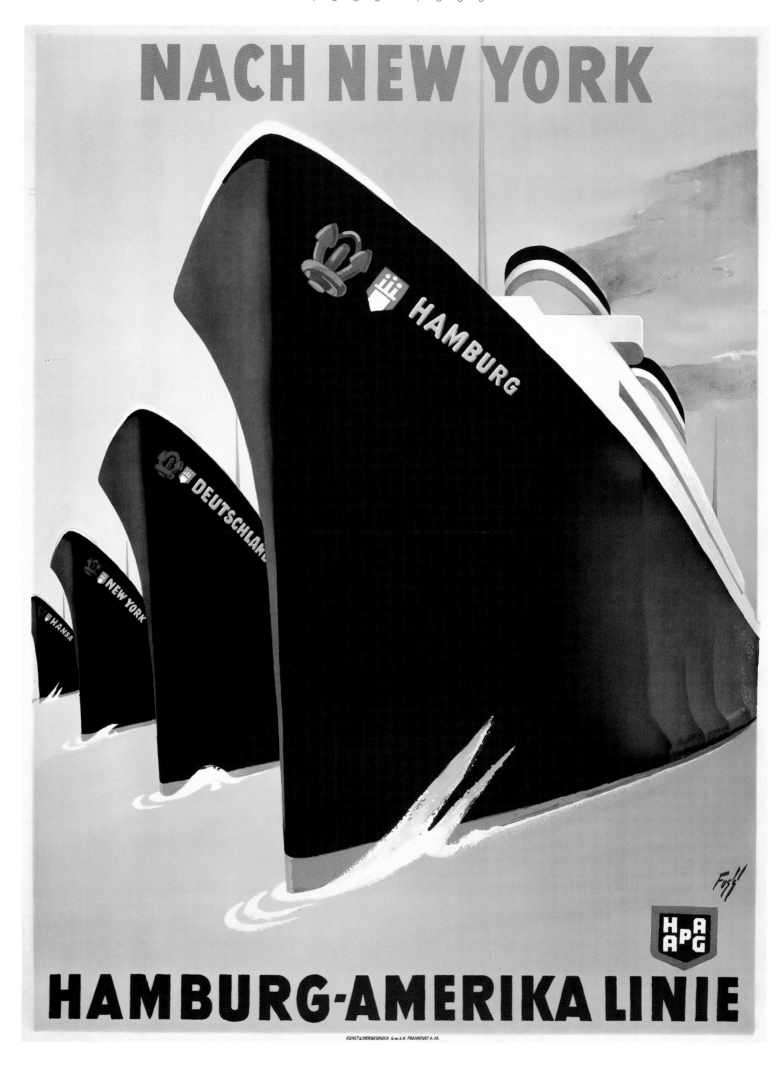

144

'Travel NYK', NYK Line, Satomi, 1935,
Kyodo Printing Co. Ltd., Japan
Ship: *Chichibu Maru*
92 x 63cm
Museum für Gestaltung Zürich,
Poster Collection

United States Lines, Edmund Maurus,
1935, Création Publix, Paris
100 x 62cm
Museum für Gestaltung Zürich,
Poster Collection

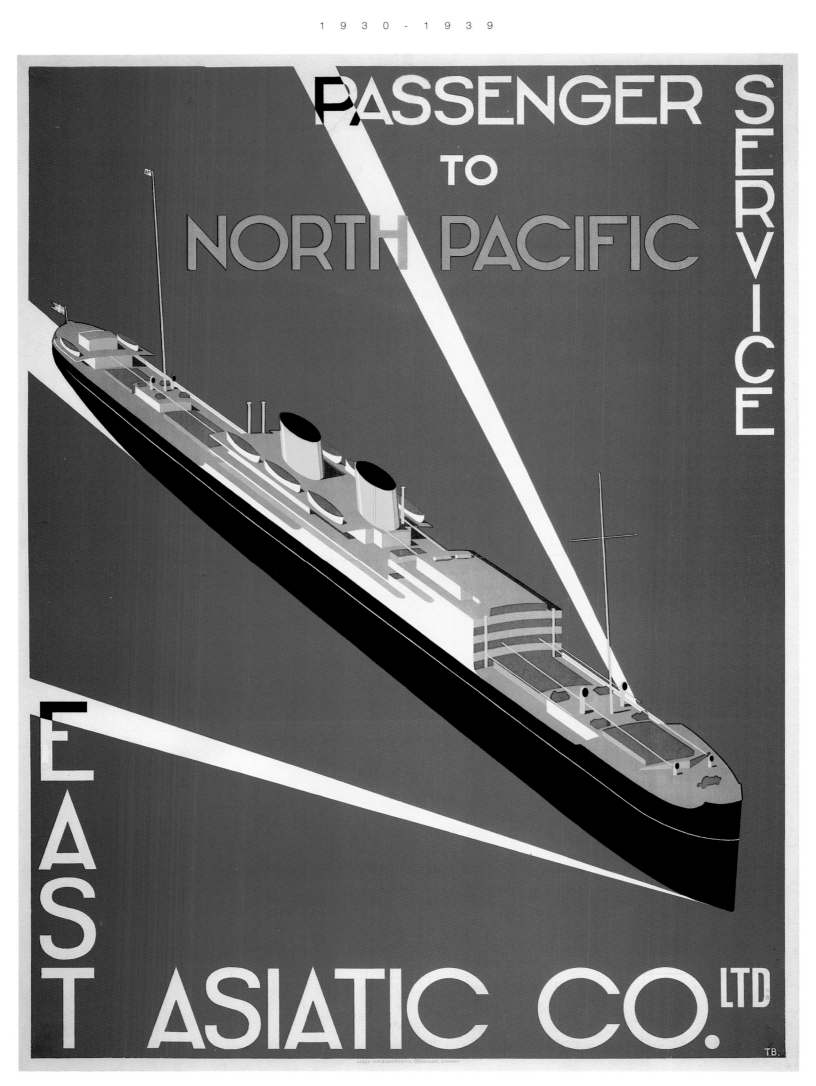

146

PASSENGER·S
TO
NORTH PACIFIC
SERVICE

EAST ASIATIC CO. LTD

TB.

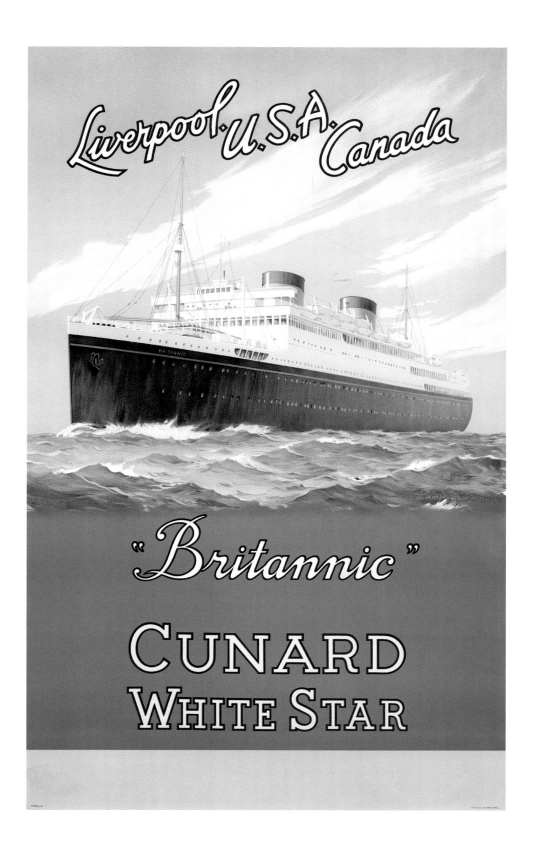

'Passenger Service to North Pacific',
East Asiatic Co. Ltd., T.B., c.1935,
Dansk Papirvarefabrik, Copenhagen
Ships: *Amerika, Europa, Canada*
84 x 62.7cm

Britannic, Cunard White Star,
Samuel M. Brown, c.1935,
printed in England
Ship: *Britannic*
100.3 x 60.5cm

'*Normandie*, Maiden Voyage,
29 May 1935', Compagnie Générale
Transatlantique, Jean Auvigne, 1935,
éditions Atlantique
Ship: *Normandie*
50.2 x 29.1cm

'*Normandie*: 60 Voyages',
Compagnie Générale Transatlantique,
Cassandre, 1935, Alliance graphique,
Paris
100.2 x 62.2cm

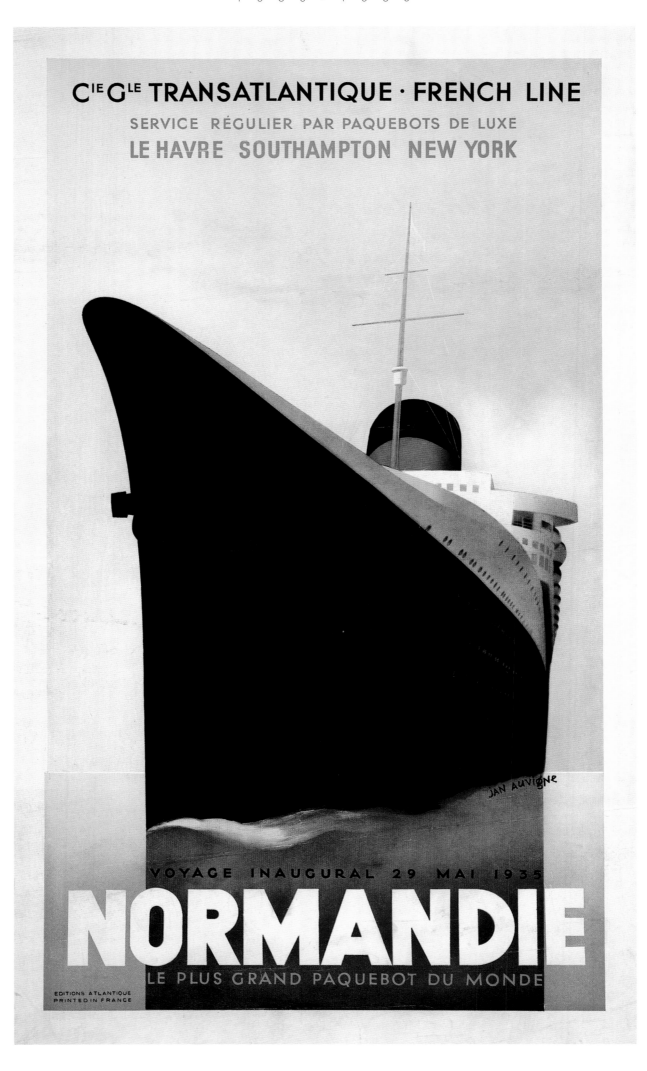

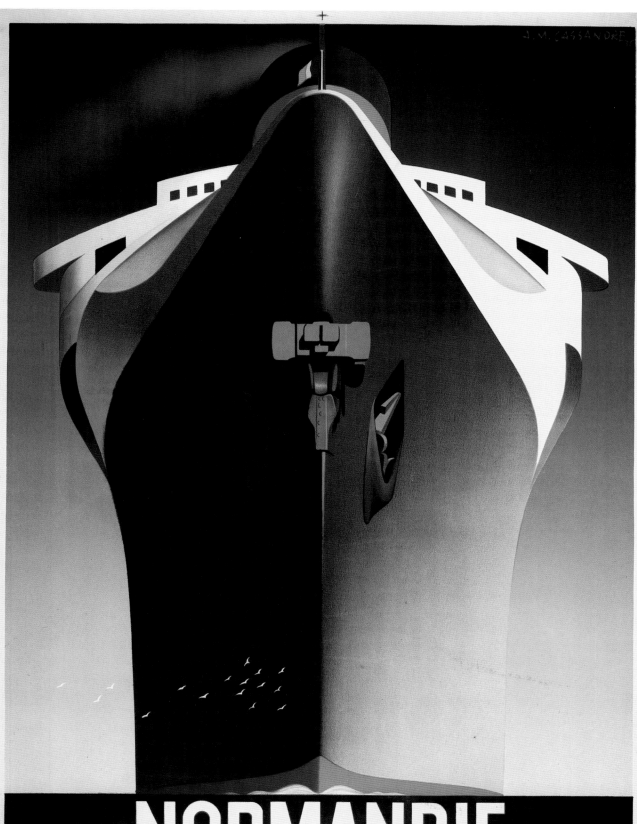

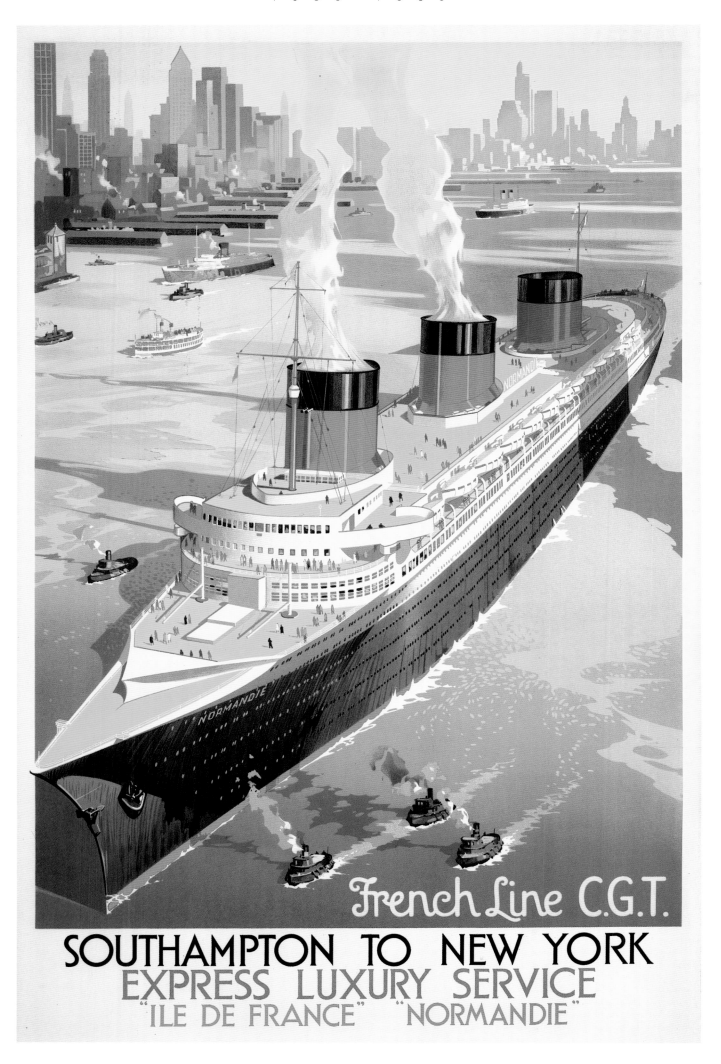

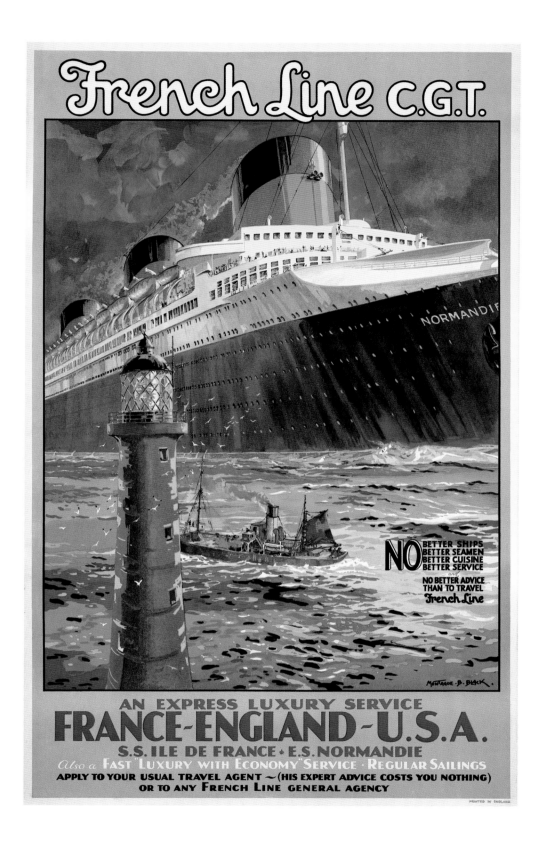

Southampton to New York,
Compagnie Générale Transatlantique,
c.1936, printed in England
Ship: *Normandie*
101.5 x 63.5cm

France-England-USA,
Compagnie Générale Transatlantique,
Montague B. Black, c.1936,
printed in England
Ship: *Normandie*
101.5 x 63.5cm

152

'R.M.S. *Queen Mary*', Cunard White Star,
Jarvis, c.1936, British Colour Printing Co.
Ltd, London and Liverpool
Ship: *Queen Mary*
95.2 x 63.8cm

Cunard White Star, Tom Curr, c.1939,
printed in England
Ship: *Queen Mary*
101 x 63.5cm

154

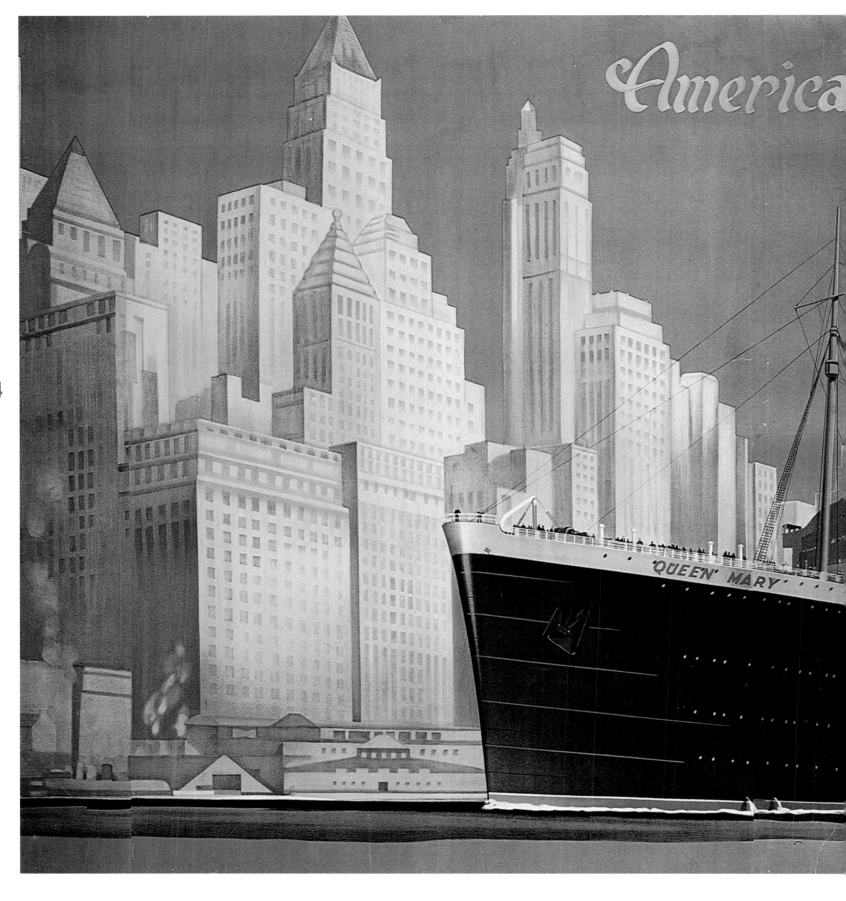

'America this year!',
Cunard White Star, 1936
Ship: *Queen Mary*
142.3 x 277.5cm
Collection Alessandro Bellenda,
Galerie L'IMAGE, Alassio

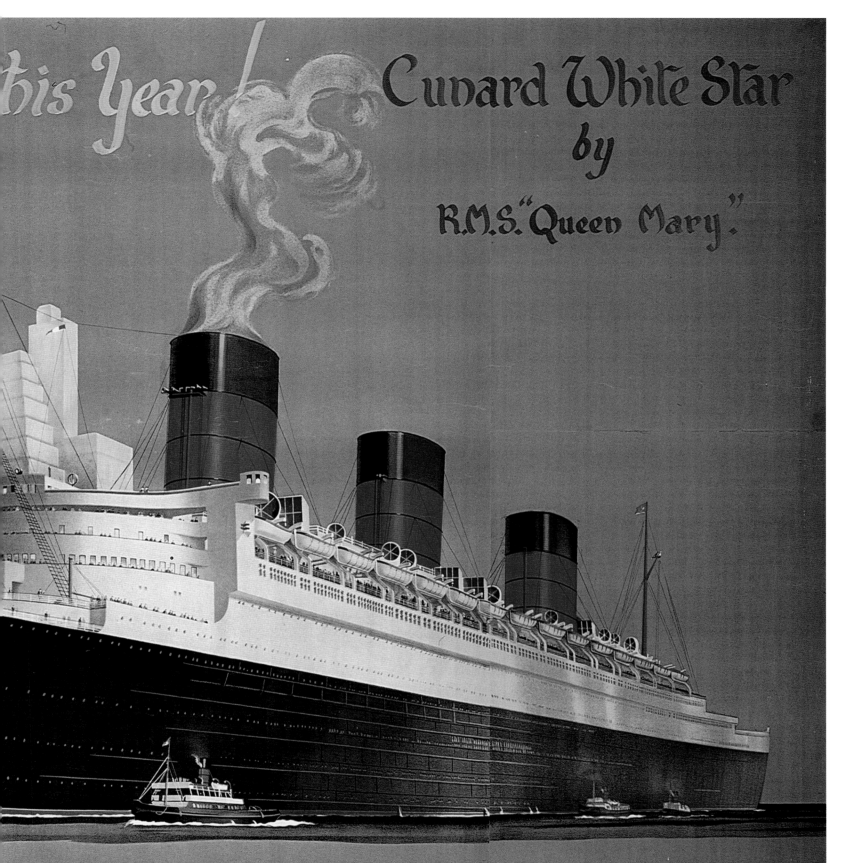

156

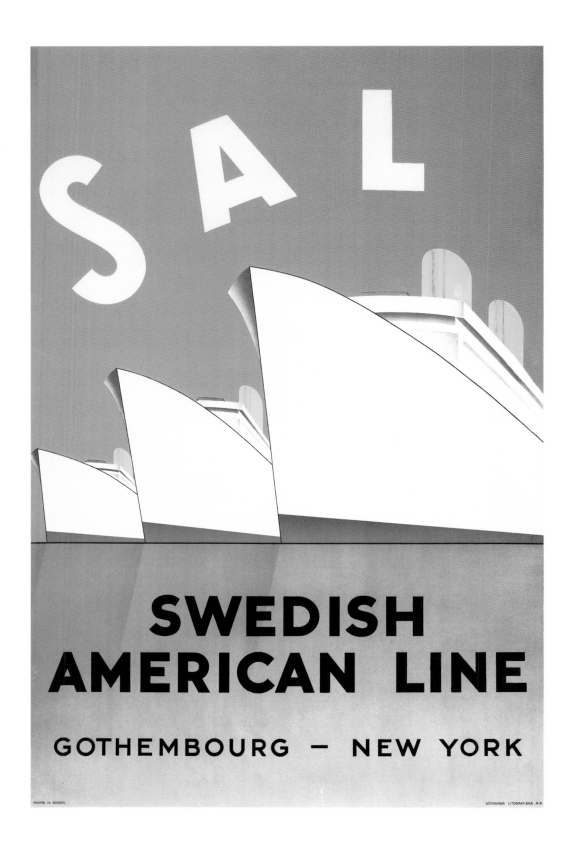

'SAL', Swedish American Line, 1937,
Göteborg Lithografiska A.B.
Ship: *Gripsholm*
96.5 x 62.7cm

Holland-Amerika Linie, Ten Broek, 1936,
Joh. Enschedé en Zonen, Haarlem
Ship: *Nieuw Amsterdam*
96 x 63cm
Museum für Gestaltung Zürich,
Poster Collection

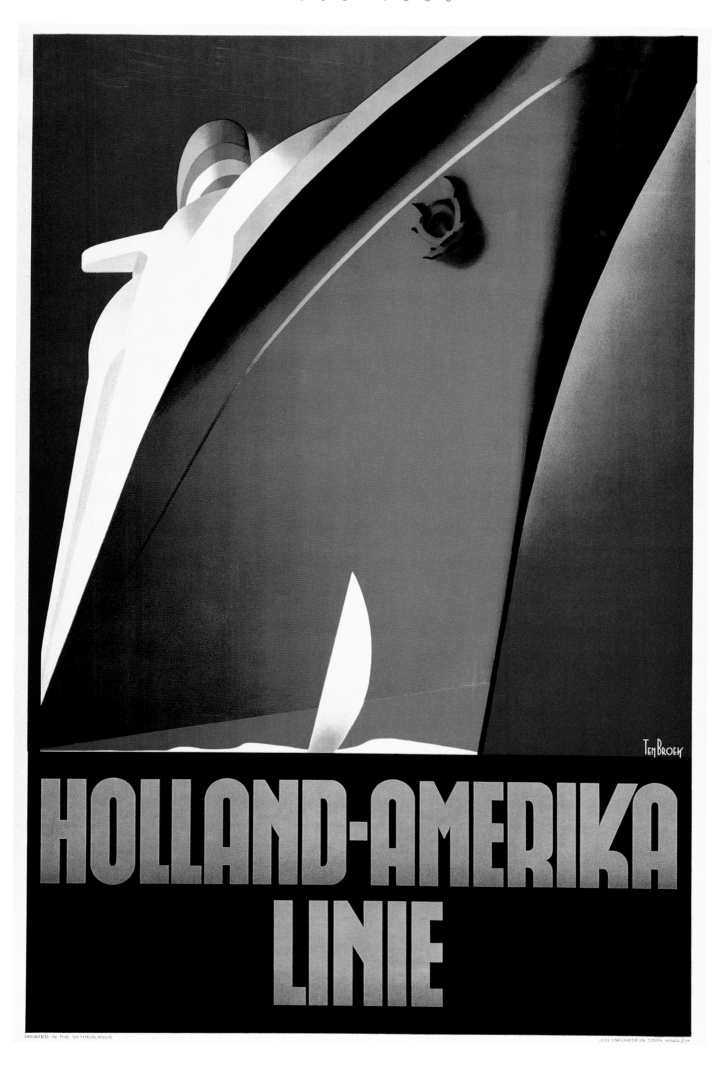

158

'N.D.L. Far East Express',
Norddeutscher Lloyd Bremen,
Feldt-Mann (Hugo Feldtmann), c.1936,
Wilhelm Jöntzen, Bremen
Ships: *Scharnhorst, Potsdam, Gneisenau*
83.8 x 61.5cm

Compagnie Maritime Belge,
Pierre Fix-Masseau, 1936,
E. Stockmans & Co SA, Merxem, Antwerp
Ships: *Albertville, Leopoldville*
99.7 x 61.8cm

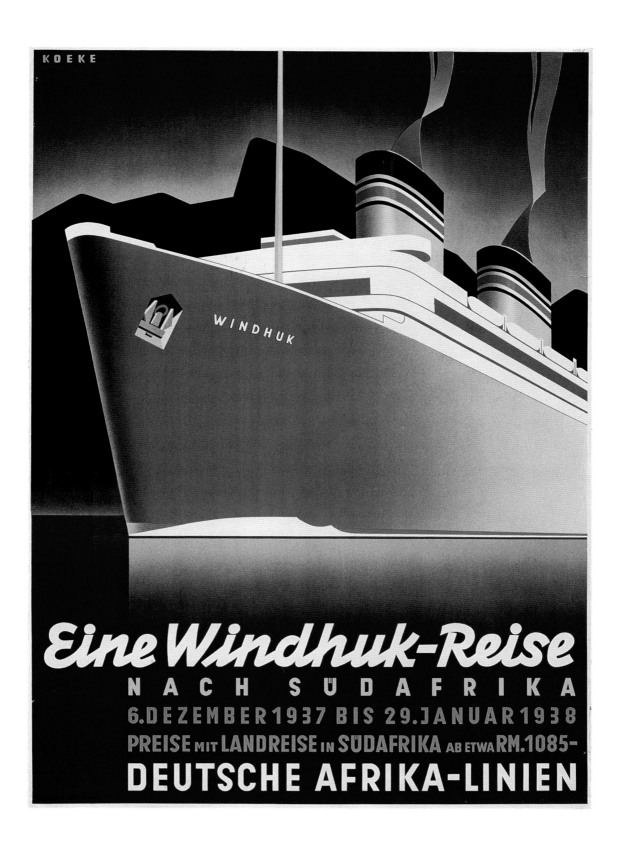

'Fast Service to South Africa',
Deutsche Afrika Linien, Loibl, c.1937,
Mühlmeister & Johler, Hamburg
Ships: *Pretoria, Windhuk*
84 x 60cm
Museum für Gestaltung Zürich,
Poster Collection

'A Voyage on the Windhuk',
Deutsche Afrika Linien, Koeke, c.1937,
Mühlmeister & Johler, Hamburg
Ship: *Windhuk*
84 x 60cm
Museum für Gestaltung Zürich,
Poster Collection

162

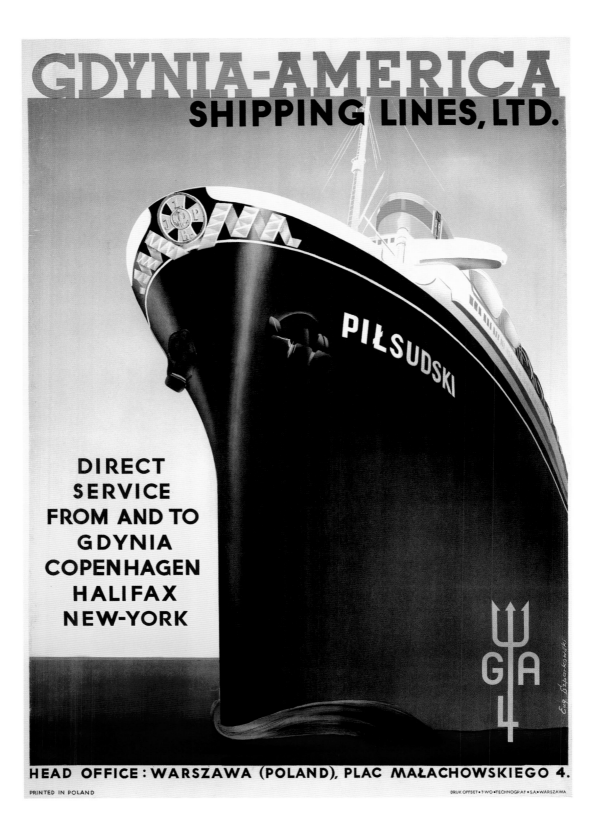

Gdynia-America Shipping Lines Ltd.,
Euq. Szparkowski, c.1937,
Druk Offset, Technograf SA, Warsaw
Ship: *Pilsudski*
100 x 69.6cm

'Passenger Service: Europe-North Pacific',
The East Asiatic Co. Ltd., M. Erlinger,
1938, Dansk Papirvarefabrik, Copenhagen
Ships: *Boringia, Erria, Jutlandia,*
Selandia, Lalandia, Meonia, Alsia
100.7 x 61.3cm

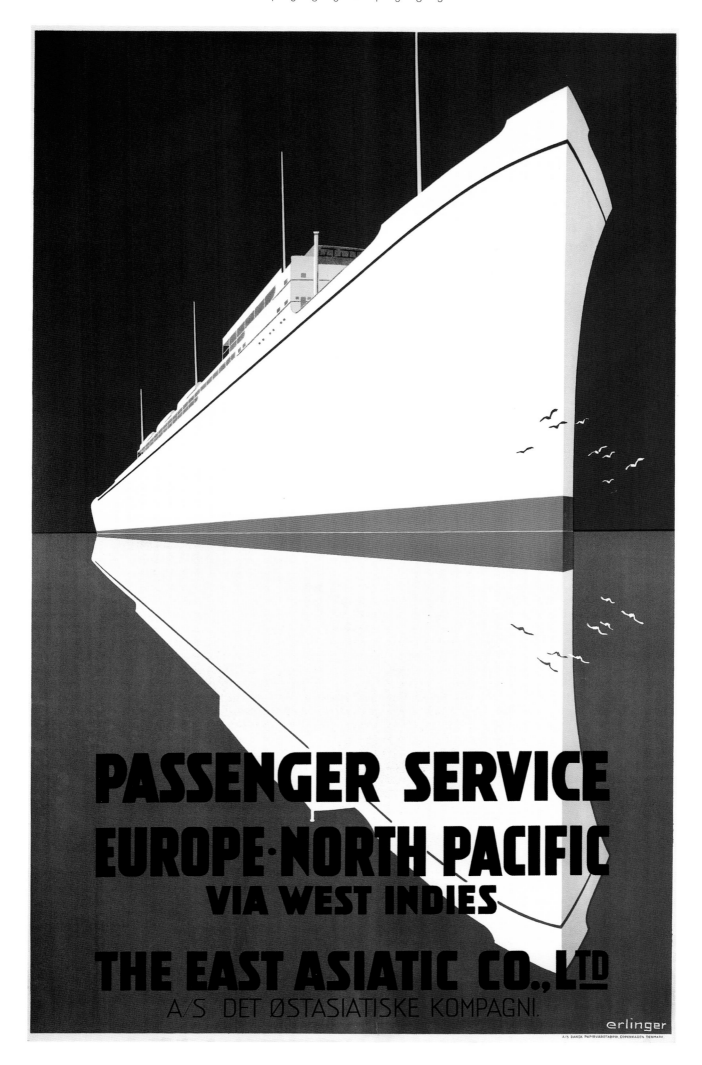

164

From the Post-war Era
to the Sixties:
The Decline and End

Nederland, Nederland Line,
Reyn Dirksen, 1953,
Joh. Enschedé en Zonen, Haarlem
Ship: *Oranje*
89.7 x 60.5cm

'Atlantic-Pacific-Mediterranean',
Compagnie Générale Transatlantique, Paul Colin,
c.1948, Transatlantic edition,
Printing SA Courbet, Paris
Ship: *Normandie* (this poster uses a pre-war illustration)
99.6 x 61cm

T he initial recovery from the Second World War was slow to take effect. Cunard's refitted *Queen Elizabeth* began to offer a trans-Atlantic passenger service from 1946. However, the style of the ship was essentially pre-War, with woods used extensively for decorative purposes, and it was firstly America, then Italy, Sweden and France who launched ships that represented nationhood within the context of Modernism and the new cultural climate of the Cold War. The era of the ocean liner had really reached an end, as the ease and cheapness of air travel negated the need to travel long distances by ship.

The Nederland Line specialised in voyages to Ceylon, Java and Egypt. The *Oranje* was introduced to the service in 1939, but was soon used as a hospital ship for the Australian Navy, only rejoining the line in 1946 (pp.165-169).

Union-Castle continued to specialise in routes from Britain to South Africa in the post-war era, and came under the new ownership of the Cayzer, Irvine & Company in 1955. The *Capetown Castle* was built in 1938 for Union-Castle (pp.170-1) and the *Pretoria Castle* in 1948, although the interiors of both ships were essentially pre-war revivalist with vague Art Deco touches, such as the mirrors. The growth in emigration from Britain to South Africa during the post war years guaranteed the survival of the company until 1977.

The *Queen Elizabeth* had been designed and built before the outbreak of World War II as a sister ship to the *Queen Mary*. One poster (p.172) shows the two liners passing mid-ocean, whilst the other, more contemporary one (p.173) shows the two ships framing the Empire State Building. The interiors were designed by Grey Wornum, as the British government insisted that a British architect be used, rather than an American one. The government also insisted that only British materials were used, and special permission was sought by Cunard to use Formica in the bathrooms. Cunard's aim had been for the *Queen Elizabeth* to join the transatlantic service in 1940. However, following the outbreak of war she sailed to New York and was employed as a troop ship. The fittings and furniture which had just been installed were removed and put into storage at various depots around the world, including Australia, North America and different areas of the United Kingdom. The furniture and fittings were located and transported back to Southampton for reassembly once the war was over, a process which took two months.

The ship eventually entered service as a transatlantic passenger liner in October 1946 and its interior design used the blueprint laid down by the *Queen Mary*, with a range of over one hundred woods being used, as well as Korkoid for the flooring. Many of the same artists and decorators were commissioned to produce very similar objects. The Verandah Grill was still a feature, but it was decorated with ivory coloured sycamore panelled walls and pale blue upholstery. The same illuminated balustrade was used and there was coloured lighting when the room was converted into a nightclub after dark. The main

165

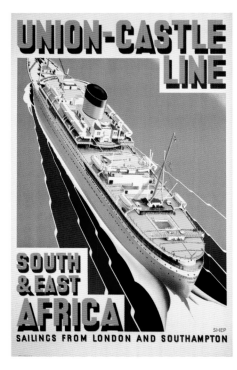

South Africa and Eastern Africa,
Union-Castle Line, Shep, 1948,
printed in England
Ship: *Pretoria Castle*
102 x 63.3cm

166 lounge on the promenade deck was panelled predominately in Canadian maple burr, this was contrasted with leather covered panels in light grey. She remained in service until 1972.

The Italia Line's *Saturnia* was seized by the USA in 1941 and used as a hospital ship during the Second World War. She was then returned to Italy in 1946 and rebuilt to carry 240 First, 270 Second and 860 Tourist passengers on the route from Genoa and Naples to New York in 1947 (p.174). Her last voyage on that service was in 1955 and she was then transferred to sailings from the Mediterranean to the US and Canada, sailing her last voyage in 1965. The *Vulcania* was also a pre-war Italia Line ship, and was requisitioned by the Italian government during the Second World War. She was then returned to the Italia Line in 1946, after being used by the US government as a troop ship. She mainly sailed from Italy to New York once she had been converted to accommodate passengers in comfort. She was sold to the Siosa Line in 1965.

This 1948 poster advertises the post-war services of the French Line and uses an image of the *Normandie* from 1937 (p.164). Of course, the art deco splendor of the *Normandie* had largely been destroyed when the liner caught fire in New York harbour, having been requisitioned by the US. The image of the ship remained vital to the French Line, as can be seen from this poster. It served as an indicator of luxury and comfort, seen here stylishly represented against the nationalistic background of the French flag.

Less stylish is the poster for the Shaw Savill Line's *Dominion Monarch* (p.176). She sailed from Southampton to New Zealand, Australia and South Africa during the post-war era, although the line is most popularly associated with the route to New Zealand. The ship was built in 1938 and disposed of in 1962. The poster for Adriatica's service to the Eastern Mediterranean introduces the white bow of the new ship, *Esperia* , contrasted with a sixteenth-century sailing ship, both sporting the winged lion of St Marks's, the symbol of Venice (p.175).

The East Asiatic Company was essentially Danish in origin and was founded in 1897 to provide a service from Copenhagen to Bangkok and the Far East. The *Falstria* was built in 1945 and this unusual poster shows it arranged around the points of a compass with various destinations listed (p.167). The Blue Funnel Line specialised in sailings to the Far East and Australia from the mid-nineteenth-century. Following the Second World War a whole new fleet of ships was introduced, comprising the *Peleus, Pyrrhus, Patroclus, Perserus, Helenus, Jason, Hector* and *Ixton* from 1949 until 1951 (p.168). This partly catered for the immigration trade from Britain to Australia. Cunard provided ships to support the movement of people, as well other trade, from Britain to Canada during the 1950s and1960s with the *Franconia, Scythia, Samaria* and *Ascania* (p.177).

Canadian Pacific also offered lines to Canada, including voyages on the popular *Empress of Scotland* (p.178). She was a pre-war ship, but was requisitioned in 1939 to carry troops. She was released back to her owners in May 1948 and rebuilt to a capacity of 26,313 gross tons with accommodation for 458 First and 250 Tourist Class passengers. She then sailed from Liverpool to Greenock, Quebec and Montreal. In 1958 she was sold to the Hamburg-American Line, but her career there was short-lived, as she caught fire at New York in 1966 and was scrapped.

The 1927 French Line ship, the *Île de France* continued to provide a service to New York until 1959 (p.179). She was requisitioned as a troop ship during the war, and returned to the French Line in 1946. She was completely reconditioned and rebuilt from 1947-49, sailing from Le Havre to Southampton and New York. She probably attracted this large investment of resources as her significance was heightened following the loss of the *Normandie*. The poster is fresh and modern and features the distinctive new typeface of the French Line's corporate identity. The French Line's *Colombie* was built in 1931, seized by the USA in 1942 and converted first into a troop ship, and then into a hospital ship named *Aleda E Lutz* in 1946 (p.180). She then reverted to C.G.T., was renamed *Colombie*, and in 1949 was rebuilt to 13,808 tons, before being sold in 1964. She specialised in voyages to the West Indies from France. The French Line's *Liberte* was originally the German transatlantic liner, *Europa*. Awarded to the French Line after the war, she underwent extensive refurbishment and conversion at the St Nazaire shipyards and was relaunched in 1950 (p.181). She had accommodation for 569 First Class, 562 Second and 382 Tourist Class. Andre Domain of La Maison Dominique was the overall designer of the interiors of the ship. A French flavour was added in the new Café de l'Atlantique with its dancefloor and the Dunand lacquer work in the Grand Salon.

The *Mekong* was introduced on the Messageries Maritimes route to the Far East, Australia and South Africa in 1949 (p.182). Travel to India continued to be provided by the British India Steam Navigation Company on ships such as the *Kenya* and *Chakdina*, introduced in 1951 (p.183). The Orient Line also continued to specialise in travel to Australia after the War. Always the mostly distinctly Modernist in style, the Orient Line's posters for travel by the new *Oronsay* were no exception (p.184). Introduced in 1951, the ship could carry 668 First Class and 883 Tourist Class passengers in Modernist interiors by Brian O'Rorke.

Compagnie Maritime des Chargeurs Reunis is best know for providing sailings to Indo-China from 1901 onwards. The company suffered severe losses as a result of the Second World War, but the *Claude Bernard* was a new ship, introduced to the service in 1948 to boost trade (p.185).

The *United States* was the first significant new passenger liner to be built after the Second World War (pp.168, 186 and 187). She was initially commissioned by the United States Navy as a troop ship at a cost of $77 million, and then sold to the United States Line upon completion for a total of $33 million. The ship

The East Asiatic Company Ltd.,
Sten Heilmann Clausen, c.1950,
Hegmond H. Petersen, København
Ship: *Falstria*
99.2 x 63cm

took the Blue Riband from the *Queen Mary* on its first voyage in July 1952, with engines to match those of the *Queen Elizabeth*, but a much smaller and elongated hull, narrow enough to traverse the Suez Canal. The 53,329 gross tons provided accommodation for 882 First Class, 525 Second and 551 Tourist Class. The interiors were designed by the architectural partnership of Eggers & Higgins in close collaboration with the interior design firm, Smyth, Urquhart & Markwald. The designers were not permitted to use wood in the outfitting of the *United States*, as the ship needed to be completely fireproof. The main structure of the ship was aluminium, a material which was lightweight and flexible and much in vogue during the 1950s. The ship was designed to convert easily into a troop ship, although she was never used for that purpose apart from being on standby during the Cuban Missile Crisis. The interiors were therefore simple and modern in design, with minimal decorative detail using modern materials, including all-metal furniture, glass fibre for curtains and bedspreads, plus plastic upholstery. Aluminium was selected for 22,000 pieces of shipboard furniture. In 1969 she was laid up, and in 1973 she was transferred to the United States Federal Maritime Administration.

The Holland-America Line continued to operate the prestigious, pre-war liner, the *Nieuw Amsterdam* until 1974 (p.188-9). She had been used as a troop ship during the war, and was reconditioned to rejoin the fleet in 1947, sailing from Rotterdam to New York and then providing cruising voyages. The first poster emphasizes the cruising and leisure based facilities on deck, rather than points such as destination, speed and scale. 'Cunard to Canada' also illustrates passengers taking part in deck-based, sporting activities in its poster for the *Saxonia, Ivernia, Corinthia* and *Sylvania* (p.190), as does the P&O poster for the *Arcadia* and *Iberia* (p.191). Even more funky is the Orient Line poster for the *Orsova*, a highly Modernist colour drawing of young people partying on deck (p.192). The *Orsova* sailed from London to Sydney and San Francisco. When the Orient Line ceased to exist in 1960, her owners became P&O Orient Lines, then in 1966 P&O bought out the last of the Orient Line, and everything became P&O.

The American President Line was a late entrant to the ocean liner trade (pp.194-5). Its foundations lay in the US government's decision to bail out the Dollar Steamship Company in 1938, which was facing financial difficulties. The company specialised in trans-Pacific and round-the-world services, but as a result of the Second World War, its entire fleet was seconded for wartime duties. Only two ships were returned to the Line after the war and two new ships were built in 1947-48 for the trans-Pacific route: the *President Hoover* (originally called the *Sea Beaver*) and the *President Grant*, which was renamed in 1967. Further ships were later added to the fleet for voyages to Asiatic ports such as Karachi, Bangkok and Yokohama; they were advertised by simple colourful posters. The *President Cleveland* and *President Wilson* were launched in 1946 to serve on the route between San Francisco and Hong Kong.

The French company, Messageries Maritimes, employed more traditional imagery to promote its voyages to the Far East in the ships *Laos, Vietnam* and *Cambodge* (p.9). The company also introduced five new ships to its fleet for round the world services in 1959 to 1960. These were the *Maori, Marquisien, Malais, Mauricien* and *Martiniquais*. The poster uses a lively and loose illustrative style (p.193).

The American Export Lines company was the largest to offer voyages between the east coast of America and the Mediterranean from 1919 until 1977, for both passengers and cargo. The company built two new ships, the *Independence* and the *Constitution*, which joined the service from New York to Naples, Cannes and Genoa in 1951 (p.196). They were sizeable, at 23,719 tons, and were named after two of the American navy's most well known sailing ships of the early nineteenth-century. They could each accommodate 295 First Class, 375 Cabin Class and 330 Tourist Class passengers.

The last great liner to be built by the French Line was the *France* (p.197). Launched in 1962, she was an impressive 66,348 gross tons, the largest ship to be constructed at the Chantiers de l'Atlantique shipyard at St Nazaire. Supported by government subsidies, the French President, Charles de Gaulle, hoped that the ship would provide a boost to French national confidence, and build on the success of the *Normandie*. The interiors were bright and modern – designed by G. Peynet, they employed brightly patterned and multi-coloured textiles and finishes. The ship was designed to operate as a transatlantic ocean liner and a cruise ship, so segregation of the classes was less marked, with vertical circulation of the two classes being enhanced by lifts and staircases which could by-pass the other class.

The First Class accommodation on the promenade deck consisted of a modern smoking room aft, decorated with star shaped ceiling lights, and white pillars, ceiling and banister with a wall panel by Jean Picart le Doux. The large central panel measured 4 x 17.5m and depicted 'Les Phases du Temps' in black, dark blue, light blue and gold. The furniture was angular, as was the lighting. Further along the promenade deck amidship was the grand salon, decorated mainly in white, with concealed lighting in the ceiling, white leather upholstered chairs and glass and metal coffee tables. An air of luxury was attempted with the addition of a multitude of contemporary French works of art, including decorative ceramic plaques by Picasso in the Tourist Class dining room and watercolours by Raoul Dufy in the private First Class bar and Cabaret Atlantique. Both classes had libraries and writings rooms, shops and a cabaret bar. The Second Class was called Rive Gauche, and was perhaps more successful than the First Class, as the style of modernism was more in tune

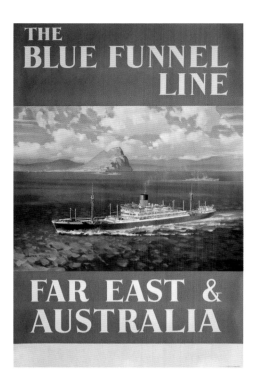

'Far East and Australia',
The Blue Funnel Line,
Walter Thomas, c.1950,
printed in England
Ship: a vessel from the series
*Peleus, Pyrrhus, Patroclus,
Perseus, Helenus, Jason,
Hector, Ixton*
100 x 64.3cm

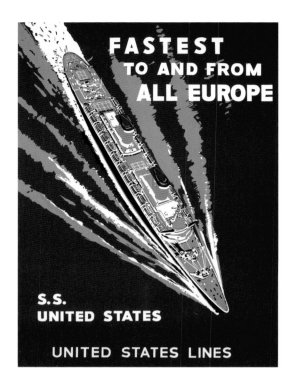

'Fastest to and from all
Europe', United States
Lines, c.1960
Ship: *United States*
81.4 x 59.5cm

168 with bare simplicity than luxurious surface decoration. For example, the smoking room had walls and ceilings faced with a plain plastic surface, with some multi-coloured rectangles for decoration behind the bar. The furniture was simple, with metal frames and fabric upholstery. The Rive Gauche section also had a glass-domed indoor swimming pool and lido bar aft on the upper deck, complemented by a glass-roofed sports centre on the sun deck.

The *France* was initially a success, but the challenge of travel by air soon led to the global demise of the ocean liner. The *France* was also hit by a withdrawal of government support for its operations and C.G.T. desperately tried to market the ship with various cruises during the early 1970s. However, this was unsuccessful and the ship was eventually sold for its scrap value and later towed to Bangladesh to be broken up.

So ends the great history of the ocean liner and the romance of travel to far off destinations by sea. The most obvious threat to travel by ocean liner was the introduction of cheap air travel. There was also the decline in emigration from Europe to America, Canada and Australasia. However, the cruise market is now booming, with the recent introduction of Cunard's *Queen Mary 2* and the growth of the Carnival Cruises group. But these are ships which provide leisure spaces and are essentially floating hotels. The ocean liners were built for the purpose of travel, to bolster and reinforce national pride and to provide mass transportation around the globe, much of the time for those seeking a better life. There are now cheaper and more convenient ways to travel, but perhaps they are less romantic when we view the history of the ocean liner and its associated nostalgia.

Oranje, Nederland Line,
Jean Walther, 1939
The *Oranje* only truly came into
service after the War, which is why
this older poster is shown here
Ship: *Oranje*
101.7 x 64.5cm

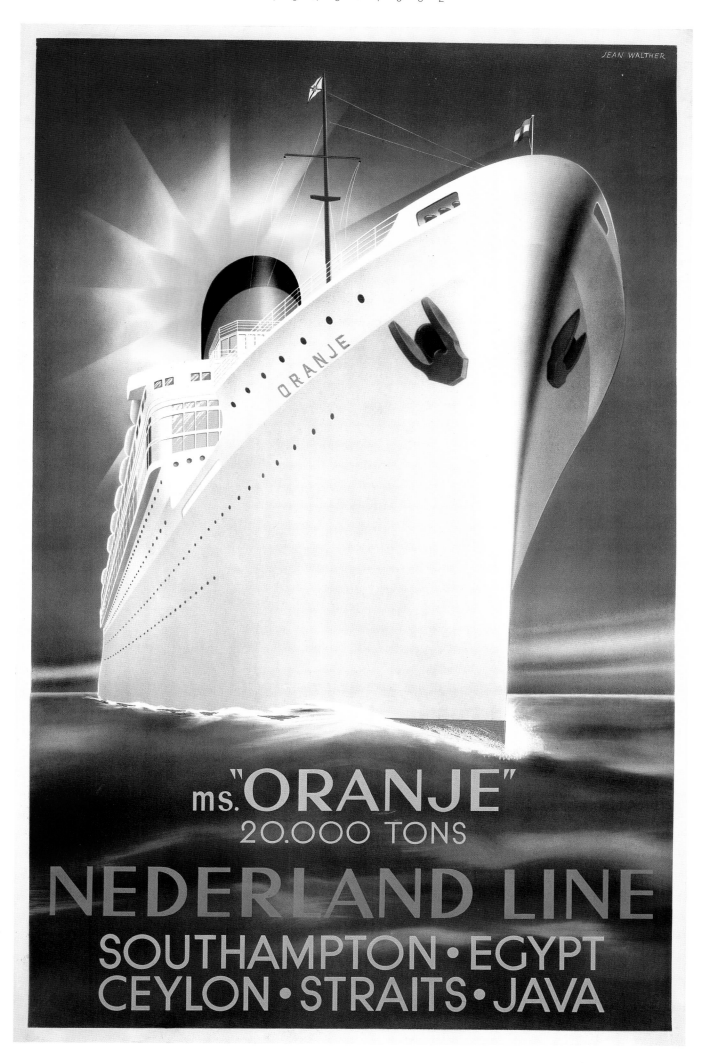

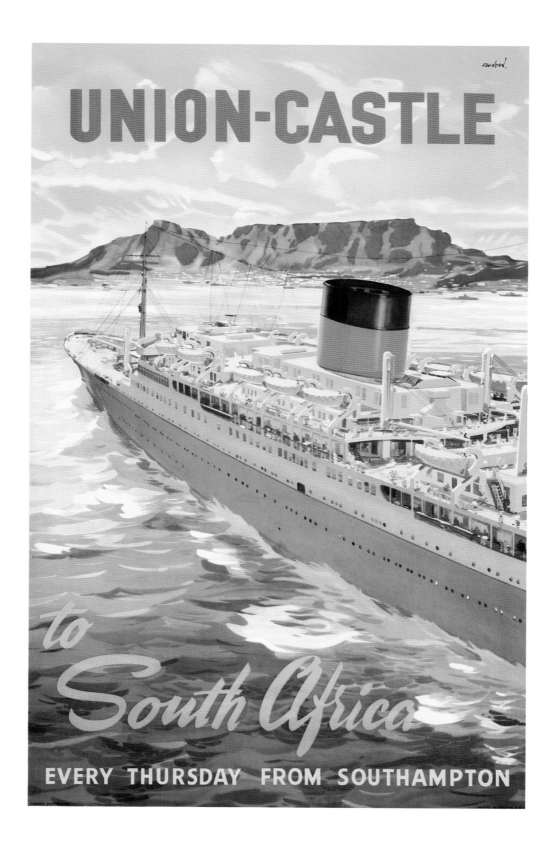

South and East Africa,
Union-Castle Linie, Creic, c.1947,
printed in England
Ship: *Capetown Castle*
101 x 63.2cm

To South Africa, Union-Castle Line,
Tom Johnston, c.1948,
Forman, Nottingham
Ship: *Capetown Castle*
101 x 63.1cm

172

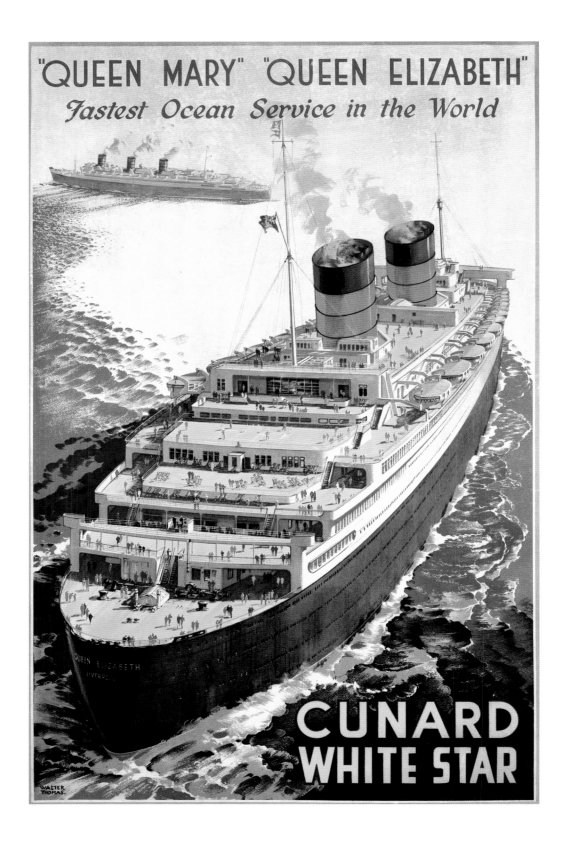

Queen Mary, Queen Elizabeth,
Cunard White Star, Walther Thomas,
c.1947
Ships: Queen Mary, Queen Elizabeth
98 x 58.3cm

Cunard White Star, A. Roquin, c.1947,
Publimp-Nadal, Paris
Ships: Queen Mary, Queen Elizabeth
98.8 x 61.8cm

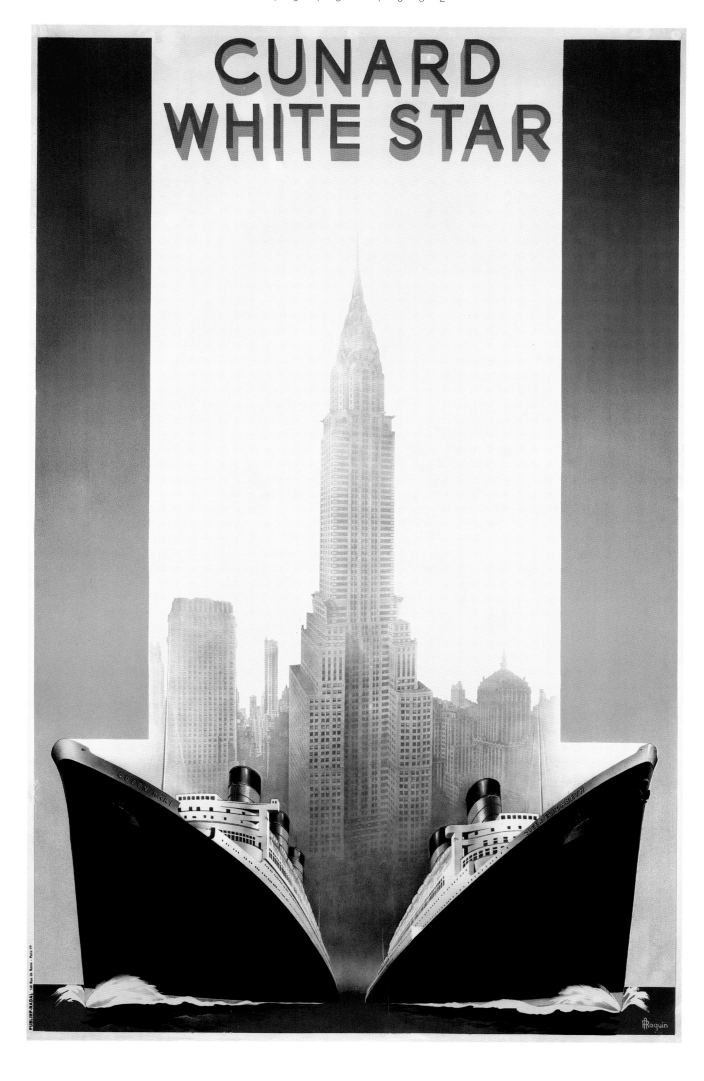

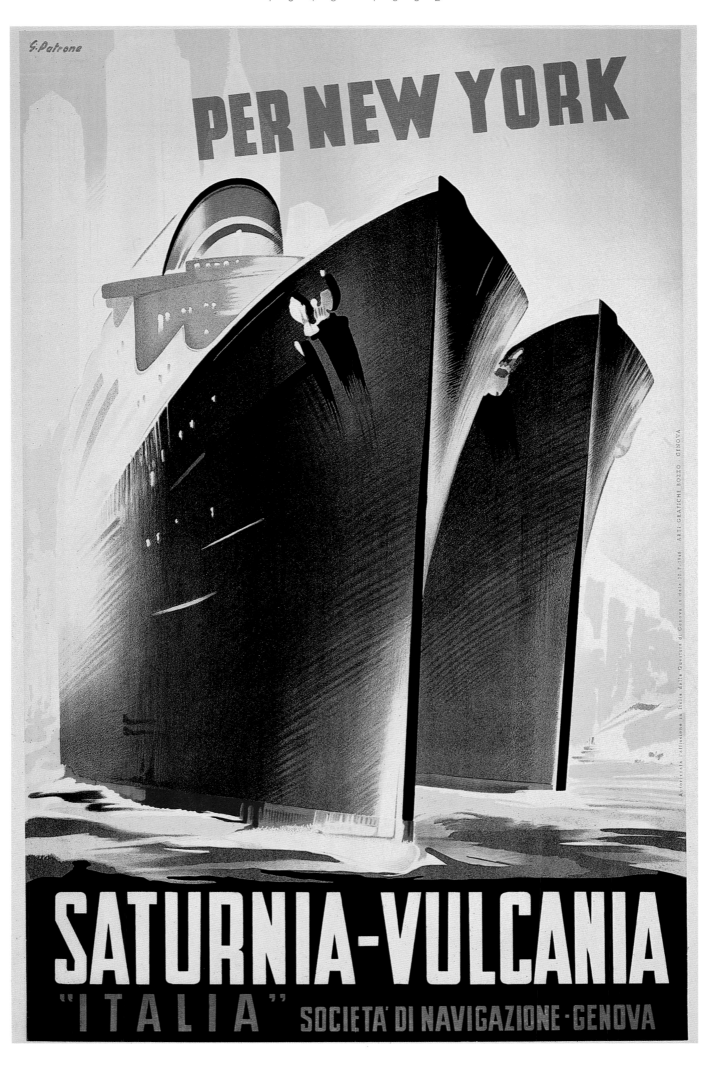

174

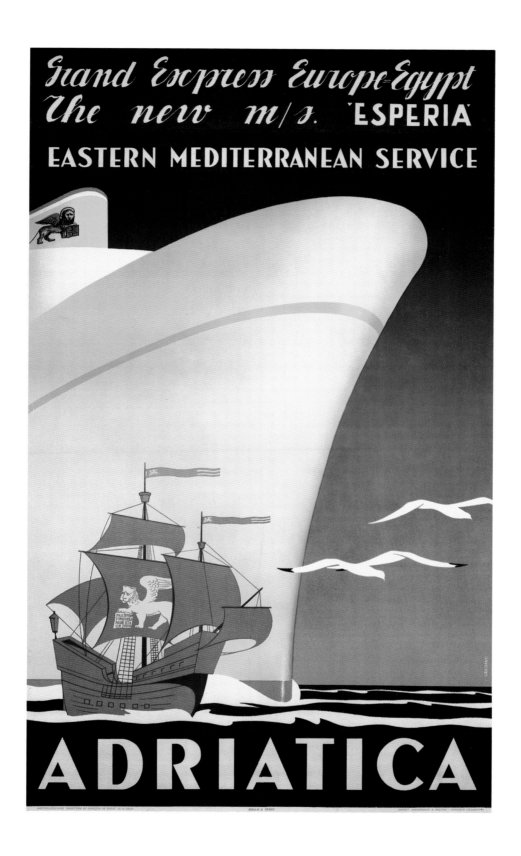

'To New York',
Societa di Navigazione, G. Patrone, 1948,
Arti Grafiche Bozzo, Genoa
Ships: *Saturnia, Vulcania*
100 x 62cm
Collection Alessandro Bellenda, Galerie
L'IMAGE, Alassio

Grand Express: Europe-Egypt, Adriatica,
Graziano, 1949,
Offset Ommassini & Pascon, Venice
Ship: *Esperia*
107.5 x 62.8cm

SHAW SAVILL LINES

DOMINION MONARCH

ENGLAND SOUTH AFRICA
AUSTRALIA NEW ZEALAND

176

England-South Africa-Australia-New
Zealand, Shaw Savill Lines, W. McDowell,
c.1948, printed in England
Ship: *Dominion Monarch*
100.3 x 63.7

'Cunard to Canada',
Cunard, C.E. Turner, c.1950,
printed in England
Ships: *Franconia, Scythia, Samaria,
Ascania*
102.7 x 63.5cm

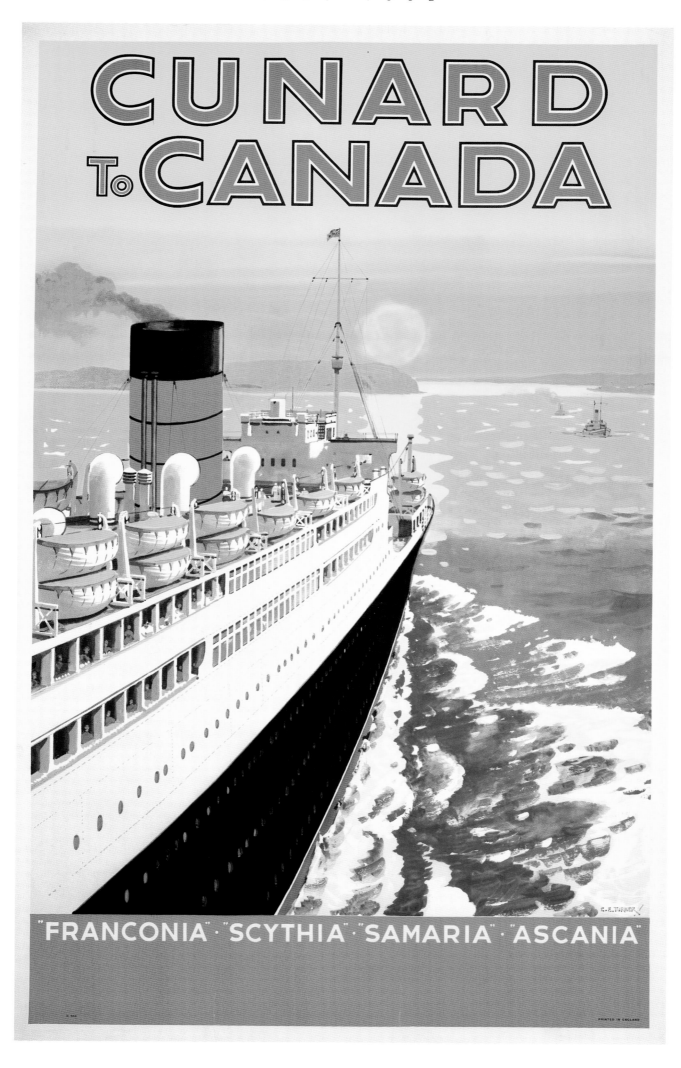

178

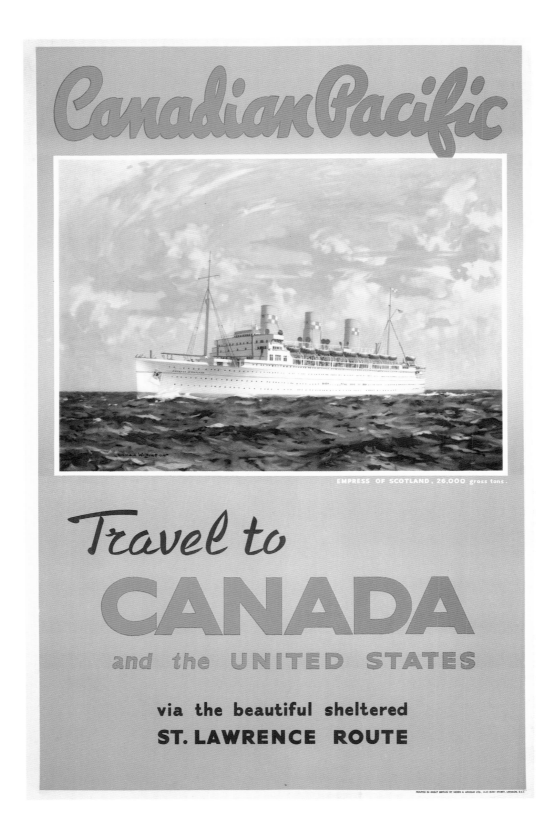

'Travel to Canada and the United States',
Canadian Pacific,
Norman Wilkinson, c.1950,
Nissen & Arnold Ltd., London
Ship: Empress of Scotland
101 x 64.5cm

Le Havre-Southampton-New York,
Compagnie Générale Transatlantique,
Paul Colin, c.1950,
Printing Transatlantique
Ship: Île-de-France
100 x 62.3cm

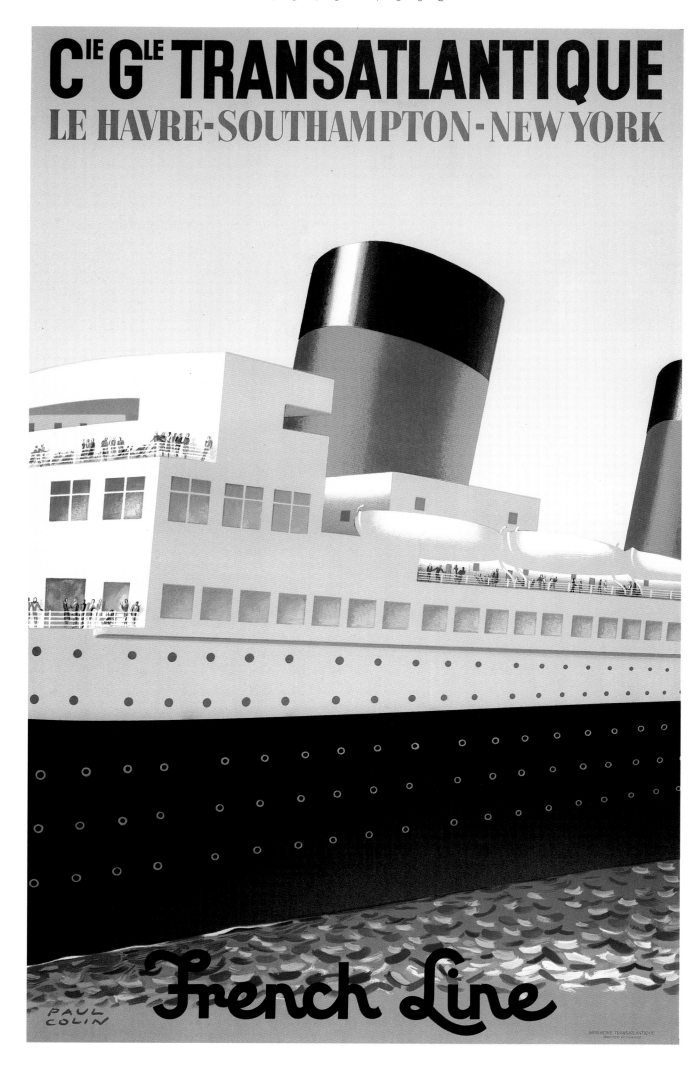

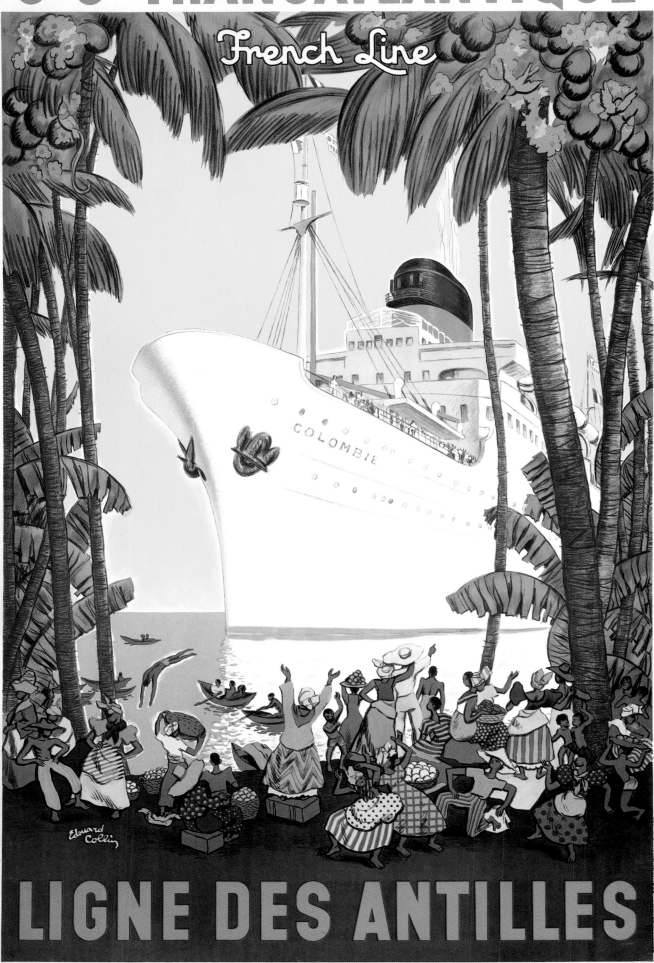

180

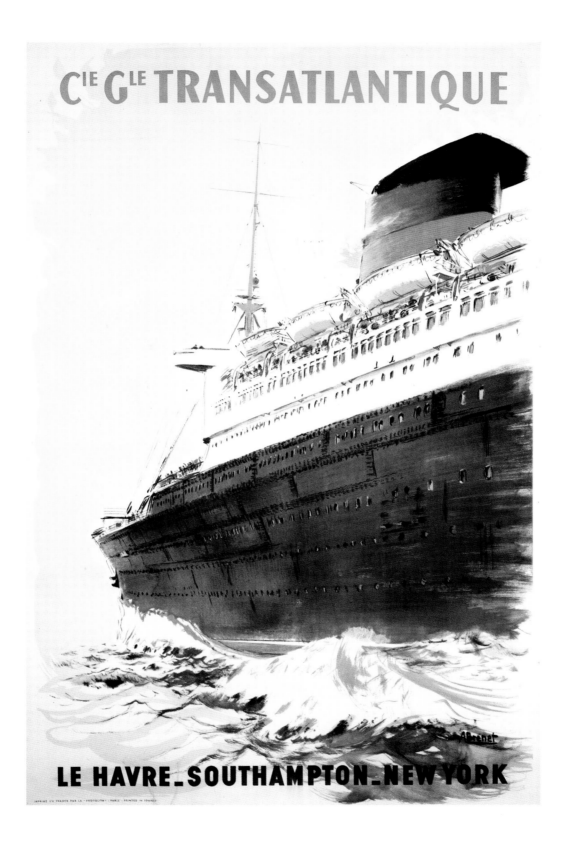

Antilles Lines,
Compagnie Générale Transatlantique,
Édouard Collin, 1950,
Editions Transatlantique, France
Ship: *Colombie*
97.5 x 62cm

Le Havre-Southampton-New York,
General Transatlantic Compny, A. Brenet,
c.1950, 'Photolit.', Paris
Ship: *Liberté*
100.2 x 65cm

182

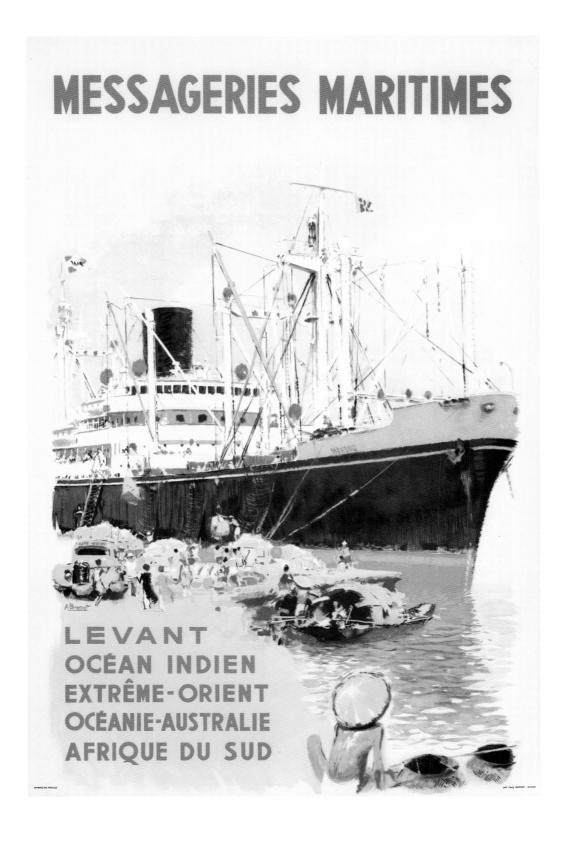

Levant-Indian Ocean-Far East-Oceania-
Australia-South Africa,
Messageries Maritimes, A. Brenet, c.1950,
Printing Paul Dupont, Clichy
Ship: *Mékong*
49.5 x 32.3cm

'B.I., Best Both Ways',
British India Steam Navigation Co. Ltd.,
c.1951, printed in England
Ships: *Kenya, Chakdina*
100 x 62.3cm

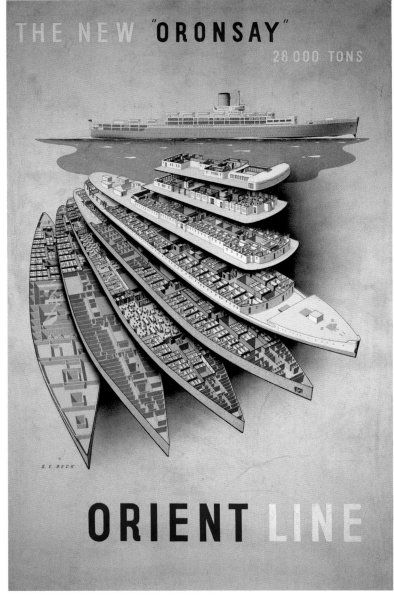

'Via Suez Canal to Australia',
Orient Line, Tom Johnston, 1951,
The Baynard Press, England
97.6 x 60.7cm
P & O Heritage Collection

'The New *Oronsay*', Orient Line,
Stuart E. Beck, 1951
Ship: *Oronsay*
95.8 x 57.8cm
P & O Heritage Collection

Indochina,
Compagnie maritime des chargeurs réunis,
Roger Chapelet, c.1952,
Printing E. Desfossés, Paris
Ship: *Claude Bernard*
99.7 x 59.5cm

EUROPE to AMERICA

by

USL
United States Lines

JOHN·S· SMITH

Europe to America, United States Lines,
John S. Smith, c.1952
Ship: *United States*
101 x 63.4cm

Europe to America, United States Lines,
Y. Delfo, 1952, printed in England
Ship: *United States*
101 x 61.9cm

188

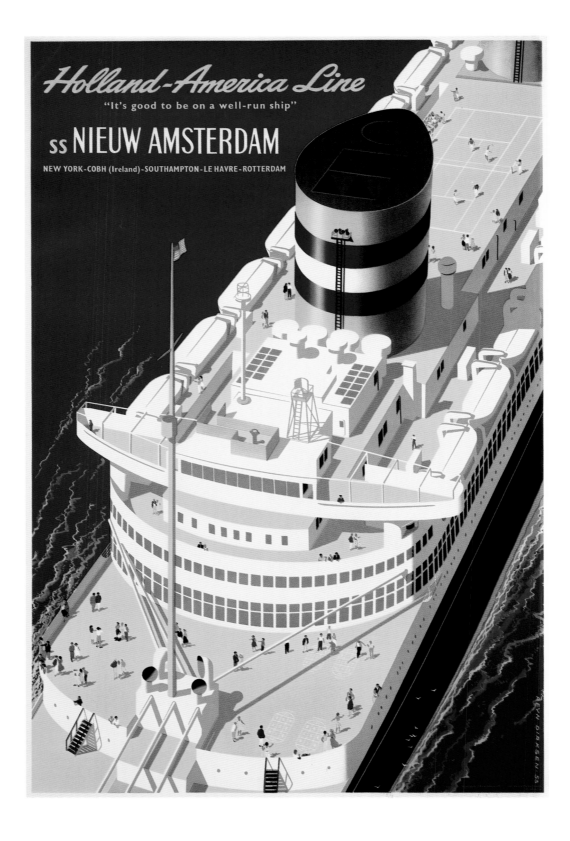

Nieuw Amsterdam,
Holland-America Line,
Reyn Dirksen, 1953,
Joh. Enschedé en Zonen, Haarlem
Ship: *Nieuw Amsterdam*
95.5 x 62.8cm

Holland-America Line, Mettes, c.1955
Ship: *Nieuw Amsterdam*
95.5 x 62.2cm

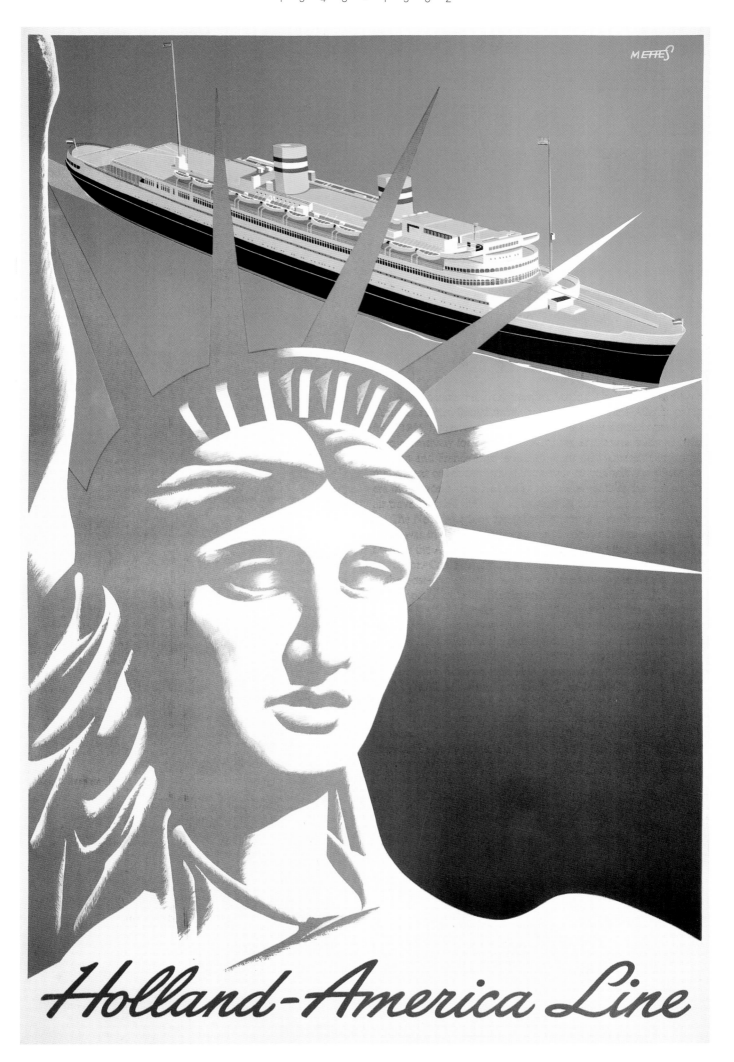

190

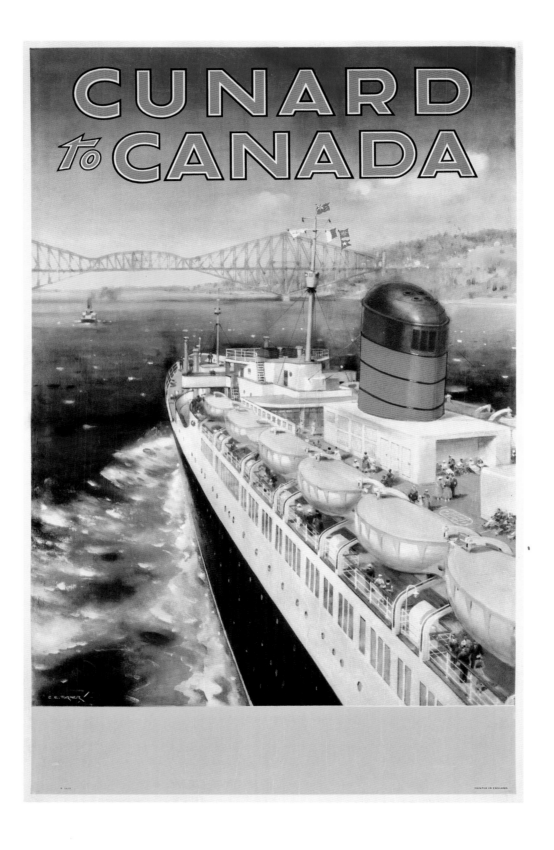

'Cunard to Canada', Cunard,
C.E. Turner, c.1954, printed in England
Ships: *Saxonia, Ivernia, Corinthia,
Sylvania*
101 x 63.3cm

'Travel P & O', P & O,
Tom Johnston, 1954,
printed in England
Ships: *Arcadia, Iberia*
101.5 x 62cm

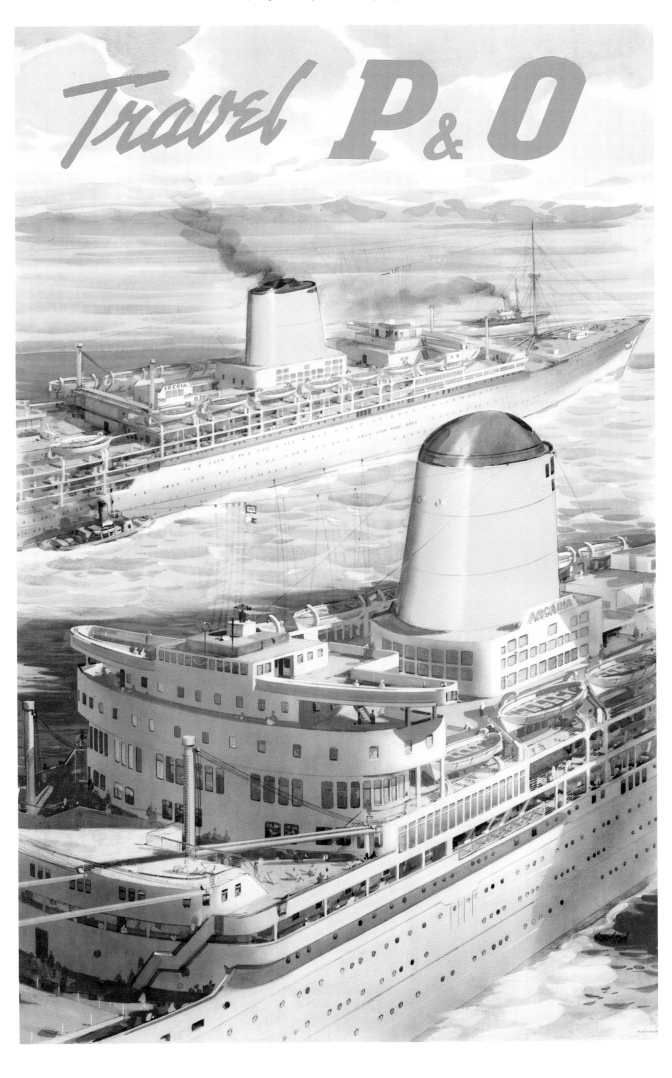

192

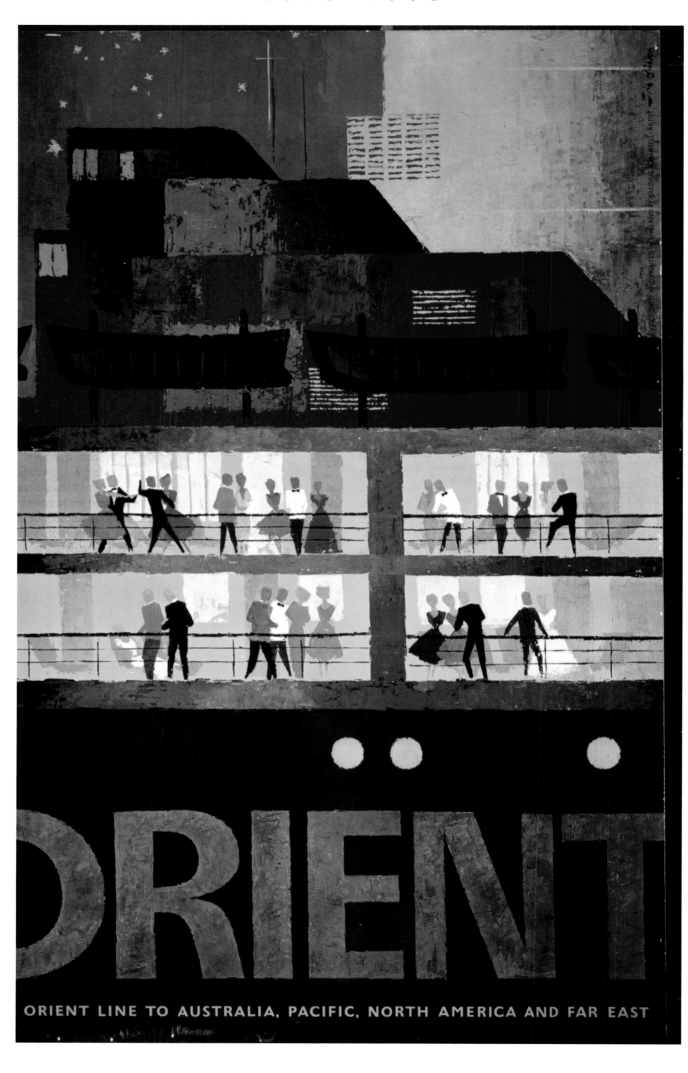

ORIENT LINE TO AUSTRALIA, PACIFIC, NORTH AMERICA AND FAR EAST

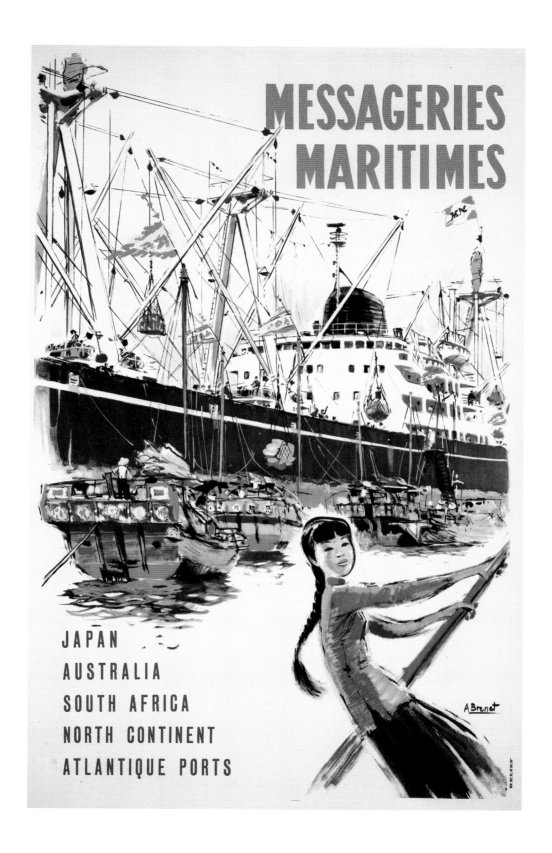

Orient, Orient Line, Fritz Buhler,
c.1955,
Bulding & Mansell, England
Ship: *Orsova*
99.5 x 61.5cm

Japan-Australia-South Africa-
North Atlantic, Messageries maritimes,
A. Brenet, 1959,
Printing Relief
Ships: *Le Maori, Le Marquisien,
Le Malais, Le Mauricien, Le Martiniquais*
51.5 x 33cm

194

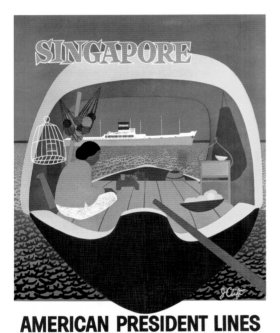

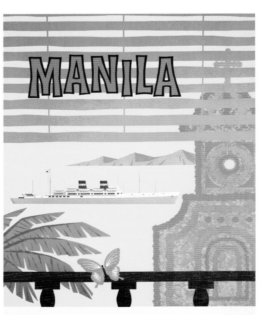

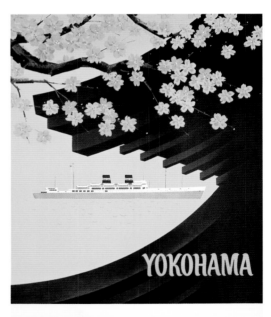

Hong Kong, American President Lines,
1957, printed in the USA
Ship: *President Hoover*
86 x 60cm
Picture This Gallery, Hong Kong

Manila, American President Lines, 1958,
printed in the USA
Ships: *President Wilson, President
Cleveland*
85.3 x 59.7cm

Karachi, American President Lines,
A.H. Merenched, 1957,
printed in the USA
Ship: *C 4 Class*
87.3 x 60cm

Yokohama, American President Lines,
1958, printed in the USA
Ships: *President Wilson, President
Cleveland*
85 x 60.3cm

Bangkok, American President Line,
F. Clift, 1958, printed in the USA
Ship: *C 4 Class*
86.6 x 59.5cm

Bombay, American President Lines, 1959,
printed in the USA
Ship: *C 3 Class*
86.8 x 60cm

Singapore, American President Lines,
F. Clift, 1958, printed in the USA
Ship: *C 3 Class*
86.3 x 59cm

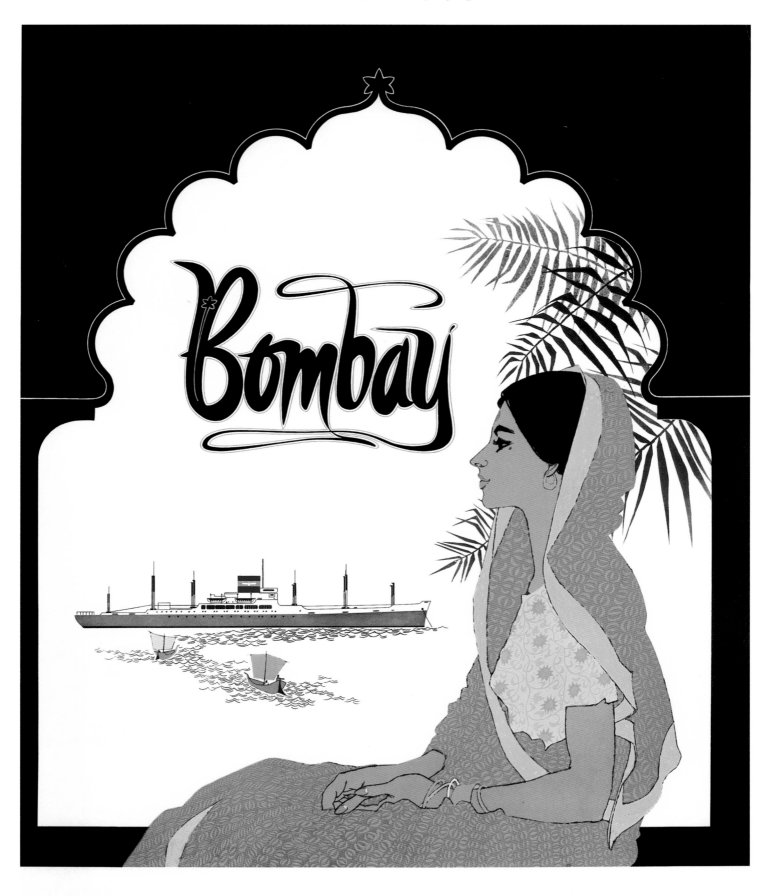

195

Bombay

AMERICAN PRESIDENT LINES

SERVING 50 PORTS ON 4 MAJOR TRADE ROUTES

196

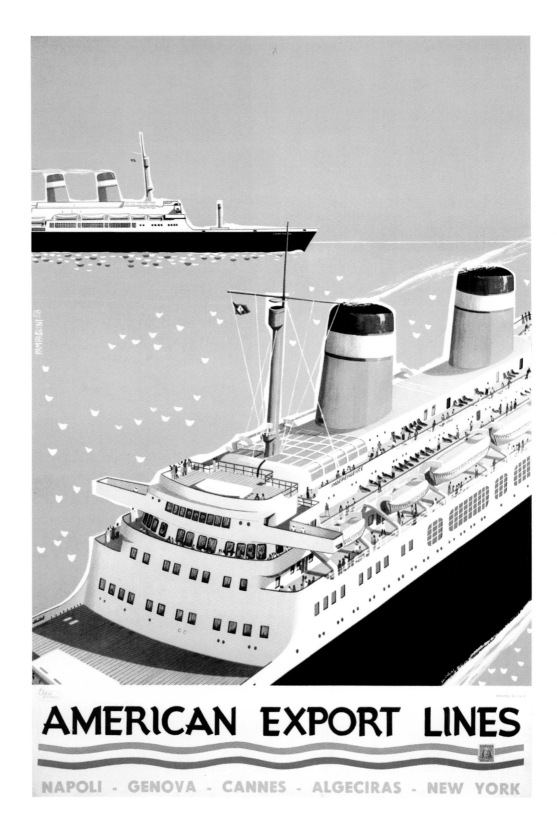

American Export Lines,
Pampaglini, 1958, A.P.E., Genoa
Ships: *Independence, Constitution*
98.2 x 61.8cm

'S. S. *France*', Compagnie Générale
Transatlantique, J. Jacquelin, c.1962,
Publicité Hubert Baille, Paris
Ship: *France*
99.7 x 62cm

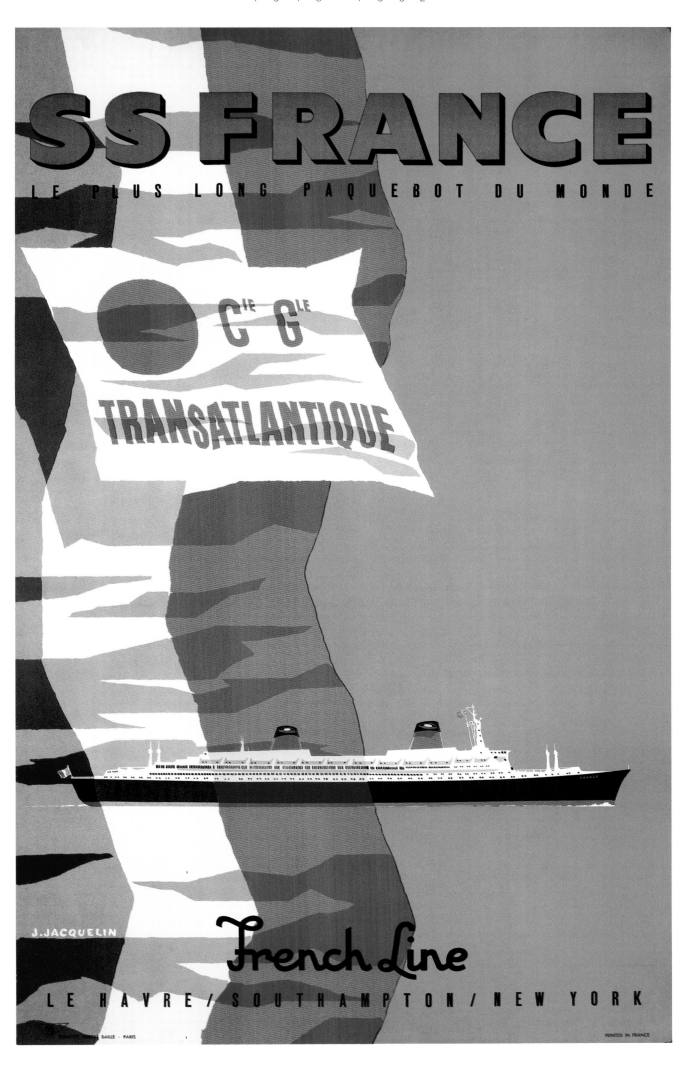

Poster Designers

OTTOMAR ANTON (1895–1976) became famous during the Weimar Republic through his posters of boats and airships. His productions for the Nazi regime were darker. Later, he returned to his roots in publicity work, in particular for colognes.

EUGÈNE D'ARGENCE (1853–1920), born in Saint-Germain-Villeneuve, became a painter for the French Navy in 1890. He favoured coastal scenes on the Channel and the Mediterranean.

WILLIAM JAMES AYLWARD (1875–1956) went to sea after studying in Chicago. As an illustrator first and foremost for magazines including *Harper's*, he worked in watercolours, oils and pastels. He became one of the American Army painters during the First World War.

MONTAGUE BIRRELL BLACK (1884–1964) was born in London and worked as a military and naval painter. He produced many posters and postcards for the White Star Line in a very appealing style.

HANS BOHRDT (1857–1945) was one of the painters of the German Navy and very close to Kaiser Wilhelm II. His works, which reflect his passion for the sea and travel, are rich in colour and display a great sense of composition.

ALBERT BRENET (1903–2005) was born in Harfleur and studied at the Ecole des Beaux-Arts in Paris. Bestowed with the title of Navy Painter in 1936, he produced many posters for the French shipping companies.

SAMUEL JOHN MILTON BROWN (1873–1963) was born into a family connected with the sea. He worked in Liverpool, painting sailing ships as well as steamships.

ABEL BRUN illustrated works of Victor Hugo. Illustrating for many newspapers, he also produced many posters for shipping companies.

FRITZ BUHLER (1909–1963), Switzerland.

CASSANDRE (Adolphe Jean-Marie Mouron, 1901-1968) was without doubt the greatest poster designer of the twentieth century. Born in Ukraine, he studied painting in Paris at the Académie Julian alongside René Menard and Lucien Simon. His posters, inspired by Cubism, remain famous, in particular for their typography, which was another field of his work. As well as being the co-founder of the advertising agency Alliance Graphique, he also worked on the magazine *Harper's Bazaar* and designed theatre scenery.

HENRI CASSIERS (1858-1944), a Belgian artist, was one of the greatest poster artists of the shipping world. He started as an architect before turning to painting, particularly in watercolours. His representations of boats, often appearing near to coasts and carrying celebrities, are among the masterpieces of the genre.

RENATO CENNI (1906–1977), Italy.

ROGER CHAPELET (1903–1995), born in Versailles, was trained at the École des Beaux-Arts in Paris. He loved shipping and became a painter for the Navy in 1936, which was his role during the Second World War. In 1974, he was named president of the Académie de Marine.

PAUL COLIN (1892–1985), painter, designer and poster artist, studied architecture at the École des Beaux-Arts in his hometown of Nancy, which at the time was one of the centres of Art Nouveau. He became famous in 1925 thanks to his poster for the Revue Nègre and produced more than 1,400 posters throughout his career. His style, which was very Art Deco at the outset, quickly became too personal to be categorised. The synthetic accuracy of his portraits, and the evocative force of his posters marked him as a master of visual communication. Considered the father of the modern school of poster art, his work today remains relevant and fresh and are on display in the world's greatest museums. Paul Colin defined his own art with this phrase: 'A poster must be a telegram addressed to awareness.'

ÉDOUARD COLLIN (1906-1983), born in Meudon, devoted himself to the study of art at a very early age. While at the École Nationale des Beaux-Arts in Paris, he won more than a dozen silver and gold medals, then the first prize. At twenty-six, he won the Championship in Rome. He designed many posters, in particular for Renault and the Red Cross before the WWII and created theatre scenery. He moved to the South of France for a few years to paint there. When he returned to Paris in 1950, he became the artistic consultant for the Compagnie Générale Transatlantique. He was very prolific in his production of figurative and lively posters.

AURELIO CRAFFONARA (1875-1945), Italy.

VICTOR CRETEN (1878-1966), Belgian painter and architect, painted in a radiant style between Art Nouveau and Art Deco.

REYN DIRKSEN (1924-1999), born in Haarlem, started to work in poster advertising shortly after the Second World War. He loved shipping and produced much work for Dutch shipping companies. His style developed in time towards the Abstract.

CHARLES EDWARD DIXON (1872-1934), born in Goring-on-Thames, Surrey, was accepted by the Royal Academy at an early age. He worked for several magazines, including *Graphic*. Being very keen on the sea, he created many illustrations for shipping companies, predominantly in watercolour in a very attractive style.

KARL PAUL THEMISTOKLES VON ECKENBRECHER (1842-1921), German born in Athens, holidayed a lot on the Mediterranean coast. His works show his love of shades of blue and grey, and diffused light.

THEODOR ETBAUER (**ETBAUER**, 1892-1975), Germany.

PIERRE FIX-MASSEAU (1905-1994) was the son of the sculptor Pierre Félix Masseau. Using a post-deco style of clean lines, his posters have remained famous, in particular those he created for the Orient Express.

ALBERT FUSS (1889-1969), Germany.

GILBERT GALLAND (1870-1956), born in Lyon, became a painter for the Navy in 1900, and was known for his many watercolours.

BERNARD FINEGAN GRIBBLE (1873-1962), born in London, started off his career in the same line as his father, as an architect. He became a famous nautical painter and exhibited at the Royal Academy between 1891 and 1904.

FREDERICK CHARLES HERRICK (1887-1970) was trained at Leicester College of Art and Crafts and at the Royal College of Art. As well as his posters of ships, he designed posters for London transport.

SANDY HOOK (aka Georges Taboureau, 1879-1960), born in Paris, was named as Painter for the Navy in 1917. All his work is of a nautical theme, either civil or military. Working for many shipyards and most of the shipping companies, he was described as a 'ship portraitist' due to the accuracy of his representations. In addition to his abundant production of posters, he also wrote for different magazines and, in 1953, exhibited at the Salon de la Marine.

HAROLD VIVIAN ING (1900-1973) painted for many shipping companies, including P & O, B.I. and United States Lines. Using watercolour and oil, he produced not only posters but also "ship portraits" and book illustrations.

JEAN JACQUELIN (1905-1989), French illustrator, specialised in posters about transport.

WILLIAM HOWARD JARVIS (1903-1964) served in the merchant navy and, during the Second World War, in the Royal Navy. His works were inspired by those of Kenneth Shoesmith.

C. JOCKER, employed by Holland-America Line, created posters for this company in addition to his official work.

HENNING KOEKE (1909-1998), Germany.

JOHAN KESLER (1873-1938) was born in Haarlem and studied there at the Kunstnijverheidsschool. He worked as an illustrator and graphic designer; his work included posters for Königlich Holländischer Lloyd.

PAOLO KLODIC (1887-1961), working in Trieste, produced many posters for Italian shipping companies.

BERNARD LACHEVRE (1885-1950) was born in Le Havre and studied in London. During the First World War, he served in the infantry and painted pictures of the soldiers. He then became one of the "painters of Honfleur" and was named Painter for the Navy in 1922. He spent a lot of time at sea on civilian and military boats. He was primarily a water-colourist.

FERNAND LE QUESNE (1856-1932), born in Paris, was the son of a great sculptor. He was a renowned artist and won several prizes at the end of the nineteenth century.

WILLIAM JOHN PATTON MCDOWELL (1888-1950), born in Barrow-in-Furness, started work at fourteen years old in Vickers shipyard. The technical skills he learnt there are apparent in his artwork. After the First World War, he devoted himself fully to nautical painting and worked for several large shipping companies. His works are very accurate.

FRANK H. MASON (1876-1965), born in Yorkshire, was a cadet in the Royal Navy. He was war artist during the First World War; much of his work is housed in the Imperial War Museum. He became a full-time artist, producing posters for many shippling lines and exhibited at the Royal Academy.

FRANS J. E. METTES (1909-1984) studied in Amsterdam, where he was born. He started work as an all-round artist, though leaning towards design and graphics. He then concentrated on poster design and left a large portfolio of work.

RICHARD HENRY NEVILLE-CUMMING (1843-1920), born in the North East of England, produced many illustrations for shipping companies and in particular for P & O.

L. NOROY (aka Louis Royon, 1882-1968), born in Belgium, took to the sea at an early age for CMBC and ended his career as captain. He was a self-taught artist and produced many posters in a very realistic style for CMBC, as well as for Red Star Line and BSL. He also designed stamps and wrote for travel journals.

GIOVANNI PATRONE (1904-1963) worked in Genoa for Italian shipping companies. His style was resolutely modern.

MAX PONTY (1904-1972), born in Paris, was a copywriter and poster designer, he became known in particular by his works for Radiola, Air France and the Galeries Lafayette. The poster showing a dancer with a packet of Gitanes cigarettes is probably his most famous.

GIUSEPPE RICCOBALDI (1887-1976), born in Florence, was an illustrator whose very modern style fitted perfectly with the 1920s and '30s. As well as the travel posters, those that he created for Fiat are the most well-known.

HARRY HUDSON RODMELL (1896-1984) worked for many shipping companies in the 1920s and '30s. He was one of the founder members of the Royal Society of Marine Artists.

ODIN ROSENVINGE (1880-1957), born in Newcastle upon Tyne, displayed a natural gift for art. He started work in Leeds and then, at the age of thirty-two, went to Turner & Dunnett in Liverpool, whose client list included the great shipping companies. Rosenvinge was one of the most prolific poster artists of his time. The new public awareness of the Middle East during the First World War influenced his choice of bright colours: his posters of the 1920s are awash with shades of orange.

JOS ROVERS (Joseph Johannes, 1893-1976), a Dutch artist, produced posters for different fields including the theatre, sport (notably the Olympic Games held in Amsterdam in 1928) and shipping.

ROBERT SCHMIDT-HAMBURG (1885-1963), a German artist, had much experience of the sea. He produced many works for the German merchant navy before and after the First World War displaying a very personal use of line, colour and light.

ALBERT SEBILLE (1874-1953), a painter and poster designer born in Marseille, was named Painter for the Navy in 1907. He worked for the Compagnie Générale Transatlantique in gouache and watercolour.

KENNETH DENTON SHOESMITH (1890-1939), born in Halifax, Yorkshire, showed his talent as an artist at a very early age. He started as a cadet on the *HMS Conway* and then joined Royal Mail Line where he became an officer of the merchant navy. He never stopped drawing and painting and his style developed in time towards Art Deco. In the inter-war years, he worked for Thomas Forman printers. A large part of his work is held at the Ulster Museum in Belfast.

JOHAN ANTON WILLEBRORD VON STEIN (1886-1965), a Dutch artist, is often compared to Cassandre for his style of drawing using clean lines. In addition to producing posters, he created objets d'art and furniture.

BERND STEINER (1884-1933), an Austrian artist, created landscapes as well as portraits and theatre scenery. He was the artistic director of a theatre in Bremen. His posters for Norddeutscher Lloyd were very popular.

WILLEM FREDERIK (WIM) TEN BROEK (1905-1993), born in Amsterdam, had a similar style to that of Cassandre. His poster for the *Nieuw Amsterdam* made him famous, but he produced others that are just as well known for the same company, as well as for the Dutch KNSM and Lloyd Brasileiro.

WALTER THOMAS (1894-1962), a naval architect turned painter, worked with Odin Rosenvinge. He worked mainly for Blue Funnel Line in oils and watercolours. During the Second World War he was responsible for the camouflage of ships for the Admiralty.

CHARLES E. TURNER (1893-1965), born in Lancaster, served in the Fleet Air Arm during both World Wars. He was proficient in the painting of seascapes. Some of his works are held at the National Maritime Museum in Greenwich.

HUGO VALDEMAR LARSEN (1875-1950), Denmark.

JOHANN (JEAN) WALTHER (Gene Walter, 1910) was a pupil of Cassandre and Loupot. He moved to Amsterdam in 1932 and designed a whole range of posters, brochures, calendars and other publicity material for the shipping company KNSM. He then worked for the advertising agency Aneta. He arrived in the United States during the Second World War and there assumed the name Gene Walter. He ran the advertising agency Walter-Bolland in San Francisco.

NORMAN WILKINSON (1878-1971), born in Cambridge and studied at the Portsmouth School of Art. He worked for *Illustrated London* and produced posters for the shipping and railway companies. During the First World War, he designed the 'dazzle painting' camouflage for the Royal Navy, which was intended to mislead the enemy about the size and location of the ships. He served in the Royal Air Force during the Second World War. He is one of the most famous British poster artists.

Acknowledgements

Gabriele Cadringher offers special thanks to Jim Lapides of the International Poster Gallery of Boston for his information about the history of the poster.

Her sincerest thanks also go to:
Irene Jacobs and Elisa Schouten, Maritiem Museum, Rotterdam, www.maritiemmuseum.nl
Susie Cox and Elis Beth, P & O Heritage Image Collection, London
Alessia Contin, Museum für Gestaltung, Zurich, www.museum-gestaltung.ch
Erika Neumann, SS Great Britain Trust, Bristol
Cristopher Bailey, Picture This, Hong Kong, www.picturethiscollection.com
Jim Lapides and Tricia Weigold, International Poster Gallery, Boston, www.internationalposter.com
Leila Boucif, Galerie Paul Maurel, Paris, www.poster-paul.com
Alessandro Bellenda, Galerie L'IMAGE – Affiches Originales du XXᵉ siècle, Alassio, www.posterimage.it
Claudia Fichera Petersen, Hambourg
Vincent Chavanes, Tonnerre
Marco Maria Pasqualini, Riproduzioni fotografiche Alassio, Italy, www.imagerie.it

Picture Credits

© 2011, Antique Collectors' Club
Sandy Lane, Old Martlesham, Woodbridge,
Suffolk, IP12 4SD, UK
www.antiquecollectorsclub.com
ISBN: 9781851496730

Printed in China for the Antique Collectors' Club Ltd., Woodbridge, Suffolk

First published in French under the title of *Affiches des Compagnies Maritimes*
© 2008, Editio-Éditions Citadelles & Mazenod
8, rue Gaston de Saint-Paul, 75116 Paris
www.citadelles-mazenod.com
ISBN: 9782850882678